VICTORIAN BOOK DESIGN

From *The Child's Book of Zoology* by J. H. Fennell, London, 1840.

Victorian
book design

& colour printing

By Ruari McLean

London
Faber & Faber
1963

First published in mcmlxiii by
Faber & Faber Limited
24 Russell Square London WC1
Printed in Great Britain
by Shenval Press Ltd, London, Hertford and Harlow
The colour plates by Chromoworks Ltd
All rights reserved

To

From *Fanny's Picture and Verse Book*,
London, 1844.

FOREWORD

More exciting things happened in book design between 1837 and 1890 than in any other comparable period in the history of the world's printing; and most of them happened in London.

While Whittingham and Pickering were in their prime, it was a period of great typography; it was also the period of Baxter, Owen Jones, George Leighton, Kronheim and all the other pioneers of commercial colour printing. It was the last period of hand craftsmanship in commercial etching, wood-engraving and lithography; the last period when labour-saving devices co-existed with cheap labour, and marvellous effects were obtained in printing and bookbinding which no one could afford today.

The period is only now coming into historical focus, and we are just beginning to discover what contemporary documents have survived the salvage campaigns and bombs of two world wars. No histories of the printing, the publishing, or the book illustration of the period have yet been written: no proper lists exist of the tradesmen, the craftsmen or the artists, although for publishers a good start has been made (confined of course to children's publishers) by Miss Judith St John in *The Osborne Collection of Early Children's Books*, Toronto, 1958, a most helpful work.

It has been impossible, in the present work, to exclude mention of illustrators whom one particularly admires, but I have had to bear in mind that my subject is the design of books as a *whole*, not book illustration.

The design of books is part of the history of art. The sort of books that are published is an important part of social history. I hope the present work may call attention to some of the many classes of books written, designed and sold during the nineteenth century, which have not so far had much notice from the social

historians – who have concentrated first, for obvious reasons, on fiction, magazines and children's literature.

Single copies of books can be highly peculiar: nearly all important books mentioned in these pages have been examined in several copies. By no means all are in the British Museum; this particularly applies to original bindings or the covers of the many books originally issued in parts.

Since perhaps the most decorative aspect of Victorian books is their exteriors, and these have never been systematically described (although sound foundations were laid by John Carter and the late Michael Sadleir), I have devoted a chapter to them and included over thirty-five illustrations. It will be only too obvious that a fuller account is badly needed.

In a work of this kind, one has to plague many friends and strangers with requests for information. Most sources are, I hope, acknowledged in the text, but for prompt, patient and helpful replies to endless questions I must particularly thank Miss St John of Toronto Public Library, and Mr Harry Carter and Mrs Thrussell of the Constance Meade Collection at the University Press, Oxford. Especially valuable help has also been given by Mr James Mosley and Mr Turner Berry of the St Bride Printing Library, Mr Christopher Bradshaw of Eyre & Spottiswoode Ltd, Miss Sybille Pantazzi of Toronto Gallery of Art (in connection with Victorian bindings), Mr James Wells (for showing me colour printing in the Newberry Library, Chicago), Mr Harold Hugo (for many introductions and other kindnesses), and Mr Howard Nixon of the British Museum, who most generously read and criticized my chapter on publishers' bindings. Unfailing help and courtesy has also been given to me by numerous members of the staff of libraries of the British and Victoria and Albert Museums, and by Miss Margaret Clark of the National Book League.

My grateful thanks are due to many friends who have let me examine or borrow their books and given me much useful information and advice, especially Robin de Beaumont, Dr and Mrs Bell, Mr and Mrs Renier, Nicolete and Basil Gray, Helmut and Alison Gernsheim, Fianach Jardine, Reynolds Stone, Lionel

Darley, Vivian Ridler, Percy Muir, Handasyde Buchanan and John Carter.

Many booksellers have been most helpful, among whom I would like especially to thank Mr Pratley of Tunbridge Wells, and Mr John Maggs and Mr Marks of London.

I am most grateful to Mrs Beatrice Cundall, widow of one of Joseph Cundall's grandsons, for much kind help and information about the Cundall family. For generous permission to study their firms' achives, and courteous help in doing so, I am grateful to Mr John Murray, of John Murray Ltd, and the late Mr Cyprian Blagden and Mrs Hurst of Messrs Longmans Green & Co. Ltd.

The devices on pp. iii, ix, xvi, 52 and 168 are printed from electros made directly from the original Chiswick Press wood engravings now in St Bride's Printing Library, by courtesy of Eyre & Spottiswoode Ltd.

Except where otherwise stated, all the photographs of books have been taken by Miss Cecilia Gray and Mr J. W. Thomas of Oxford, to whose skill and care I am greatly indebted. For permission to photograph the items illustrated in plates 11A and 43A, I am grateful to the Trustees of the British Museum.

Thanks are also due to the Editor and Publishers of *Penrose Annual*, No. 56, for permission to include in this book the colour plates used to illustrate my article on Joseph Cundall; to David Bland for his help and patience; and to James Shand and the Shenval Press for the care with which this book has been printed.

CONTENTS

ILLUSTRATIONS

COLOUR PLATES

MONOCHROME PLATES

ILLUSTRATIONS

LINE ILLUSTRATIONS

I

The Background

THIS BOOK is about book design in the Victorian period. By 'book design' I mean all the ingredients which when put together successfully result in books which are pleasant or remarkable to look at and to handle. These ingredients are, briefly, the outside binding or case, which during the Victorian period included many other materials besides the usual leather, paper, or cloth; the designs thereon; the way the book is bound, which affects how it opens and shuts, and feels generally; the paper used for the pages, its weight, and suitability for the type and illustrations; the size of the page and the margins, their proportions and relationship to the type, and to the thickness of the book; the types used for the text, and headings, the way they are arranged and, most important, the way they are actually printed on to the paper; and the illustrations and decorations on the pages. Although all these ingredients can be examined separately, they interact on each other; a successfully designed book may appear to be unremarkable in every detail yet right as a whole. Decoration is not an essential part of a well-designed book, although often a desirable one: a book may be beautiful without elaborate initials, illustrations or other embellishments, if its type is in itself good, well laid out, and well printed on the right sort of paper.

It must perhaps be emphasized that illustration is not the subject of this book. Although a complete history of Victorian book illustration has yet to be written, and I long to read it, a good deal has been written on the subject. I have tried to avoid going over ground already well covered, and have neglected those artists who have already been much written about. I have especially tried, not always successfully, to exclude artists who, in my opinion, made their contribution to individual pages, rather than to books as a whole. I have

also, in the choice of illustrations, tried to avoid showing pages already illustrated in easily accessible works.

The scope of this book is, roughly, book design in Britain from the accession of Queen Victoria in 1837 to the establishing of the Kelmscott Press in 1890. The period has a unity, since it was the last period of hand-worked printing and illustration processes in commercial book production. The introduction, around 1890, of photographic process blocks, photo-lithography and photogravure, introduced a completely new epoch.

The eighteenth century had been a great period for printing in England and Scotland: for the first time good types were being made in England, by Caslon, and were even being exported: and, also for the first time, British books (printed in Glasgow by Foulis, or in Birmingham by Baskerville) were respected and bought by connoisseurs abroad.

A tradition was established, and continued. In the early years of the nineteenth century, there was enough money and taste in England to support at least three outstanding printers, Bulmer, Bensley and Charles Whittingham; and the existence of a Law of Patents was an additional attraction to foreign technicians and inventors. It was in Bensley's workshops in London that the German inventor Koenig perfected the steam cylinder press which *The Times* adopted in 1814. It was first to Edinburgh, then London, that the American naturalist J. J. Audubon came in 1826 for the production of *The Birds of America*, which contained four hundred and thirty-five hand-coloured aquatint plates in four double elephant folio volumes – one of the largest 'books' (it contained no text) that has ever appeared.

A visitor to the London bookshops in the 1820s – say to Hatchard's in Piccadilly, or Ackermann's Library of the Fine Arts in the Strand – would have been able to look at such a collection of printed books as had never been seen in the world before. Most of the bigger ones, folios and quartos, would have been illustrated with fine etched or aquatinted plates. Many of these plates would be exquisitely coloured – all by hand. He would have found William Daniell's *A Voyage round Great Britain*, and Thornton's *Temple of*

Flora, and Samuel Curtis's *Beauties of Flora*, and the *Microcosm of London*, with coloured plates drawn jointly by Augustus Charles Pugin and Thomas Rowlandson, and *Greenwich Hospital*, with coloured plates by George Cruikshank. He would probably not have found, in those shops, any of the marvellous coloured books of William Blake, printed by the artist himself in such limited quantities; but they existed. He would certainly have found some books illustrated in black and white by Thomas Bewick and his pupils, who were restoring to dignity the long-neglected wood block. And in plain texts, down to pages of almost thumb-nail size, there was no printer in Europe whose press-work or typography surpassed those of the elder Whittingham at the Chiswick Press.

When Victoria came to the throne in 1837, one could buy in London certainly the best typography and probably the finest printing and bookbinding in the world.

But in 1837 an author or publisher contemplating publication had to use approximately the same equipment as Caxton. Although *The Times* had been printed on steam cylinder presses since 1814, it was thirty or forty years before steam presses were much used for books, and the gradual change to power printing did not affect their design or appearance.[1] The change from hand-made to machine-made paper was also gradual, and hand-made continued, of course, to be the best available. Until about 1870, all paper was normally damped before printing.[2] The introduction of mechanical methods for punch-cutting and type-casting was slow: the increased number of new faces made possible by mechanization affected jobbing rather than book work, and throughout the period books were normally set in only one kind of face, the 'Modern'. Caslon Old Face was revived in the 1840s, but was never common; from 1860, there was also 'Old Style', a compromise between the two. Mechanical composition, and the many new faces introduced by

[1] Arthur Warren states that until 1860 no steam press was in use at the Chiswick Press; but William Clowes, printer to the Useful Knowledge Society, had nineteen steam presses by 1839 (R. D. Altick, *The English Common Reader*, University of Chicago Press, 1957).

[2] W. T. Berry, *Oxford History of Technology*, London, 1958.

3

the Linotype and Monotype companies, did not really begin to affect book design until the 1920s.

In 1837 the mediums of book illustration were, as they had been for nearly four hundred years, the wood block and the copper plate, and since about 1800 steel had been used as a harder alternative to copper; but there was also a newcomer, the lithographic stone or zinc plate. This too was a hand process like the others. Photography began to be a factor from about the middle of the century, but was of minor influence until the 1890s. When the photographic plate finally ousted the hand processes for interpreting artists' drawings for commercial book illustration, a new age began.

During the Victorian period, the techniques of book design and manufacture were changing slowly, but the world, the readers and users of books, and the nature of the book itself were changing fast. An old world was disintegrating: the foundations of a new one were being discussed, sketched, and excavated. People were changing: children were being born into utterly new urban conditions: an enormous demand for books was being created by the rocketing population and the growth of cities. The purpose and character of books themselves was becoming vastly more diversified.

Publishing had begun to emerge as a profession separate from bookselling during the eighteenth century, but the distinction was still blurred during the nineteenth.

Throughout the century many booksellers also published books – as indeed they still do. At least until 1840, novels were sold in sheets to booksellers and libraries, who ordered the binding themselves.[1] Ackermann, Pickering and Bohn, famous as publishers, were all first and foremost booksellers.

Publishing had been considered, like the wine trade, an occupation permissible for gentlemen, perhaps from the fallacy that the most necessary qualification was an appreciation of literature. In fact, then as now, a publisher, to achieve success, needed charm, financial acumen, a knowledge of the future, a stony heart, and a very rich wife. The complications of dealing with authors and financing literature are well known. But literature is only one

[1] M. Sadleir, *The Evolution of Publishers' Binding Styles*, London, 1930.

4

department, although the most romantic, of a publisher's business. Gift books, which necessarily feature rather largely in the following pages, school books, children's books, science, religion and natural history, are all also important; the risks in such works were often divided up between publisher, author and printer, and other parties as well. But the day had not yet come, as it has now, when it was almost impossible to make a profit from a book published in a small edition. The average first printing of a serious book, at least up to 1860, was seven hundred and fifty or one thousand copies.[1]

The structure of publishing, as indeed of all consumer industries, and of company law and business finance generally, was developing throughout the century. The Companies Act was passed in 1862; the Publishers Association of Great Britain and Ireland was not founded until 1896.

The Victorian period was one of rapid change, of fertile invention, and of enormous vitality, all of which is reflected in its books. It was a period of gradually lowering standards in the design of nearly all manufactures, but one in which that decline was vigorously protested against by a few; it was also a period of craftsmanship, at least in printing, which the present age would do well if it could emulate. If artists and designers were fumbling with their new tools, at least the pressmen had mastered theirs, and could print blocks and type on paper with a skill never before, and now rarely, seen. This skill in machining is at its most obvious and basic in black and white work: but this was also the period of the first commercial colour printing – perhaps the most beguiling, and certainly the most characteristic feature of Victorian books. Working in most cases without photography, preparing all blocks and plates with their own hands and eyes, the Victorian colour printers produced some fantastic results; their contribution to the art of the book was unique. Those slowly acquired skills no longer exist, and many of their most fragile books will never again be seen as they once were; but enough remains.

[1] As shown, for example, by the Chiswick Press ledgers in the British Museum; cf. R. D. Altick, *The English Common Reader*, Chicago, 1957. In Great Britain today (1963) the average first printing of a serious book is between 3,000 and 7,000 copies.

2
Whittingham and Pickering

THE FOREMOST name in Victorian book design is that of the Chiswick Press; it was a name established twenty-six years before Queen Victoria came to the throne, and by unusual chances of succession it continued to be synonymous with good typography and printing throughout the period, until and after the days of William Morris.

The imprint was first used in 1811 by its founder, Charles Whittingham the elder (1767–1840), a remarkable man who was an innovator in many printing techniques, particularly in the machining of wood-engravings, at that time the letterpress printer's most searching test. He also conceived and published, from about 1814, one of the earliest series of pocket books in uniform bindings. The Chiswick Press was therefore already a great name in printing when the founder's nephew, Charles Whittingham the younger (1795–1876), became his uncle's partner in 1824. The nephew was also of rare ability, and parted from his uncle in 1828 to set up on his own in Took's Court, Chancery Lane, London. When his uncle's health began to fail, a new settlement was made which resulted in the nephew gaining practical control of the Chiswick Press in 1838.

Charles Whittingham, the nephew, would in any case have been renowned for the excellence of his printing, and at least the soundness of his typography: but the association of Whittingham and the publisher William Pickering resulted in books which neither could have produced alone and which are among the greatest (and most easily accessible) glories of British book design.

Whittingham the nephew first met William Pickering (1796–1854) in 1828, when Pickering had been in business as a bookseller and publisher for some eight years. Pickering's first venture in publishing was the 'Diamond Classics', so-called because they

were set in diamond type, equivalent to $4\frac{1}{2}$ point. They could not be read except with a magnifying glass, but were apparently successful. The first title was *Horace*, 1820, and the series included *Shakespeare*, 1823–5, *Milton*, 1828, and *Homer*, 1831. The series' chief claim to fame, however, is that it included the first books to be sold in cloth bindings. At that time, books were normally issued either in sheets, for booksellers, libraries or private customers to pass to their own binders, for binding in leather or half-leather[1]; or in paper-covered boards, a state not intended to be durable. Pickering had the genius to look for something cheaper than leather, more serviceable than paper. It is not known which title had the honour to be the first to be bound in cloth, or exactly when: but it seems probable that it was one of the 'Diamond Classics', and probable that it was in, or soon after, 1822, and that the cloth was a reddish glazed calico.[2]

The first cloths used for books were adapted from curtain or dressmaking materials. In 1825 the binder Archibald Leighton put on the market the first cloth specially manufactured for covering books, a stiffened dyed calico impervious to the glue required to stick it to the boards.

In the early 'forties, J. L. Wilson set up in Hoxton the first book cloth factory.[3] The first books bound in cloth had the titles printed on paper labels stuck on the spines, a habit continued by Pickering for many of his titles for many years; but in 1832 John Murray published the first book in the world to have gold blocked direct on to its (cloth) spine. 'At once', writes Mr Darley, 'cloth binding moved forward to the finished appearance hitherto only attained by hand-tooled leather; cloth became an acceptable permanent binding.' This development became possible by the invention of the Arming Press, which was really nothing more than the adaptation of an iron printing-press for stamping on cloth-covered boards.

[1] See Michael Sadleir, *The Evolution of Publishers' Binding Styles, 1770–1900*, London, 1930, Ch. IV.

[2] See John Carter, 'The Origins of Publishers' Cloth Binding', *The Colophon*, No. 8, New York, 1931.

[3] L. S. Darley, *Bookbinding Then and Now*, London, 1959.

Gold leaf can be made to adhere to leather or cloth only by a heated tool: previously, all tooling in gold had been done by hand. The design had to be executed like a drawing. A line was made by a wheel: but every other mark had to be made by single tools individually. Now, a design covering the whole spine or side of a book could be cut on brass and impressed at one pull of the handle. But the cover had to go into the Arming Press flat, like a sheet of paper. This entailed another revolution in book manufacture – the covers, or 'cases' as they are called, had now to be made separately, blocked, and then attached to the books by glue. Shortly after this, it was discovered that even sewing could be dispensed with. The sections of a book were guillotined down the back, so that the book, instead of being, say, ten sections of thirty-two pages, became three hundred and twenty loose sheets of paper. By using a special kind of adhesive called caoutchouc, or gutta-percha, these pages could be made to adhere to the case quite satisfactorily.[1] This process, known now as 'perfect' or unsewn binding, is still used, e.g. for telephone directories and paper-backs, but it is not perfect. The adhesive in time becomes perished and brittle. Many a handsome Victorian volume is now a dismembered wreck, owing to its perished gutta-percha binding.

After the 'Diamond Classics', Pickering published books in larger formats, at the same time continuing to maintain a large antiquarian bookselling business. Most, but not all, of the books he published before 1830 were printed by Thomas White, whose work for Pickering is his chief claim to fame. In 1825 began the 'Oxford English Classics', a series published by Pickering in association with Talboys & Wheeler of Oxford, and printed at Oxford, but showing clearly Pickering's influence on the design. The whole series, which included Smollett's *History* and Gibbon's *Decline and Fall*, consisted of forty-four volumes, and fifty or seventy-five copies of each work were printed on large paper.

By 1825, at least three years before he met Whittingham,

[1] A patent for caoutchouc binding was taken out by William Hancock on December 7, 1836, No. 7247. *Abridgement of Specifications Relating to Books, etc.*, 1870.

Pickering had developed the style which we recognize today as being particularly his.

In trying to analyse a book designer's style, and say in what way he was original, it is nearly always possible to find examples of what one had thought were his innovations in a preceding period. Everything, it seems, has always been done already by somebody. Certainly, in book typography, absolute novelty is not only rare, it is a danger, since it is liable to interfere with the reader's convenience. Yet designers do have styles, and Pickering's is unmistakable.

The usual style for title-pages in early nineteenth century England was to have very long titles, sometimes consisting of hundreds of words, set in capitals, usually without much variation in size. Some printers, like Bulmer and Bensley, could make these title-pages look distinguished; but generally they were cumbersome. Pickering realized that if the number of words on a title-page was reduced to the bare minimum, and they were set in small capitals (the size of the text face employed in the book) carefully letter-spaced, with a simple, openly-engraved device or ornament, he could hardly fail to achieve a beautiful title-page. He did not invent this formula: Bulmer had used it, for example, in his beautiful 1804 edition of *Poems by Goldsmith and Parnell*, with wood-engravings by Bewick; in the hands of Pickering it became the basis of the English title-page for a hundred years. Among his earliest uses of it are the 1822 edition of Chaucer's *Canterbury Tales*, printed by T. White, *Portraits of the Sovereigns of England*, 1824 (p. 11), and *Prose Works of Abraham Cowley, Esq.*, printed by D. S. Maurice, 1826. All these were produced before he met Whittingham or used the Chiswick Press. The Chiswick Press style, without the influence of Pickering, may be seen in *The Vicar of Wakefield*, for Thomas Tegg, 1825; *The History of Rasselas*, for John Sharpe, 1828; *Robinson Crusoe* for Baldwin & Cradock, 1831; and Kidd's *New Guide to the 'Lions' of London*, c. 1831.

Pickering's style reached its perfection of simplicity in the 'Aldine Edition of the British Poets', which he began, with Whittingham, in 1830.

The page size of the Aldine Poets is $6\frac{1}{2} \times 4$ in., and they are

still most agreeable books to read. The title-page of every volume carries an engraving of the dolphin and anchor (which three hundred years earlier had been Aldus Manutius's device) with the words 'ALDI DISCIP. ANGLUS', underlining Pickering's aim to produce the classics in cheap yet beautiful formats. Pickering went on using the dolphin and anchor, in a variety of forms, as his main device until he died. Apart from the small vine-leaf ornament ❧ on the half-titles there is no other decoration: books published in series need to be plain, since decoration palls if repeated too often, and what may be appropriate to one title may not suit the next. In this series, incidentally, he began to omit full stops at the ends of lines on the title-pages, an innovation in which he was not consistent.

The Aldine Poets ran to fifty volumes between 1830 and 1853. They sold at 5s. each bound in dark blue cloth with paper labels, or at 10s. 6d. in morocco.

Pickering also published works by George Herbert, Thomas Fuller, Francis Bacon, Jeremy Taylor and others, in the same octavo format as the Aldine Poets, but with woodcut title-page borders and ornaments in the text. These were usually based on, or were direct reproductions of, sixteenth and seventeenth century designs, but there was no boring attempt to make the books accurately Elizabethan or Stuart: it was an intelligent and appropriate archaism. The woodcuts were mostly made by Mary Byfield (1795 –1871), who worked for the Chiswick Press nearly all her life, and whose craftsmanship played a remarkably large part in the appearance of most of the smaller Pickering editions. Designs for woodcuts were sometimes provided by Whittingham's daughters Elizabeth and Charlotte.[1] Pickering's 1853 edition of *Queen Elizabeth's Prayer Book* of 1569 was perhaps Mary Byfield's masterpiece, and every page contains her work; she cut over a hundred blocks for it, mostly based on the designs of Holbein, Dürer, Tory and others. The cuts harmonize perfectly with the type (which is Caslon) and this small volume (of which some copies were printed on vellum)

[1] See notes in Chiswick Press block record books in the Constance Meade Collection, Oxford University Press.

PORTRAITS

OF THE

SOVEREIGNS OF ENGLAND:

ENGRAVED FROM THE BEST AUTHORITIES

BY

W. H. WORTHINGTON.

LONDON:

PUBLISHED BY WILLIAM PICKERING,

57, CHANCERY LANE.

MDCCCXXIV.

The Pickering style was already evolved before Pickering met Whittingham in 1828 (*reduced*).

is a triumph of printing as well as of illustration and typography.

The use of Caslon's Old Face type was itself an innovation pioneered by Pickering. It had been supplanted during the eighteenth century by Baskerville's types with the 'modern' tendency of vertical shading, of which Bodoni's and Didot's were the conclusion. Types in England in the early nineteenth century were all 'modern' and mostly undistinguished: to Pickering, perhaps the chief attraction of Caslon was that it looked (he thought) old-fashioned in the best sense. He used it for several title-pages in 1840; Herbert's *Temple* and *Lady Willoughby's Diary*, both of 1844, were among the first books wholly set in Caslon. Its use spread slowly: for many years it tended to be reserved for gift books rather than ordinary reading books.[1] It remained in comparatively rare use until revived by Emery Walker and William Morris; under their influence George Bernard Shaw helped to restore it to general circulation by choosing it as the standard face for his books shortly before 1900.

During the 1840s, Pickering and Whittingham collaborated on a series of reprints of the Prayer Book, and liturgical histories, which were not only magnificent specimens of printing, but also of considerable textual and historical importance. Keeling's *Liturgiae Britannicae*, for example, a small quarto published in 1842, is a comparative edition, in four columns on an opening of the six earliest Liturgies of the Churches of England and Scotland, printed throughout in red and black: and is a classic example of most complicated setting beautifully laid out. In 1844 Pickering published William Maskell's *The Ancient Liturgy of the Church of England* followed by seven further works by the same author, of which the most important was *Monumenta Ritualia* (1846–7), 'the scientific value of which was confirmed nearly forty years later in 1882, when it was reprinted at the Clarendon Press. From Maskell ... English liturgical scholarship has gone from strength to strength.'[2]

In 1844, Pickering also published no less than seven magnificent folio editions of the Prayer Book. Six were historical reprints, set

[1] See A. F. Johnson, *Type Designs*, second edition, 1959, p. 80.
[2] S. Morison, *English Prayer Books* (3rd edn), Cambridge, 1949.

in black letter, with Caslon roman (helped out, for small sizes of italic, with a modern, since Caslon's italic was not yet available from the founders), and printed, in red and black, on Pouncy's hand-made paper; they were sold only in sets, at eighteen guineas, bound in parchment gilt. The seventh was a Prayer Book for contemporary use, also set in black letter, rubricated, with a wood-engraved border on the title-page, superbly in keeping with Barry's and Pugin's new Houses of Parliament then being constructed (pl. 4). All these were printed by Whittingham, and it is safe to say that, even if the conception was Pickering's, the execution and typographic design in detail was the printer's; they were, perhaps, the crowning achievement of that great collaboration.

It is not possible here to describe every important book, or even every important category of book, published by Pickering: but enough has been said, it is hoped, to indicate his importance. He did not put his name on a single book that was not of distinguished appearance, and most were also of distinguished content. Among other things, he was the first to republish in ordinary typography, in 1839, William Blake's *Songs of Innocence and of Experience*;[1] and in 1840 he published the first edition of Donne's *Devotions* since the seventeenth century. He died in 1854, not only not wealthy, but bankrupt, owing to the default of a friend for whom he had acted as guarantor. His creditors were paid in full from the proceeds of the sale of his stock. Sir Geoffrey Keynes, whose illustrated *Memoir and Hand-list of Pickering's Editions*, published in 1924, though incomplete, is invaluable, stated justly: 'Commercial book production at the present time owes more to Pickering's enterprise than has ever been either claimed or admitted,' and, forty years later, that claim can only be more strongly emphasized.

[1] Edited by Dr Garth Wilkinson, who 'saw fit to alter the poems considerably' according to R. H. Shepherd, editor of the edition published by Pickering's son Basil in 1868. Shepherd claimed that his was the first to publish the songs 'in their integrity'. See Geoffrey Keynes, *Bibliography of William Blake*, New York, Grolier Club, 1922, p. 265.

3
Novels and gift books up to 1850

ALL BOOKS published by Pickering, and nearly all books printed by Whittingham, have that general air and style about them, to be first noticed from the spine, which denotes the conscious care of a book designer. In this, they were exceptional among early Victorian books.

Many of Pickering's books were reprints; but he also published a considerable number of new works. Much of it was serious, anti-quarian or religious. He rarely touched novels, children's books (but he published one of the first translations of Hans Andersen in English in 1846: see p. 44) or books of the drawing-room table variety. Nor did he enter the field of the large illustrated folio, with the exception of Henry Shaw's works on medieval art, to be described in a later chapter. The folios dealing with travel, topo-graphy, or natural history, illustrated by aquatint or engraving, are characteristic of the earlier years of the nineteenth century, and will not be described here. Those which appeared in the Victorian period and were illustrated with lithography are described in Chap-ter 11. As far as typography was concerned, the Bulmer and Ben-sley tradition continued to influence the larger books towards at least some dignity and restraint. The bold display types and borders invented by Vincent Figgins and other English typefounders dur-ing the Regency were often used appropriately and richly on the paper covers of works issued in parts, but rarely appeared in the books themselves.

Smaller books, during the earlier years of the Victorian period, continued to follow traditional patterns of mediocrity. Their title-pages were often burdened with over-long titles, requiring a skill

to set them out clearly and attractively which was usually lacking. They were always set in a Modern face, occasionally varied with a line or two in black letter, in the Bensley style, and even more rarely with some words in a Sans, an open Sans, or a shaded Roman: why the early Victorian book printers so rarely dipped into the wealth of decorative faces newly available from the founders is a mystery, but title-pages like those of *Insect Changes*, 1847, with five different faces (pl. 26A), or *Specimens of Early English Metrical Romances*, 1848 (with at least ten different faces, see p. 19), are extremely unusual. Decorative title-pages were common, and often most attractive, but they were drawn and reproduced by engraving or lithography, followed by a purely typographical title – sometimes, to confuse bibliographers, bearing different wording.

New novels were still published as 'three-deckers', i.e. in three volumes, at 31s. 6d., as Scott's had been; indeed, novels continued to be published in three, or two, volumes until the 'nineties. This meant that most novel readers borrowed their books from the circulating libraries, which were this sort of publisher's best market. Throughout the century, the ordinary circulating library novel was normally printed in an edition of one thousand or one thousand two hundred and fifty copies.[1]

Another form of publication long used for many kinds of books, especially those with illustrations, was the shilling (or more) monthly part. This scheme was chosen by Chapman & Hall for the publication in 1836 of Charles Dickens' *Pickwick Papers*, the text of which had been commissioned purely as a vehicle for Seymour's etchings. The sales of the first part were so disappointing that only five hundred copies of the second part were printed;[2] but sales began to soar after the appearance of Sam Weller, and by part fifteen had reached the sensational figure of forty thousand copies per issue. It was completed in twenty shilling parts and then published in bound form at 21s. After *Pickwick*, publication in parts

[1] Statistics in this chapter are mostly taken from Richard D. Altick's *The English Common Reader*, University of Chicago Press, 1957, or from Marjorie Plant's *The English Book Trade*, London, 1939; and the sources quoted by them.

[2] *Victorian Fiction* (ed. John Carter), National Book League, London, 1947, p. 3.

was accepted for novels, and was used for many of the works of Thackeray, Ainsworth, Lever and Trollope. Novels in parts usually appeared in coloured paper covers embellished with a vigorous illustrative woodcut (not included in the bound volume) printed in black (pl. 12); non-fiction works usually had typographic covers.

The break-through in cheap fiction publishing seems to have started in February 1846, with the publication of complete novels, in cloth, at 2s. 6d., or in wrappers at 2s., by Simms & McIntyre of Belfast, followed a year later by novels in paper boards at one shilling. The idea caught on quickly and was soon copied by Routledge and others in London.[1]

It must be pointed out that Simms & McIntyre were not actually the first to publish cheap fiction. Apart from Bentley's and Colburn's Standard Novels, Sadleir himself mentions Burns' Fireside Library, which began not later than 1844. It was advertised as 'A series of cheap Books for Popular Reading, suited for the Fireside, the Lending Library, the Steamboat, or the Railway Carriage, elegantly printed and done up, with illustrations'. Burns' List of c. 1847 gives thirty-five titles at prices from 6d. to 2s. 6d.

The high cost of books printed in comparatively small quantities for the circulating libraries and wealthy readers was constantly under fire from both philanthropists (who, unlike Ruskin, believed that cheap literature would do good to mankind) and progressive publishers, who believed that cheaper books would do good to themselves. From early in the century, various series of reprints were issued, in octavo and smaller sizes, at 5s. a volume. One of the most successful was Bentley's Standard Novels, begun in February 1831 at 6s. a volume, later 5s. and 3s. 6d. (They were originally published with Colburn, who in 1832 became independent and from 1835 published his own 'Standard Novels'.) Bentley's famous series ran until 1855 and comprised one hundred and twenty-six volumes, all carefully edited and decently printed, with, up to number ninety-two, an engraved frontispiece and title-page,

[1] See John Carter, *Victorian Fiction*, published for the National Book League by Cambridge University Press, London, 1947; Michael Sadleir, *XIX Century Fiction*, London, 1951; and the essays by G. Pollard and M. Sadleir in *New Paths in Book Collecting*, London, 1934.

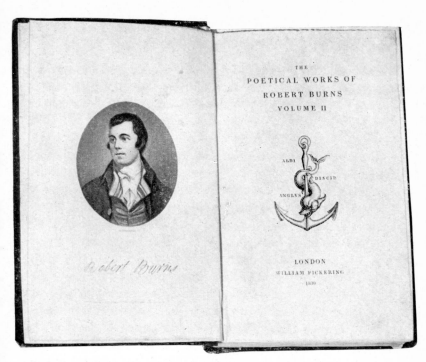

1A The title-page opening of one of Pickering's Aldine editions of the Poets, printed by the Chiswick Press, 1830. $6\frac{1}{2} \times 4$ in.

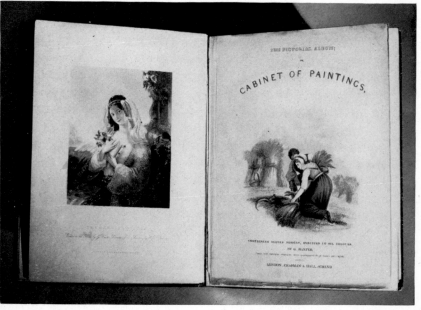

1B *The Pictorial Album; or, Cabinet of Paintings*, 1836. Baxter's only book of his own colour plates. $9\frac{9}{16} \times 7\frac{1}{4}$ in.

The · vision · and · the · creed · of
Piers · Ploughman

newly · imprinted

London · William · Pickering
M dccc xxxxij

2 A Pickering/Chiswick Press title-page of 1842, printed in black and red, actual size.

The Book of Common Prayer

Printed by Whitchurch March 1549.

Commonly called

The Firſt Book of Edward VI.

LONDON

William Pickering

1844

3 Title-page of one of the Pickering/Chiswick Press Prayer Books, 1844.
In black and red, $13\frac{3}{4} \times 9\frac{1}{4}$ in.

4 Title-page of the 'Victoria' Prayer Book, 1844. Pickering/Chiswick Press, printed in black and red. The wood-engraved border is by Mary Byfield. $13\frac{1}{2} \times 9$ in.

DECII JUNII JUVENALIS

AQUINATIS SATIRÆ

DECEM ET SEX

AULI PERSII FLACCI

SATIRÆ SEX

LONDINI

cIɔIɔcccXLV

5 *Juvenal*, 1845. Large paper copy, printed by Charles Whittingham as an Eton Prize. Black and red. 13¾ × 9¼ in.

6A A Pickering/Chiswick Press title-page of 1840. Black and red. $6\frac{5}{8} \times 4$ in.

6B A Pickering/Chiswick Press title-page of 1841. Black and red. $6\frac{5}{8} \times 4$ in.

The Passion of our Lord Jesus Christ,

pourtrayed by Albert Durer.

EDITED BY HENRY COLE,

AN ASSISTANT KEEPER OF THE
PUBLIC RECORDS.

ɤ

London:

Joseph Cundall, 12, Old Bond Street; William Pickering,
177, Piccadilly; George Bell, 186, Fleet Street;
J. H. Parker, Oxford; J. and J. J.
Deighton, Cambridge.

1844.

7A A Cundall/Chiswick
Press title-page of 1844.
$7 \frac{11}{16} \times 5\frac{1}{8}$ in.

THE

LIFE AND ADVENTURES

OF

ROBINSON CRUSOE,

OF YORK, MARINER.

WITH AN ACCOUNT OF HIS TRAVELS
ROUND THREE PARTS OF
THE GLOBE.

London:

JOSEPH CUNDALL, 12, OLD BOND STREET;
THOMAS EDLIN, 37, NEW BOND STREET.

1845.

A Cundall/Chiswick Press
title-page of 1845. $7\frac{3}{4} \times 5\frac{1}{2}$ in.

8 *A Booke of Christmas Carols*, Cundall, (1845). Borders drawn by John Brandard, chromo-

DING, dong, bell,
　Pussy's in the well!
Who put her in?—
　Little Johnny Green.
Who pulled her out?—
　Little Johnny Stout.
What a naughty boy was that
To drown his poor grand-mammy's cat,
Which never did him any harm,
But kill'd the mice in his father's barn.

DINGTY, diddledy, my mammy's maid,
She stole oranges, I am afraid,
Some in her pocket, some in her sleeve,
She stole oranges, I do believe.

YE winker, 　[*smooth the eyebrows.*
Nose dropper, 　[*stroke the nose.*
Mouth eater, [*press the lips together.*
Chin chopper, 　[*shake the chin.*
　Chin chopper.

FOUR and twenty tailors
　Went to kill a snail,
The best man among them
　Durst not touch her tail.

She put out her horns
　Like a little Kyloe cow:
Run, tailors, run,
　Or she'll kill you all e'en now.

GAY go up and gay go down,
　To ring the bells of London town.

Oranges and lemons,
　Say the bells at St. Clement's.

Bull's eyes and targets,
　Say the bells of St. Marg'ret's.

Brickbats and tiles,
　Say the bells of St. Giles'.

Halfpence and farthings,
　Say the bells of St. Martin's.

Pancakes and fritters,
　Say the bells of St. Peter's,

9 *Traditional Nursery Songs of England*, Cundall 1846. Home Treasury series. Printed by Chiswick Press. 6⅜ × 4⅝ in.

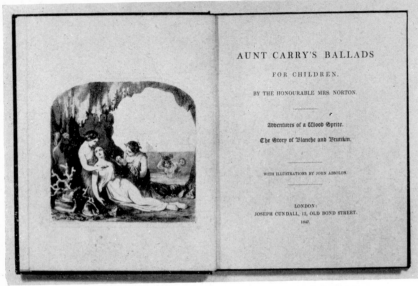

10A A Cundall/Chiswick Press title-page of 1847. $7\frac{3}{4} \times 6\frac{1}{4}$ in.

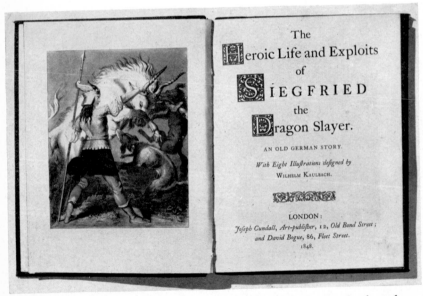

10B A Cundall/Chiswick Press title-page of 1848, with hand-coloured frontispiece. $8 \times 6\frac{1}{4}$ in. *Constance Meade Collection, Oxford.*

ULL. The Bull,
as you see here, is stout
and broad-chested, with
a thick short neck, and
a fine full eye. He lives in the fields
among the Cows, which give us sweet
milk, but the Bull gives us none; yet
his flesh makes good food, called beef.
He eats grass and herbs. His skin is
thick and hairy, and of various colours,
black, red, brown, and white; it is
called a hide, and makes stout leather.
He is not gentle like the Cow, but often

11A *An Alphabet of Quadrupeds*, Cundall (Home Treasury), 1844. Chiswick Press. The initials were borrowed from Henry Shaw's *Alphabets Numerals and Devices of the Middle Ages*. $6\frac{3}{8} \times 4\frac{5}{8}$ in. *British Museum*.

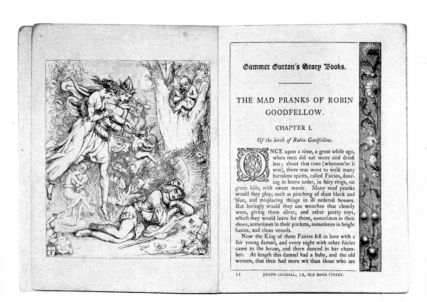

11B *Robin Goodfellow*, Gammer Gurton's Story Books, Cundall, *c.* 1845. Illustration by J. Franklin, cut on wood by E. Dalziel. $6\frac{3}{8} \times 4\frac{3}{4}$ in.

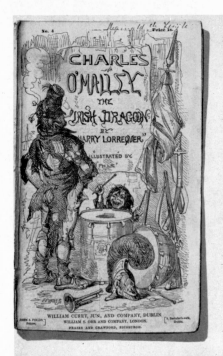
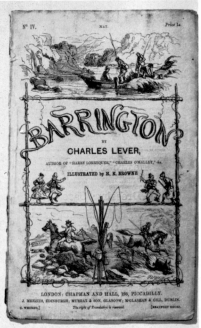
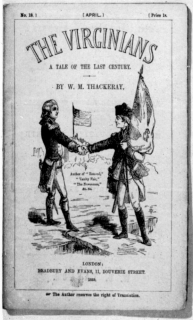
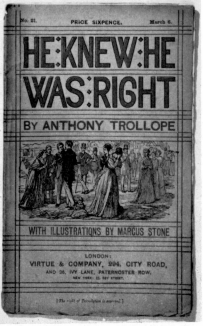

12 Cover designs of four novels published in parts. In black, or black and red, on coloured paper. *Charles O'Malley*, 1839; *Barrington*, 1863; *The Virginians*, 1859; *He Knew He Was Right*, 1869.

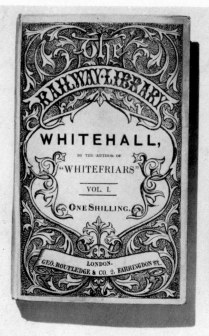
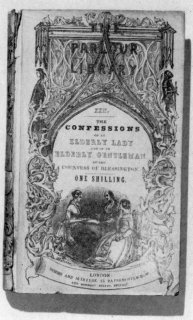

13A Paper boards: *Whitehall*, 1853. Unsigned design in blue on turquoise paper. Parlour Library cover, 1848, designed by H. Warren, cut on wood by W. Dickes, in red-brown on green paper.

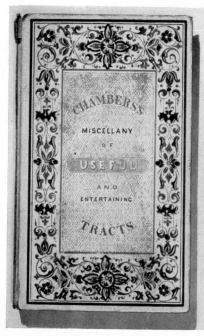

13B Paper boards: *Chambers's Miscellany*, 1845, printed from wood in red, brown and blue on white glazed paper. Scott's *Poems*, Simms & McIntyre, 1846, chromolithographed in gold, blue, red and black.

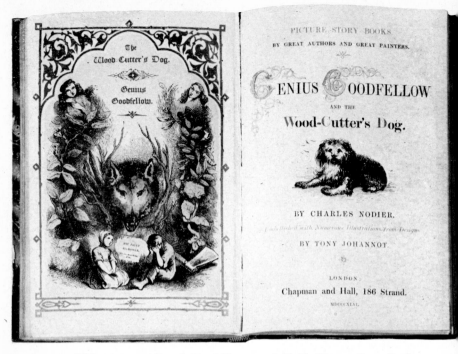

14A Title-page opening of one of Chapman & Hall's 'Picture Story Books by Great Authors and Great Painters', one of several series copying 'Home Treasury' ideas. The frontispiece is printed in two colours and gold, and hand-coloured: the title-page is in black and red. Printed by Vizetelly Brothers, 1846. $6\frac{1}{2} \times 4\frac{1}{4}$ in.

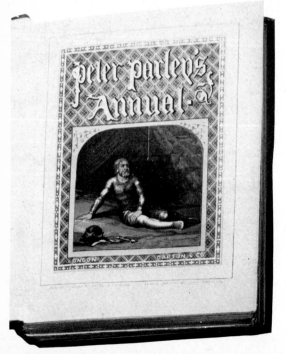

14B *Peter Parley's Annual* 1848. Title-page printed from wood in about eight colours by Reynolds & Collins. 6×4 in.

38.

LITTLE Tommy Tucker,
 Sing for your supper.
What shall he eat?
White bread and butter.
How shall he cut it
Without e'er a knife?
How shall he marry
Without e'er a wife?

39.

NOSE, nose, jolly red nose;
 And what gave thee that jolly red rose?
Nutmegs and cinnamon, spices and cloves,
And they gave me this jolly red nose.

44.

PRETTY maid,
 pretty maid,
 where have you been?
Gathering a posie
 to give to the queen.

Pretty maid,
 pretty maid,
 what gave she you?
She gave me a diamond
 as big as my shoe.

15 Two pages from *Nursery Rhymes Tales and Jingles*, James Burns, 1844. Printed by Robson, Levey & Franklyn. The unsigned drawings are on wood. 8 × 6 in.

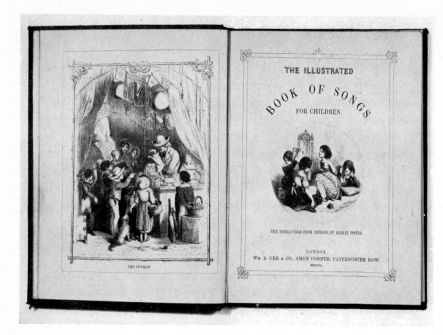

16 *The Illustrated Book of Songs for Children*, 1850, illustrated by Birket Foster when he was twenty-four. The drawings were engraved and the book printed by Henry Vizetelly. $7 \times 5\frac{1}{4}$ in.

and thereafter an engraved frontispiece only. Four binding styles were used; the first three were comparatively plain, but the fourth, used from 1849–55, had a very attractive spine blocked in gold with an Adamesque design headed by the Royal Arms (Bentley had been appointed 'Publisher in Ordinary' to Queen Victoria in 1838). This style appeared also on the spines of competing series, for example Colburn's Standard Novels, 1835–48; Routledge's Standard Novels, 1851–*c*.60; Ingram, Cooke's National Illustrated Library (*c.* 1850–*c*.54); Bohn's Standard, Illustrated, Antiquarian, and five other Libraries (1846–mid '60s); and Simms & McIntyre's Parlour Library (1847–62), which virtually put an end to the whole lot by selling books bound in cloth first at 2*s*. 6*d*., then at 1*s*. 6*d*.[1]

The quality of the gold blocking on some of these series was so good that it is still possible to find copies in bookshops today shining quite untarnished, a century and a quarter later. The cloth also, on these and other cheap books, was given a variety of finishes both in colour and grain, conferring on many otherwise ordinary books a distinction never associated with the cheap cloths and cloth substitutes of today.

A leading and sympathetic figure in the battle for cheaper literature was Charles Knight (1791–1873). As superintendent of publications for the Useful Knowledge Society founded by Henry Brougham, he specialized in publishing works of information, in numbers and in book form, for example, the *Penny Magazine*, 1832–45, and the *Penny Cyclopaedia*, 1833–44, often profusely illustrated with woodcuts. These made notable contributions to publishing technique and to public education, but not to book design. His early and important contribution to printing book illustrations in colour from wood blocks is described in Chapter 5.

Most of the books so far mentioned in this chapter were intended to be read. But there were many other kinds of book intended rather to be looked at. These usually consisted of steel engravings interspersed with short passages of prose or poetry: the literary

[1] The remarkable achievements and subsequent history of John Simms and James McIntyre are briefly described in Sadleir's *XIX Century Fiction*, vol. 2, pp. 146–7.

contents were of negligible quality and since the books sold very largely on their appearance a great deal of care and ingenuity was lavished on their bindings.

In this category is Fisher's *Drawing Room Scrap Book* series, which ran from the 1830s to the 1850s: the page size is $10\frac{3}{4} \times 8\frac{1}{2}$ in., and they contain sixty-four pages of text and thirty-six plates, mostly steel engravings, by various hands, reproducing paintings. Their price was 21s., the normal gift book price for many years. Although many of the engravings are skilful, the impact as a whole is deadening, perhaps partly because the illustrations are usually on such a small scale, and many are landscape, requiring the book to be turned. The 1834 *Scrap Book* contained one of Baxter's earliest colour prints as frontispiece (see p. 30), but this promising innovation was not repeated and colour was not used again in the series. The contents, in fact, did not live up to the attractive, rich-looking exteriors (pl. 50).

Equally rich exteriors – overall gold and blind blocking, in traditional binding patterns, on coloured cloths – were used by David Bogue for his *Court Albums*, published between 1850 and 1857. These volumes, slightly larger than the *Drawing-Room Scrap Books*, contained 'portraits of the female aristocracy engraved by the best artists from drawings by John Hayter' and short historical texts. Queen Victoria's Court used to give these books as presents.

A series of art gift books in larger size was published at the beginning of Victoria's reign by Charles Tilt (1797–1861), who specialized in lithographic illustrations and was also a frequent employer of George Cruikshank. Among these was *Pearls of the East*, 1837, containing twelve plates of voluptuous houris, designed by Fanny Corbaux, drawn on stone in two colours by Louisa Corbaux, and printed by Hullmandel. The page size is $14\frac{1}{2} \times 10\frac{3}{4}$ in., and the book cost 31s. 6d., in cloth, blocked in gold, all edges gilt, or £2 12s. 6d. with the plates completely coloured (by hand).

In 1838 Tilt published *The Authors of England*, containing fourteen portraits, after medallion drawings by H. Weekes and E. W. Wyon, engraved on steel by Achille Collas's patent process: a curiosity, perhaps, but the skill of the technique is breath-taking.

SPECIMENS

OF

EARLY ENGLISH METRICAL

ROMANCES,

TO WHICH IS PREFIXED

AN HISTORICAL INTRODUCTION

ON THE

RISE AND PROGRESS OF ROMANTIC COMPOSITION IN FRANCE AND ENGLAND.

BY

GEORGE ELLIS, ESQ.

A NEW EDITION, REVISED BY

J. O. HALLIWELL, ESQ., F.R.S.

LONDON:

HENRY G. BOHN, YORK STREET, COVENT GARDEN.

MDCCCXLVIII.

A title-page of 1848. Decorated types were not often used inside books in this way.

The process, known as 'anaglyptography', was one of several in which a tracing arm, moving over a rounded object such as a plaster cast of a medal, could produce by mechanical means an engraving which had an uncanny appearance of being embossed.

For larger books, lithography was obviously now cheaper than any kind of engraving; lithographic works are discussed in chapters 8–11.

Another, more serious, kind of book with steel engravings was the Picturesque Annual, usually about $9\frac{1}{4} \times 6\frac{1}{4}$ in., containing twenty or so engravings, often made by the most skilled engravers after drawings or paintings specially commissioned from artists of the calibre of Maclise, Cattermole, Clarkson Stanfield and even Turner, with a well-written text describing the scenes illustrated. Such volumes were also sold on their appearance and were always handsomely bound, sometimes in leather, sometimes even in green velvet, as were the two volumes on Ireland published by Longman in 1837 and 1838. Jennings's *Landscape Annuals*, in this category, with engravings after drawings by David Roberts, and texts by Thomas Roscoe, were published from 1830 to 1839. The normal price for all these books was 21*s.* a volume.

One of the finest books of steel engravings was Clarkson Stanfield's *Coast Scenery*, originally published by Smith, Elder as a quarto in 1836, and republished in 1847 as an octavo ($8\frac{7}{8} \times 5\frac{7}{8}$ in.). Turbulent seas and skies seem to have been one of the most suitable subjects for the steel engravers: another work of this kind was *The Harbours of England*, with twelve superb plates mezzotinted by Thomas Lupton after drawings by Turner, which although engraved much earlier were not published until 1856, when they were accompanied by some of Ruskin's most picturesque prose.

The copper and steel engravings of the Victorian period deserve more attention than they have yet received; but their place is rather in the history of illustration than of book design.

Books of copper and steel engravings continued to be published for many years, but often these were plates which had been already published, whose copyright had been sold off cheap.

Colour printing was the innovation of the 'forties, and the illumi-

nated gift book, usually printed by chromolithography, and dressed in one of several varieties of fancy binding, became more interesting than the traditional book of copper and steel plates. The illuminated gift books of the 'forties and 'fifties are described in chapters 9, 10 and 11.

It might have been expected that the best of British book design would have had a good showing in the Great Exhibition of 1851, in the preparations for which the leading book designers and printers of Britain all had much to do. This was, however, not so.

The official *Reports by the Juries*, of the Great Exhibition in 1851, states on p. 401 'The Jury have strongly regretted, and this regret has been recorded on their minutes, that almost the whole of the printers of England have refrained from exhibiting the beautiful productions of their presses, owing to the instructions given to the Local Commissioners, which stated that printed books were inadmissible. However, some fine specimens of good printing seem to have crept in by mere chance, such as Messrs BRADBURY and EVANS's beautiful work for Mr Marryat, "Collections towards a History of Pottery and Porcelain", neatly executed;[1] Mr PICKERING's "Victoria Book of Common Prayer", in large Old English type, the rubrics in red ... Also the first six books of Euclid, with the diagrams and symbols printed in colour ... these are from the press of Mr WHITTINGHAM.' Mr Whittingham was one of the Jurors, and, as Reporter of the Jury, presumably wrote the above passage. It was unfortunate that books were so inadequately represented, since at that time there would have been many remarkable examples to show from England, which would probably have surpassed anything to be shown from the Continent or the United States. The books of Pickering and Whittingham, in particular, would have been outstanding in any company.

The *Catalogue of the Great Exhibition* and the *Reports of the Juries* were, however, themselves notable achievements of British book design and production. Both were printed by William Clowes:

[1] A by no means outstanding book, but illustrated with some very good colour plates printed by Stephen Austin.

the former, in three volumes, consisted of over one thousand five hundred pages, the latter of one thousand pages.

Although lacking the grace that Whittingham could have given if he had printed them (they were presumably well beyond the capacity of the Chiswick Press) they were set in a specially cast Miller & Richard Modern face, well laid out and very well machined; probably no other country in the world could have produced official catalogues of anything like that quality at that time.

CHILDHOOD'S

THOUGHTS:

OR,

THE PRIMROSES.

Illustration by R. Doyle, cut on wood by G. Dalziel, in the *Juvenile Calendar and Zodiac of Flowers*, 1850.

4
Colour printing becomes commercial

WHEN BOOKS were entirely written by hand, they were among the most colourful things ever made by man. When moveable types were invented, and numbers of identical copies of a page of words could be produced one after the other in quick succession, spaces were left blank for initials and illustrations to be drawn in and coloured by hand. It was cheaper to do this than to put the sheets through the press again for a second colour: but as books became cheaper, they also became, inevitably, less colourful.

It was, of course, possible to make printing inks in other colours besides black: the *Mainz Psalter* of 1457, the second book known to have been printed in Europe from type, was printed in black and red, and some big initials were printed in red and blue. These may have been stamped in by hand or they may have been inked separately and printed with one impression; but the red type in the text was definitely printed by a second impression, in register. Colour printing in any number of colours was theoretically possible and the problems of printing in register (i.e. of laying the sheets of paper accurately enough to print a second colour in correct relation to the type already printed) were not insoluble. The printing of type in a second colour, usually red, has in fact always been practised by printers right down to the present day; but the additional expense involved has prevented it being common.

The printing of a picture in colour was of course much more difficult.

The basic method of introducing coloured illustrations in a printed book was to print an outline, either by wood block or copper plate, and colour it by hand in water-colours. The task of

hand-colouring an edition was systematized by the use of stencils and cheap labour, often by children. Hand-colouring with translucent water-colour inks will give exquisite effects, and some bright colours, that can never be achieved by any printing process; but it has severe limitations. It is clearly difficult, if not impossible, to give an adequate representation of an oil painting by means of water-colours, although it was attempted during the early nineteenth century (e.g. in John Burnet's remarkable *A Practical Treatise on Painting*, 1827, which contains small copper plate reproductions of old masters, hand-coloured).

Various experiments were made in printing from wood blocks in colour, of which the chiaroscuro prints were the most successful: these were often very large, usually in only two or three colours, but not often used in books. Chiaroscuro prints were being made in both Germany and Italy probably before 1500; Ugo da Carpi was granted a sort of copyright in the process in Venice in 1516; fine colour printing from wood was done by J. B. Jackson (*c.* 1700–*c.* 1777).

Copper plates were also printed in colour, and J. C. Le Blon, a Frenchman born in Frankfurt in 1667, actually originated a three-colour process, based on Newton's discovery that all colours can be made up from the combination of yellow, red and blue. Neither Le Blon nor any of the other engravers, mostly French, who were experimenting with colour printing during the eighteenth century, succeeded in producing a method of commercial importance.

Some quite beautiful results were also obtained by colouring a single copper plate with a brush, from which a colour print could then be made, from one impression: this method was used, for example, in the famous series of reproductions by Bartolozzi of Holbein's drawings, printed by Bulmer in 1792, and in an edition of *The Castle of Otranto*, 'illustrated by a lady', and printed by Bensley in 1795. In this process, it is obvious that no colour can be printed over another colour, and colour can only be used in lines.

The demand for coloured illustrations in books was, however, growing, and experiments were made with various methods of colour printing from the early 1830s onwards.

The hand-colouring of book illustrations was raised to a high degree of art in England during the last few years of the eighteenth and the first thirty years of the nineteenth centuries. The key plates were generally aquatinted copper plates, sometimes printed in two or even three colours. The books themselves were mostly of views (e.g. Daniell's *Voyage round Great Britain*, and Ackermann's volumes on London, Oxford, Cambridge and the Public Schools) reflecting the discovery of the Picturesque, and the Romantic Movement, or they were monographs on newly-discovered plants or birds, another facet of the Romantic Movement but also scientific in purpose. These books, or at least the coloured plates they contained, are among the most beautiful things ever made in England (they were, of course, also made in France and elsewhere in Europe, but the biggest output and sales were in England) and they provided a tradition and also standards, which the Victorian colour printers had to emulate.

The great hand-coloured books were, however, for rich men.[1] The poor could have, if they could afford them, the woodcut ballad sheets or prints, 'penny plain, twopence coloured', or they could see, in the print shop windows, the bright colours, hand-painted, of the latest 'H. B.', Cruikshank or Seymour cartoons. It was for the rapidly growing middle classes that colour printing, and, in fact, an entirely new publishing trade, had to be developed. The swiftly accelerating population and education figures are the basic fact in any consideration of technical progress in the printing trade in the nineteenth century.

The first true colour printer of the nineteenth century[2] was

[1] Ackermann, and others, produced hand-coloured aquatint books for a widening market; *Real Life in London*, for example, came out from 1821 in weekly numbers at 6d. each, containing one colour plate. But the parts of Daniell's *Voyage round Great Britain*, in 1814, each with two colour plates, cost 10s. 6d., and there were three hundred and eight plates in all; the monthly parts of Ackermann's *Microcosm of London*, 1808–10, with four colour plates, cost 7s., later increased to 10s.; J. C. Nattes, *A Tour of Oxford*, 1805, came out in twenty-five parts at 12s. each, coloured; Pyne's *Royal Residences*, 1819, came out in about twenty-four parts at £1 1s. each (Abbey, *Scenery of Great Britain and Ireland*, 1952).

[2] Some patents for colour printing were taken out between 1819 and 1820 by Sir William Congreve, but his invention of interlocking steel plates was mainly

William Savage (1770–1843). In 1815 he announced *Practical Hints on Decorative Printing*, and finally achieved its publication, in two parts, in 1818 and 1823. One plate was printed from twenty-nine wood blocks, and several were in ten or more workings. They were, however, technical rather than artistic triumphs, and did not have the great richness of colour that one would expect from so many workings. The simpler subjects, printed in three or four colours, are better, and successfully reproduced the tones and softness of an aquatint or wash drawing. Savage describes in detail his methods of working and his materials, and gives the recipe for his ink, made without oil, which today, nearly one hundred and fifty years later, is still a beautiful dense black and has not stained the paper, as oil-bound inks frequently do.

Savage was awarded a silver medal and £15 15s. by the Society of Arts in 1825 for his colour printing, but that was probably all the financial reward it earned him. In 1832 he published *On the Preparation of Printing Ink*; and in 1840–1, the result of a lifetime's labours, a *Dictionary of the Art of Printing*, still a useful reference book, although curiously enough it contains almost nothing about developments in colour printing. Savage was clearly one of those devotees of the craft of printing who are more interested in technical perfection than in production, but who perhaps deserve the title of 'master printer' more than many of the printers whose first concern is to get rich quickly. He was of the class which, in Updike's words, 'helps on sound taste in printing, because they are willing to make sacrifices for it'.

What Savage had done experimentally, Baxter and Knight proceeded to do commercially, and independently, some twenty years later. Commercial colour printing by lithography began at almost exactly the same time. Baxter obtained his patent on October 23, 1835, Knight got his in June 1838; one of the earliest dated colour lithographs in England is the print in Owen Jones's *Plans, Elevations and sections of the Alhambra* dated March 1, 1836; Hull-

used for security printing of banknotes, etc., and did not affect books. It was also used for lottery tickets, and many specimens of work by Whiting & Branston, up to the last State lottery in 1826, are in the Constance Meade Collection, University Press, Oxford.

mandel's Lithotint patent was dated November 5, 1840; Engelmann published *Manuel en Couleurs* in 1835 and patented 'chromolithography' in France in 1837.[1]

It is also worth noting that in 1835 there appeared a small book, *Chess for Beginners*, by William Lewis (a prolific chess author), published by Chapman & Hall, in which the diagrams of chess positions are printed by letterpress in green, blue and red. The printer was Whiting, of London. There is nothing technically or artistically remarkable about this book, which is an unpretentious and efficient little manual: but it may be the first use of colour printing in a nineteenth century book, in Britain, for a practical rather than an aesthetic purpose. Whether there are earlier examples or not, it is evidence that about this time ordinary commercial publishers were beginning to make use of printed colour.[2]

Letterpress printing is the process by which letters (or blocks) meet the paper (or vellum, or whatever surface is being printed) under pressure, so that some sort of dent is made in the sheet. During the Victorian period, type was normally printed only by letterpress: when type was transferred to a stone, to accompany an illustration, there was nearly always a lack of crispness, which can easily be seen with the naked eye. But is often difficult to decide whether a coloured illustration has been printed by letterpress or lithography. In Victorian books, this can usually be decided by turning over the page and holding its back horizontally to the light; if printed by letterpress, there will almost certainly be a slight dent or impression casting a shadow. If this is not visible, then types, and lines, and the edges of solid areas, must be examined with a magnifying glass: a line printed from stone is usually quite even, but printing from a raised surface usually carries a thickening of ink along the edge, from the ink deposited on the side as well as on the face of the relief. Modern letterpress machines, which print both

[1] See Abbey, *Travel in Aquatint and Lithography*, 1956, pp. 135–7 and elsewhere.

[2] The first commercial colour printer in America seems to have been Gustav Sigismund Peters, born in 1793 in Germany, who was printing children's books with colour from wood blocks in Pennsylvania from 1826. See Kirke Bryan, *The First Amercan Colour Printer*, Norristown, Penn. (privately printed), 1957.

sides of a sheet of paper almost instantaneously, are so delicately adjusted that there is almost no impression: but Victorian books were printed by the muscular heave on the lever of a hand-press, until, in the 'sixties, steam cylinder machines became common.

The term 'letterpress' covers all printing from relief surfaces, such as type, wood or metal blocks or stereo plates.

Type and wood or metal blocks can be printed together, provided they are all the same height to paper. A different sort of press is required for printing either from intaglio copper (or steel) plates, or from lithographic stones.

Since the shape of a metal type face, and the lines in a wood block, are both produced by cutting, there is a visual affinity between the two which distinguishes them particularly from the drawn lines natural to lithography. This does not mean that type and wood-engravings cannot be harmonized with lithography; but it is a distinction of which the book designer is always conscious.

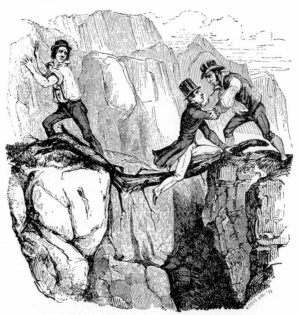

'The Broken Bridge', engraved on wood by Orrin Smith, from *Paul Preston's Voyages, Travels and Remarkable Adventures*, London, 1838.

5

Colour Printing: the inventions of George Baxter and Charles Knight

GEORGE BAXTER was born in Lewes, Sussex, in 1804, the son of John Baxter, printer, publisher, bookseller, and co-inventor, with Robert Harrild, of the composition roller. The young Baxter learned lithography, perhaps from Hullmandel, and wood-engraving from Samuel Williams, and was (from the surviving examples of work in both fields known to be by him) clearly an extremely able artist. It is not known what put colour printing in his mind or even, with any certainty, when he started it: but his earliest surviving colour print, of butterflies, in seven printings from wood blocks, is believed to have been made in 1829. While experimenting with colour, he also worked as a normal wood-engraver and illustrated, among other works, Mary Russell Mitford's *Our Village*, for an edition published in 1835: Miss Mitford described Baxter's visit to her in a letter to her father and wrote of his woodcuts 'I never saw engravings on copper more beautifully finished'.[1]

On October 23, 1835, Baxter obtained his patent, which was for reproducing paintings in colour by means of printing by letterpress in oil inks from a succession of wood or metal relief blocks on a key printed either from a copper or steel plate or lithographic stone or zinc plate. There was no actual new process which he had invented. The originality he claimed was in the first impression from an intaglio or lithographic plate, which, he said, gave the finished print 'more body and character'. This first impression was printed

[1] Quoted by C. T. Courtney Lewis, *George Baxter*, n.d. (1924), p. 144, from which work most of the biographical information on Baxter is taken.

in a neutral colour, usually grey or terracotta, and it contained a range of tone, built-up by dots, only obtainable from mezzotint or aquatint (or, to a lesser degree, from lithography, but Baxter chiefly used intaglio plates). This key, coupled with the number of printings (usually between ten and twenty, but sometimes as many as thirty[1]), gave Baxter's prints the richness that none of his rivals ever attained and which still amazes us today. His other 'secrets' (which in greater or lesser degree he was able to teach his assistants, and which rivals also learned) were great skill in selecting the colours to be engraved, in engraving them, and in obtaining exact register in printing.

The first Baxter prints to appear in books were title-page vignettes in volumes I and II of Mudie's *Feathered Tribes of the British Islands*, 1834, and the frontispiece to Mudie's *The Natural History of Birds*, 1834, the latter from a painting by Landseer. These are from wood blocks only, with no intaglio plate; they do not look very different from the ordinary hand-coloured plate of the day. Also in 1834 there appeared Fisher's *Drawing Room Scrap Book*, with a frontispiece illustration of a Hindoo temple printed by Baxter from wood blocks (again no plate) in about eight workings; the area of colour measures $8\frac{5}{8} \times 6\frac{1}{4}$ in. In 1835 there appeared *The Artist, or Young Ladies' Instructor in Ornamental Painting, Drawing etc*, by B. F. Gandee, published by Chapman & Hall, a charming little book with a floral border to the title-page printed in colours and, as frontispiece, a Baxter reproduction of a painting by Gainsborough printed (as is stated proudly in the book's Preface) from no less than twelve wood blocks.

The first books to contain a Baxter print by the patented process were probably Mudie's *The Heavens* (edition of 1836), and Baxter's *Agricultural and Horticultural Gleaner*, 1836.

The first attempt by a publisher to capitalize Baxter's new process was made by Chapman & Hall, who published *The Pictorial*

[1] C. T. Courtney Lewis says 'For each of "The Coronation" and "Opening of Parliament" thirty or more were used' (*George Baxter*, p. 86): but Baxter's own 'Description of the Art of Colour Printing' presented to subscribers to those prints mentions only between ten and twenty printings (Courtney Lewis, op. cit., Appendix, p. 553).

Album; or, Cabinet of Paintings in 1837, the same year in which they re-issued *Sketches by Boz*, and were selling *Pickwick Papers* in such pleasing quantities. *The Pictorial Album* (pl. IB) was an attempt to break into the Christmas Annual market: it contained eleven of Baxter's colour reproductions of paintings. Three were by genuine R.A.s, with verse by Miss Landon (L.E.L.) and prose by James Ollier; it was elaborately bound in red morocco, inlaid with red, green and yellow panels, blocked in gold, and it was dedicated 'by express permission' to His Majesty King William IV, who, however, died in June 1837, presumably before publication date. *The Album*, with this unlucky start, seems not to have been a commercial success, since it was not repeated. It is, however, a remarkable book, and it is certain that nothing like the colour plates had ever been seen before. The styles and subjects of the mediocre paintings chosen are varied (but surprisingly include no storm at sea or animal subjects) and fully demonstrate the richness of Baxter's results, although the reproductions are all small. The book also contains a Preface on the history of colour printing, with a description of the new process by Carpmael, Baxter's Patent Agent; he christens the process 'Picture-Printing', states that for some of the pictures up to twenty blocks were used, 'and even the most simple in point of colour, have required not less than *ten*', and adds that it is hoped to produce another series 'should they be favourably received by the Public, with whom the decision respecting their merit must finally rest'.

In fact, no collection of Baxter's prints was ever again published in book form: he concentrated on selling his work as individual prints. Courtney Lewis lists eighty-seven books containing Baxter prints, nearly all as single frontispieces, and often also published separately. There was one other book for which Baxter provided a series of important coloured illustrations: Sir Harris Nicolas's *History of the Orders of Knighthood of the British Empire*, 1842, four quarto volumes printed by Whittingham and published by Pickering on behalf of John Hunter, Robe Maker to Her Majesty. Volume I contains a magnificent doublespread title-page in colours by Baxter, one of the finest title-page openings of the century, and

there are twenty-one other plates by Baxter depicting the various collars, ribands, badges and medals in full colour. Baxter's plates (and some hand-coloured lithographs, by Madeley, of Peers in their robes) coupled with Whittingham's typography, Mary Byfield's wood-engravings and the rolling pageantry of the prose, make this work a great example of Victorian book production.

Another book, perhaps the only other, containing a series of Baxter prints, was Isaac Frost's *Two Systems of Astronomy*, 1846. These prints were coloured diagrams.

Baxter himself had no further direct impact on book design; and his system of colour printing, once perfected, was never materially altered or developed. Two of the most ambitious of his prints were *Queen Victoria's Coronation* (measuring $21\frac{7}{8} \times 17\frac{3}{8}$ in.) and *The Arrival of ... Queen Victoria ... to open the First Parliament of her Reign* (measuring $21 \times 16\frac{3}{4}$ in.). Both prints were published in 1841 and were sold to subscribers at five guineas each. Baxter was present at both functions, and made the prints from his own drawings. He was also accorded the rare favour of being one of the only two artists (the other was the Queen's drawing master, George Hayter, knighted in 1842) commanded to be present at the baptism of the then Prince of Wales: but, as far as is known, no print resulted from this privilege, although the watercolour painting he produced was exhibited at the Royal Academy in 1845.

Baxter, like other dedicated artists and inventors, was a poor business man, and in 1844 had to call a meeting of his creditors: at that time he owed his family upwards of £2,500. He obtained four years to pay, and by 1849 had paid his other creditors, but still owed his family over £2,500. In 1849 his patent expired, and after a trial before the Judicial Committee of the Privy Council, under the presidency of Lord Broughton, Baxter was granted a five years extension, and advised to sell licences. Lord Broughton's summing-up is quoted by Courtney Lewis, pp. 101–5.

Baxter had some striking successes, and various of his prints sold in hundreds of thousands: but he became more and more cantankerous and embittered, quarrelled with his mother, father and brother (without whose financial help he would long ago have

failed), retired in 1860, tried to recommence, and went bankrupt in 1865. In 1866 he was struck violently on the head, apparently by another vehicle, while boarding an omnibus at the Mansion House, London, and he died on January 11, 1867.

His methods of colour printing were used and modified both by those who took out licences (Abraham Le Blond, William Dickes, J. M. Kronheim, Joseph Mansell, Myers & Co., and Bradshaw & Blacklock) and by his one-time pupil, George Cargill Leighton. No one of these surpassed Baxter in quality: most were concerned with surpassing him only in cheapness.

Mention should however be made here of a firm which originated in his own workshop. Among those apprenticed to Baxter were Charles Gregory, Alfred Reynolds, Alfred Crewe, Harrison Weir, Thomas Thompson, and Thomas Dowlen.[1] Of these, Gregory (and probably Reynolds) completed seven-year indentures in April 1843, and in that year set up as colour printers, under the title Gregory, Collins & Reynolds, at 10 St James' Street, Clerkenwell, that address being given on a colour plate by them which appeared in 1844 in *The Child's First Step in English History*. An illuminated title-page signed by them, and printed in red, blue, green, black and gold, appears in a pocket volume *Palestine, and other Poems* by Bishop Heber, published by H. G. Clarke in 1843 (see Chapter 9, p. 63). In 1845 several plates by them carry the address 108 Hatton Garden, and in 1845 or 1846 they moved to 3 Charterhouse Square, the address Baxter had left in 1843.

Among their other clients were the architectural publisher John Weale (plates in *Quarterly Papers on Architecture*, volume III, 1845), Joseph Cundall (plates for the Home Treasury series), James Burns (children's book covers), Longmans (*Songs, Madrigals & Sonnets*, 1849, see p. 51) and Darton & Co. (plates for *Peter Parley's Annual* and other children's books from 1846).

In 1849, Gregory left the firm to join Kronheim at the wage of two and a half guineas a week (Alfred Crewe, after fourteen years with Baxter, was getting only 34*s*. a week at Vizetelly's, where he

[1] Statement of G. C. Leighton dated March 15, 1849, quoted by Courtney Lewis, *George Baxter*, p. 92.

superintended the Owen Jones *Book of Common Prayer* published by Murray in 1845)[1], and, later, Reynolds went as an artist to Minton's Pottery at Stoke-on-Trent: for a short period the firm signed work as Collins & Reynolds. Later in 1849 the firm was acquired by George Cargill Leighton and became Leighton Brothers: their history is continued in Chapter 16. Who Collins was, and what he did, is not known: but the title-page of the 1852 *Peter Parley's Annual* carried the legend 'printed in colours by W. B. Collins'. The colour printing of it and the seven other plates is noticeably inferior to, and in a different style from, the work of Gregory, Collins & Reynolds, and of Leighton. I have not found any further references to W. B. Collins.

The high quality of Gregory, Collins & Reynolds' work is a tribute to the standards insisted on by Baxter. They were not allowed to use Baxter's patented process, which depended on a first printing from an intaglio plate; they simply printed from wood blocks, usually in up to ten colours. Their best work, as in the plates for the 'Gammer Gurton' and 'Peter Parley' series, achieved great richness and delicacy. Whatever it owed to the originals in water-colour by Weir, Absolon, Franklin and others, it also owed much to the taste and skill of the printers: they created a style which makes their work recognizable, and their best plates are as good as anything produced by Edmund Evans or the Dalziels in the 'sixties.

The second early letterpress colour printer, who worked quite independently of Baxter, was Charles Knight (1791–1873), one of the pioneers of cheap literature. The son of a bookseller, Knight became himself a bookseller, publisher and author. From 1827 to 1846 he acted as superintendent of publications for the Society for the Diffusion of Useful Knowledge, which had been founded in 1825 by Lord Brougham: for them he started the *Penny Magazine* which, by the end of 1832, he claimed had a circulation of 200,000 weekly.

He published many further works whose aim was to present information to the masses both accurately and pleasantly, in the

[1] Evidence quoted at Baxter's Patent Trial, 1849, quoted by Courtney Lewis, op. cit., p. 101.

course of which he became interested in the possibilities of colour printing. In June 1838 he patented a method for using wood and/or metal relief blocks in which all the colours (at first, four, but later up to sixteen) were printed one after the other on to the paper so that each print was finished before the next was started. The paper was not moved: the blocks were on a rotating table, each one being brought into the correct position successively. Two examples of Knight's so-called 'Patent Illuminated Printing' were given, and the process described, in John Jackson's *A Treatise on Wood Engraving*, 1839, where it was claimed as an advantage that 'the union of two colours to produce a third is effected perfectly, in consequence of the rapidity of the process, which does not allow the colours to dry and become hard' – although it is difficult to see how colours can be overprinted wet without dirtying the plates. The same passage describes a sheet being printed 'four up', with four colours being printed at one pull on one sheet, the turntable being then turned, and eventually four four-colour prints being obtained from four pulls. In this case, the colours in each print would be printed in a different order, which would only not matter if the colours were not superimposed.

Knight's aim was to provide colour plates cheaply for the masses, but he did not achieve it, and the normal method continued to be (as it still is today, on small presses) to print every sheet one colour at a time, waiting until each colour is dry before printing the next. The disadvantages of this system include the varying of the paper size if humidity alters, which may ruin the register of the colours, and the fact that the finished result cannot be seen until all the colours are printed – which leads to disaster if one of the earliest colours is wrong.

Knight's colour printing is best seen in two works of popular history, *Old England*, issued in ninety-six parts between 1844 and 1845, and *Old England's Worthies*, 1847. The former contains twenty-four colour plates and no less than two thousand four hundred and eighty-eight numbered wood-engravings; the latter, a shorter work, has twelve colour plates, numerous wood-engravings, and twelve plates of etched portraits, six on a page. An explanation

of the new process was inserted in *Old England's Worthies*, which mentions Baxter's work as being 'very superior to any previous attempt' and claims that 'what is here sold for sixpence is a copy, so exact as scarcely to present a difference to an unpractised eye, of an original which has cost Ten Guineas. The process enables thousands of copies to be multiplied without any deterioration . . .' It also says that up to sixteen printings were used for some subjects.

Knight apparently reversed nearly all Baxter's usages, since he used metal plates for his colours and wood for his key, which he always printed *last* (according to the passage already quoted in Jackson's *Treatise on Wood Engraving*); but the variations in the process, which were probably themselves frequently varied, do not matter so much as the results achieved, and these deserve high praise. The coloured illustrations in *Old England* and the *Worthies*, mostly of architectural subjects, were large (about $9\frac{1}{2} \times 7$ in.) and engagingly unpretentious. They were probably mostly drawn by T. Scandrett, who signed two of them, and engraved by S. Sly. They are reminiscent of the work of George Cattermole, the architectural illustrator of *The Old Curiosity Shop*; they would have made a fine background for figures by Cruikshank or Phiz. The colouring is quiet, in the aquatint tradition: the artist excels in the handling of soft browns and greys on old stone and woodwork, as in the plates of the Coronation chair and Henry VII's Chapel at Westminster Abbey; yet he can also be triumphantly polychromatic, as in the rendering of the roof of the Temple Church, the sort of subject soon to become the preserve of the chromolithographers.

Charles Knight's books were the first ever to offer printed colour plates to a wide and popular market. To our eyes, they have great subtlety and charm; but perhaps, for their intended market, they were not garish enough. Knight seems never to have used colour again in any of his later publishing projects. *Old England* and *Old England's Worthies* were both re-issued twenty years later by James Sangster, with the colour plates well printed by Leighton Brothers: one of the extra plates added at that time was engraved from a

photograph on the wood; but the hand-engravers still had some years of prosperity ahead of them, even then.

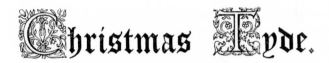

LONDON
WILLIAM PICKERING
1849

A Chiswick Press title-page for Pickering, 1849 (*reduced*).

37

6
Children's books up to 1850

'ALL CHILDREN are by nature evil' was said firmly by Mrs Sherwood, author of *The Fairchild Family* (published in four volumes between 1818 and 1847), one of the most widely read children's books of that period. How terribly children could then be treated, even by well-meaning adults, is described in Mrs Gaskell's account of the childhood of the Brontës. In Charlotte Brontë's *Shirley*, 1849, Mrs Yorke says to her child, who was showing only normal affection towards Shirley: 'Jessy, curb that tongue of yours, and repress your forwardness!' Woman themselves were still deep in that thraldom to men which it took the Suffragette Movement and a World War to break.

Some charming and light-hearted children's books had been published – including an illustrated book of limericks in about 1820, which was probably read by Edward Lear, then aged eight[1] – but when Henry Cole (1808–82) looked around for books for his own children in 1840, he was profoundly dissatisfied. He decided to supply the want himself, using the pseudonym 'Felix Summerly' (which he had already been using for guide-books, see p. 41), and launched 'The Home Treasury of Books, Pictures, Toys, etc. purposed to cultivate the Affections, Fancy, Imagination, and Taste of Children'.

In the prospectus, he wrote: 'Of our national nursery songs, some of them as old as our language, only a very common and inferior edition for children can be procured. Little Red Riding Hood and other fairy tales hallowed to children's use, are now turned into ribaldry as satires for men ... That the influence of all this is hurtful to children, the conductor of the proposed series

[1] A page is reproduced in colour in Philip James's *Children's Books of Yesterday*, London, 1933, p. 65.

38

firmly believes . . . He purposes . . . to produce a series of works for children, the character of which may be briefly described as anti-Peter Parleyism.' This was a hit at his most serious competitors. 'Peter Parley' had been the pen-name of several writers of children's books for more than ten years previously; and *Peter Parley's Annual*, believed to be the first boys' annual, had been started in 1839 (see below, p. 45). The easiest sales talk, when launching something new, is to disparage what has gone before.

Peter Parley, in the Preface to his 1844 *Annual*, commented 'if he [Felix Summerly] pleases his readers half as much as he seems to have pleased himself, he will, no doubt, sell a great many of his books . . . in one point, which he seems to have had in view, he has certainly succeeded, that is in the exclusion of anything that might instruct his reader'.

The Peter Parley books were, in fact, rather good; but Cole was a great salesman, and gave the Home Treasury the most distinguished design treatment ever given to children's books. Who, between editor, publisher, and printer, contributed exactly what, we will never know: but the fine typography was certainly due to Charles Whittingham, who printed all the Home Treasury books at the Chiswick Press. The format was $6\frac{3}{8} \times 4\frac{3}{4}$ in.; the first titles were bound books, at 2s. or 2s. 6d. plain, 3s. 6d. or 4s. 6d. coloured. The first to be published, in 1843, were *Bible Events*, with illustrations after Holbein, *Traditional Nursery Songs*, *Sir Hornbook* (by T. L. Peacock), *Little Red Riding Hood*, *Reynard the Fox*, and *Beauty and the Beast*.

Reynard the Fox was published in 1843 with forty coloured plates by Everdingen at £1 11s. 6d., but no other Home Treasury book cost anything like as much as this. The bound books were followed by a shilling series, consisting of sixteen pages of text with three illustrations, bound in bright paper covers, printed with a geometric design (unsigned) in gold and silver on blue, orange or emerald-green paper. The shilling series were also issued in stiff covers, with the illustrations coloured by hand, at 2s. 6d. A further series in paper covers was published at 6d. each, called 'Gammer Gurton's Story Books'; they consisted of sixteen pages and one

illustration only. They were also issued at 9*d*., with the illustration printed most charmingly in colours from wood; they are nearly the earliest children's books to contain printed colour.

The Home Treasury toys included *Tesselated Pastime*, 'formed out of the Mosaics published by Mr Blashfield, purposed to cultivate correct taste in Ornament', and a Box of Terra Cotta Bricks 'geometrically proportioned, each brick being one eighth of the size of the common brick', made by Messrs Minton, in the best architectural taste.

The Home Treasury illustrators were also chosen on the highest level of taste, and besides Holbein, Raphael and Durer, included the Royal Academicians W. Mulready, T. Webster and C. W. Cope; and R. Redgrave and J. C. Horsley, later to become so; also John Linnell, John Absolon and E. H.Wehnert. This was an attempt to put the best art into the hands of the children; but at least to our eyes the results are rather stilted, and the charm is chiefly in the colour printing. Cruikshank and Doyle never worked for the Home Treasury.

The illustrations in the earlier titles were usually printed by lithography: later ones were cut on wood. To begin with, all colouring was by hand. When colour printing was introduced, it was all from wood. It was not carried out by the Chiswick Press, but by Gregory, Collins & Reynolds, who at this time were also producing colour plates for Darton's children's books and for James Burns.

The publisher chosen by Cole for the Home Treasury was Joseph Cundall (1818–95). Cundall was born in Norwich, and (according to the *Times* obituary) trained as a printer in Ipswich. He came to London in 1834, and worked first with the publishers Whitaker & Co., and then with Tilt & Bogue. In 1840, Tilt published *Tales of the Kings of England: Stories of Camps and Battle-Fields, Wars and Victories, from the Old Historians*, by Stephen Percy (alias Cundall). It is a pleasant little book of two hundred and forty pages, illustrated with wood-engravings after John Gilbert, and it went through several editions; it was later translated into German. In 1841, Cundall published, through Tilt & Bogue, *Robin Hood and his Merry Foresters*, also by 'Stephen Percy', with hand-coloured

The Home Treasury.

TRADITIONAL NURSERY SONGS
OF ENGLAND.

WITH PICTURES BY EMINENT MODERN ARTISTS.

EDITED BY

FELIX SUMMERLY.

SECOND EDITION, WITH NUMEROUS ADDITIONS.

LONDON:
JOSEPH CUNDALL, 12, OLD BOND STREET.
1846.

I A 'Home Treasury' edition printed by the Chiswick Press. The colour plates, from wood blocks, were probably printed by Gregory, Collins & Reynolds. 6⅜ in. x 4⅝ in.

lithographed illustrations by Gilbert: a third edition was published by Cundall himself in 1845.

In 1841, Cundall, still only twenty-three, became the successor to N. Hailes at the Juvenile Library, 12 Old Bond Street. The first work I have seen published by him from that address is *Cousin Natalia's Tales*, 1841, a little book printed by Clarke with six lithographed illustrations by Fanny Corbaux. It was followed by *The Royal Alphabet of Kings and Queens*, dedicated to the infant Prince Edward, born on November 9, 1841, and illustrated with twenty-four hand-coloured wood-engravings after John Gilbert. This also was printed by Clarke.

It says much, both for Cole and Cundall, that the important new project was placed in the hands of so young a publisher, especially since Cole already had considerable experience as an author.[1]

For since 1833 he had been writing a series of Guide-books to places of cultural interest, under the pen-name of Felix Summerly; but until he came to the Chiswick Press, possibly at the suggestion of Cundall, his books were not much better designed than the average of their time. His *Handbook for the Architecture, Sculpture, Tombs and Decorations of Westminster Abbey*, for example, with 'fifty-six embellishments on wood engraved by Ladies' (the advantages of wood-engraving as an occupation for ladies was at that time one of Cole's enthusiasms), published by George Bell in 1842, was finely printed by Vizetelly Brothers, but with no typographical distinction. His *Handbook for the National Gallery*, however, published by Bell in 1843, was beautifully designed and printed by Charles Whittingham, and produced in decorative yellow paper boards printed in black and red.

While publishing the Home Treasury, Cundall continued to produce children's books on his own account or in association with other publishers. Some were in a format almost identical with the Home Treasury, others were larger. One enterprising venture was a series of novels produced in adult style for children, called the

[1] The compliment was repaid in 1881, when Cundall dedicated his *On Bookbindings Ancient and Modern* 'To Sir Henry Cole, K.C.B., my earliest and kindest instructor on all questions of art, with sentiments of deep gratitude'.

'Holiday Library'. The format was octavo: the first two were printed by Whittingham and the third, with the same wood-engraved ornaments, by Reynell & Weight. Each contained four hand-coloured lithographed illustrations. There was a uniform embossed red leather binding.

Another venture was a monthly magazine for children, *The Playmate*, which appeared in 1847 and reprinted a certain amount of Home Treasury material. It had a beautiful paper cover printed in colours by Gregory, Collins & Reynolds, the text being printed by G. Barclay, but it had a short life, probably of about a year. In 1854 Cundall published another children's monthly, *The Charm*, which ran until 1855. In neither were coloured illustrations used in the text.

Cundall used several printers beside those already mentioned. These included Thomas Harrild (e.g. *The Two Doves*, 1845), Robson, Levey & Franklyn (e.g. *A Danish Story-Book*, 1846), and F. Skill (e.g. *The Good-Natured Bear*, 1846). Everything he published was carefully designed, but those printed by Whittingham were the best. Mention must specially be made of Cundall's *Robinson Crusoe*, 1845, with hand-coloured lithographs after Stothard's earlier etchings, which is, typographically speaking, one of the finest editions of *Robinson Crusoe* ever published (pl. 7B); and of *The Heroic Life and Exploits of Siegfried the Dragon Slayer*, 1848, with hand-coloured litho plates after Kaulbach, and a magnificent Chiswick Press title-page (pl. 10B).

In 1846, Cole persuaded Herbert Minton to allow him to design a tea-service, which was plain, simple, and all white.[1] It was exhibited at the Royal Society of Arts, marketed as Summerly's Tea-service, and sold in thousands. Cole and the Royal Society of Arts were set on the path that led to the Great Exhibition of 1851. The Home Treasury had perhaps not been a great financial success, and in 1846 was acquired by Chapman & Hall.[2]

In 1849, Cundall moved to 21 Old Bond Street and into partnership with Addey; he stayed there until 1852, when he left

[1] In the Victoria & Albert Museum, and illustrated in Alf Bøe, *From Gothic Revival to Functional Form*, Oslo, 1957, pl. 12.

[2] Chapman & Hall's List dated January 1, 1847, announces that the series is now their property. Constance Meade Collection, Oxford.

Addey and moved again to 168 New Bond Street. Possibly in 1849, he suffered bankruptcy, and in an entry of 1849 in the Chiswick Press account books Addey is also entered as a bankrupt.

After Pickering's death in 1854, Joseph Cundall of Old Bond Street was listed by the Chiswick Press among Pickering's debtors as a bankrupt for the sum, in the Bad Debts column, of £6 13s. 11d. No other details of the bankruptcy are known, but there seems to have been no period during which he ceased to produce books. The books which he published for adults, and his later career, are described in Chapter 13.

Almost the only other pleasantly produced children's books of the 1840s were published by James Burns (1808–71). In 1843, for example, he published *Little Alice and her Sister* (no author mentioned, and unillustrated) in sixteenmo format, with delicately designed wood-cut borders round every page, to appeal rather to parents than to young readers. In 1844 he published *Nursery Rhymes, Tales and Jingles*, with charming wood-engraved illustrations on every page (pls. 15A, B). The simple and unstilted treatment strikes an entirely fresh note in book decoration of the period. The illustrations, unsigned, are by W. Dyce, C. W. Cope, J. C. Horsley and others.[1] In 1845 Burns published *The Book of Nursery Tales, A Keepsake for the Young*, in which he copied the aims and format of the Home Treasury, but not, apparently, with intent to plagiarize, since he states in the preface that the present collection 'consists of a series of old favourites, in a somewhat new, and, it is hoped, agreeable dress. It has been attempted to impart as much of ornament and illustration as possible without making the work a very expensive one...' and he adds in a footnote: 'Those who may be desirous of procuring these tales in a more illustrated and expensive form, are recommended to Mr F. Summerly's Home Library [*sic*] ... in a large and handsome type, and with the addition of tinted or coloured plates'. There are three bound volumes, each dated 1845 and containing six tales, which were originally published separately, like the Home Treasury series.

[1] See Burns's List of 1847, announcing a second edition, in Constance Meade Collection, Oxford.

Each tale has an exquisitely engraved frontispiece, by various artists: the frontispiece for *The Children in the Wood* in the third series is one of Tenniel's earliest published illustrations.[1]

The children's books so far mentioned nearly all consisted mostly of text, with a few illustrations added; they were conceived and produced like adult books. But children's books in paper covers, consisting largely of pictures, were also being produced during the entire period. Some of the pictures, nearly always cut on wood, were of excellent quality, and were sold either plain or coloured. Dean & Munday, later Dean & Son, were pioneers in cheap children's books and in books with moving parts: but one suspects that their character and appearance were not refined enough for Henry Cole's taste. That may have applied also to Edward Lear's first *Book of Nonsense*, which appeared in 1846, and to *Struwwelpeter*, which came over from Germany in 1848; but Cole must have been pleased with Hans Andersen's fairly tales, which appeared in England in 1846. Mary Howitt's translation was published by Chapman & Hall, and rival versions were brought out in the same year by both Pickering and Cundall. Pickering's was a highly elegant Chiswick Press octavo, without illustrations; Cundall's was illustrated by Count Pocci, with tinted lithographs and woodcuts. If any of these works had had coloured illustrations, they would almost certainly have been hand-coloured; colour printing remained rare in children's books for many years to come.

The earliest known children's books to have an illustration printed in colours were published by Darton, containing a single frontispiece printed by Baxter, from woodblocks only. The first three, undated but all of 1835, seem to have been Mary Elliott's *Tales for Boys* and *Tales for Girls*, and Mrs Sherwood's *Caroline Mordaunt*.[2] Colour printing was still probably more expensive than hand-colouring, at least for small editions, and was not much used for many years; no children's book with more than a single Baxter colour plate is known to me.

Darton, however, continued to pioneer the use of printed colour

[1] Reproduced in *The Osborne Collection of Early Children's Books* 1566–1910, Toronto, 1958, facing p. 38. [2] See Courtney Lewis, *George Baxter*.

in children's books, and used it in *Peter Parley's Annual*, believed to be the earliest boy's annual.[1] The small fat volumes, bound first in yellow and then, from 1845, in red cloth, with a page size of about $6 \times 4\frac{5}{8}$ in., were profusely illustrated with woodcuts and a few etched plates. Two-colour frontispieces, utilizing Griffith's patent chromographic process, a combination of steel engraving and lithography, were used in 1843, 1844 and 1845, but in 1846 the Annual appeared with a frontispiece and title-page printed in about ten colours from wood blocks by Gregory, Collins & Reynolds (see Chapter 5, p. 34). That year, and in 1847, the other plates in *Peter Parley's Annual* were steel engravings, but in 1848, and most years thereafter, the *Annuals* contained colour plates inside as well as at the beginning. Some of the Peter Parley colour title-pages, combining illustration, decoration and lettering, are extremely good (pl. 14B). The *Annual* continued publication until 1894.

Darton published a number of other 'Peter Parley' books, some of which contained the same colour plates as those used in the *Annuals*, or similar ones, printed by Gregory, Collins & Reynolds; and in 1847 Darton began publishing *Green's Nursery Annual*, in about the Home Treasury size, with Gregory, Collins & Reynolds's colour plates, and coloured borders to the text pages. Early volumes were bound in red velvet. These annuals continued at least till 1860, when they contained very poor colour plates by Edmund Evans.

Several other series were launched about this time more or less in imitation of the Home Treasury; one was Chapman & Hall's 'Picture Story Books by Great Authors & Great Painters' (pl. 14A).

Children's books were not yet big business, which is why colour printing was so slow to find its way into that market. Colour printing for children did not really come into its own until George Routledge and Frederick Warne began their various sixpenny and shilling Toy Books in the 1860s.

[1] The volume dated 1841 refers to an 'Annual for 1839'. It appeared in monthly parts, but when published in volume form was dated 1840; a copy of the 1840 volume is in the Osborne Collection, Toronto Public Libraries. The 1843 volume's preface starts 'For the fourth time Peter Parley now greets his little readers with a volume of his Annual'. The *Annual* dated 1844 calls itself the fifth volume, but the one dated 1845 calls itself the seventh, in error.

7

Henry Shaw's coloured books and Chiswick Press colour printing

HENRY SHAW (1800–73) was an antiquary and a draughtsman of exceptional skill, who devoted his life to publishing a series of books of plates on many aspects of medieval and Elizabethan art and architecture, and, in particular, the art of the illuminated manuscript. Shaw had most of his books published by Pickering and printed at the Chiswick Press, and they are among the finest achievements of Victorian book design and illustration.

His first published work was *The History and Antiquities of the Chapel at Luton Park*, a folio of twenty copper plate engravings with short text, published by James Carpenter of Old Bond Street between 1827 and 1830. The title-page, with decorative lettering based on letters on a door head illustrated in the plates, shows Shaw's feeling for graphic art as well as his skill as an engraver.

For his second book, he employed the Chiswick Press, and Pickering as publisher. It was *Illuminated Ornaments selected from manuscripts of the middle ages*, with descriptions of the plates by Sir Frederic Madden of the British Museum. This work began publication in monthly parts in June 1830 (the earliest date of publication mentioned on some of the plates): Pickering advertised it in 1831 as appearing in twelve monthly parts each containing five plates, price 3s. 6d. each part,[1] plain, or, carefully coloured from the originals, 7s. 6d.; and 'a very limited number will be printed on Imperial Quarto, and the ornaments more highly finished in

[1] For comparison, the monthly parts of *Pickwick*, in 1836, each containing four uncoloured plates, cost 1s.

opaque colours, heightened with gold, at 15s. each part'. The date on the printed title-page is 1833, and the book was sold at £5 5s. quarto, half-bound morocco, or £10 10s. Imperial Quarto.

The key drawings by Shaw are printed from etched (often stone-etched) or lithographed plates (the same illustration occurs in both etched and lithographed versions, for no apparent reason) and the colours painted in by hand. In the large paper copies ('more highly finished in opaque colours, heightened with gold') one can only say that the results are hardly less beautiful than the medieval originals; they are hand-illuminated with the utmost skill, and the gold used is gold leaf. On the 'ordinary' copies, almost the only difference is that yellow water-colour is used instead of gold leaf.

In 1832 Pickering began issuing the parts of Shaw's *Specimens of Ancient Furniture*, which was published as a complete book in 1836; and in 1834 the parts began appearing of *Specimens of the details of Elizabethan Architecture*, which appeared as a complete book in 1839.

In 1836 Shaw's *The Encyclopedia of Ornament* began to appear in parts; the plates included engraved and aquatinted stone and copper plates, and a zincograph, all hand-coloured, and several plates were printed in colour from wood blocks, which if they appeared before 1840 are probably the first examples of colour printing by the Chiswick Press. The title-page, dated 1842, when the work was published complete, is printed from wood blocks in yellow, blue, green, red and black, all flat colours with no over-printing. The book was intended to be practical and cheap (the twenty parts cost a shilling each, and the bound book was priced £1 10s. or, large paper, plates coloured, £3) and the Preface states 'the Author trusts that the present Collection will be highly conducive to the enlargement of correct taste in all branches of decorative art'. It was a modest forerunner of Owen Jones's monumental *Grammar of Ornament* of 1856 (see below, p. 89), and of the numerous other pattern books which followed the Great Exhibition. Especially in its large paper fully coloured version, Shaw's book is perhaps the most beautiful of them all.

Shaw's next work, *Dresses and Decorations of the Middle Ages*,

was his most ambitious. It began appearing in monthly parts in 1840, each part containing four hand-coloured copper plates, letterpress text and woodcuts printed in up to four colours, at 6s. a part; or, Imperial Quarto, the plates highly finished and heightened in gold, 15s. each part. It was published in two volumes in 1843 at £7 7s., the large paper at £18. It is a magnificent production. There are ninety-four plates, showing paintings, miniatures, stained glass, furnishings, glasses, chests, vestments, gold cups, jewellery, etc. etc., mostly on copper, hand-coloured in the most sumptuous way; in addition the text accompanying every item is, in both large and small paper versions, adorned with elaborate initials and decorations printed in colour from wood blocks, the only other Shaw-Whittingham book in which this occurs. It has a considerable claim to be called the most handsome book produced in the whole of the nineteenth century: some of Ackermann's volumes of aquatints, and Daniell's *Voyage round Great Britain*, may run it close, but they are much less handsome typographically.

Among the other works produced by Shaw are: *Examples of Ornamental Metalwork*, 1839, containing beautifully engraved and printed copper plates, some of which are hand-coloured; *Alphabets Numerals and Devices of the Middle Ages*, 1845, of great interest to students of lettering; *A Booke of Sundry Draughtes, principally serving for Glasiers*, 1848, with a charming wood-engraved title-page, and lithographed plates; and *The Decorative Arts Ecclesiastical and Civil of the Middle Ages*, 1851, richly illustrated with woodcuts, hand-coloured etchings and some chromolithography: all these were published by Pickering, and the letterpress text, if any, printed by Whittingham.

In November 1855 he began publishing *The Arms of the Colleges of Oxford* in ten monthly quarto parts, each containing two plates and descriptive text by the Rev. J. W. Burgon. The complete work was published by Spiers & Son of Oxford and is dated 1855. The plates are among the finest he ever did: the shield and surrounding gothic frame are drawn on stone and most richly and exquisitely hand-coloured. The typography is characteristic of the Chiswick Press, but no printer's imprint appears.

 resses and Decorations of the Middle Ages by Henry Shaw F. S. A.

Volume the First

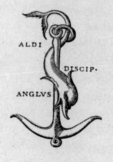

ALDI

DISCIP.

ANGLVS

London

WILLIAM PICKERING

1843

17 Title-page (small paper copy) of one of Henry Shaw's finest books, printed by Chiswick Press. Black and red. $11\frac{1}{4} \times 7\frac{3}{4}$ in.

18 *The Decorative Arts* by Henry Shaw, (small paper copy) 1851. Half-title and title-page. Both printed in black and red. Chiswick Press. $10\frac{7}{8} \times 7\frac{7}{8}$ in.

STAINED GLASS.

FROM THE CATHEDRAL AT BOURGES.

THE subject of our present plate is a double Lancet Window in the Cathedral at Bourges. It has been copied from the large folio work by Messrs. Arthur Martin and Charles Cahier, under the title of "Monographie de la Cathédrale de Bourges." In this publication, the most splendid, the most ample, and the most accurate of any that has yet appeared on early painted glass, will be found all the varieties remaining in that gorgeous Cathedral, together with many examples, both in England and on the Continent, calculated to show in the most comprehensive manner, the peculiarities of design to be found in this brilliant feature of ecclesiastical Architecture during the thirteenth and fourteenth centuries.

The first subject in our Plate represents the Blessed Virgin and the Infant Saviour under a low canopy characteristic of the Architecture of the period. The figure of the Virgin is remarkable for the ease and grace of her attitude, combined with considerable elegance and beauty in the arrangement and distribution of her draperies.

The figure of St. Stephen, who supports with his right arm the model of a church, and whose head is surrounded by a nimbus of a more simple character than those given to the Virgin and Child, is attired as a Deacon, having a robe termed a Dalmatic over the Alto, and a jewelled maniple hanging from the right arm instead of the left as is usual and correct.

The wood-cut on the next page is taken from the border of one of the other windows in the same Cathedral as our principal subject. The outer band next the masonry is of white glass, the next of blue, the corresponding one on the opposite being of yellow. The band round which the foliage is entwined is green. The larger leaves and stems, (covered with a tint in our cut) are yellow on the outer side, and green on the inner one. All the rest of the foliage is white shaded with brown,

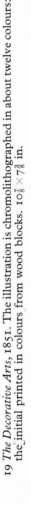

STAINED GLASS.
IN THE CATHEDRAL AT BOURGES.

19 *The Decorative Arts*, 1851. The illustration is chromolithographed in about twelve colours: the initial printed in colours from wood blocks. $10\frac{7}{8} \times 7\frac{3}{8}$ in.

20 *Ancient Spanish Ballads*, 1841. The earliest of Owen Jones's illuminated gift books. The border of this page is printed in blue from wood, by Vizetelly Brothers. $9\frac{3}{4} \times 7\frac{3}{4}$ in.

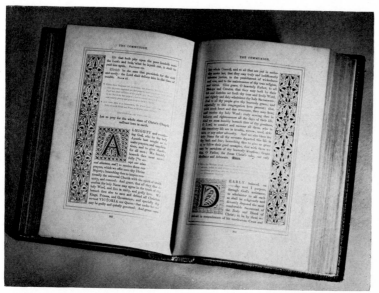

21 *The Book of Common Prayer*, Murray, 1845, illuminated by Owen Jones. The page with the angel is chromolithographed in five colours. The other decorations are printed from wood in colours, by Vizetelly Brothers. $9\frac{3}{8} \times 6\frac{1}{8}$ in.

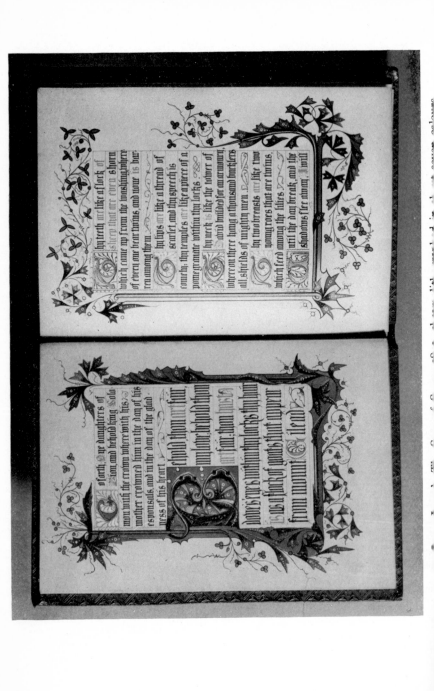

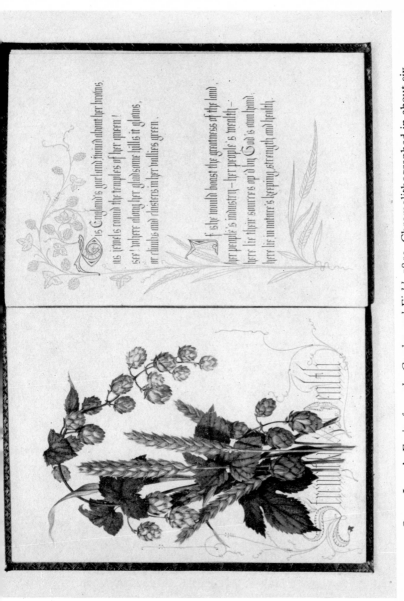

23 Owen Jones's *Fruits from the Garden and Field*, 1850. Chromolithographed in about six colours. 10⅛ × 7 in.

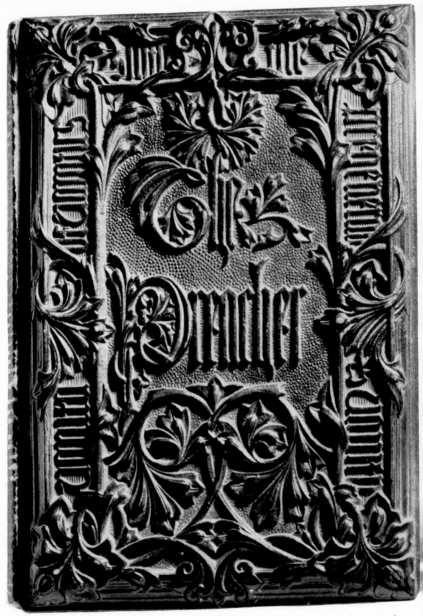

24 *The Preacher*, 1849. Wooden binding, designed by Owen Jones and manufactured by Remnant & Edmonds. $11\frac{1}{2} \times 7\frac{5}{8}$ in.

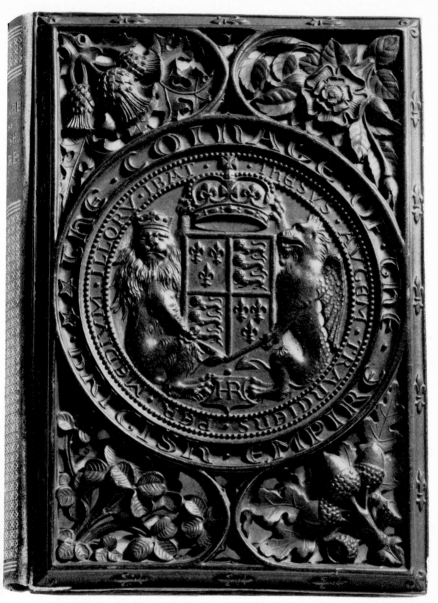

25 *The Coinage of the British Empire.* 3rd edition, 1863 (same sides as 1st edition, 1855). Black papier mâché binding signed HR (W. Harry Rogers). $10\frac{1}{8} \times 6\frac{3}{4}$ in.

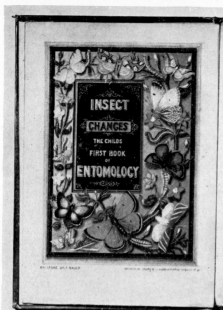

26 *Insect Changes*, 1847, written and illustrated in chromolithography by H. Noel Humphreys. The frontispiece (top, left) should have been bound in as a right-hand illuminated title-page. 6⅜ × 4⅝ in.

The Marigold, or, as it is sometimes termed by the elder poets, the Golde, is made by Chaucer an emblem in the hand of

"——— Jealousy
That weared of yellow-goldes a
garland."

The word "Golde" is, however, applied indifferently to various gold-coloured flowers: thus Gower calls the sunflower a golde, when describing the metamorphosis of Clitia, who was changed

"Into a floure was named Golde,
Which stont governed of the sun."

27 *The Poets' Pleasaunce*, 1847. Border drawn by H. Noel Humphreys, engraved on wood by W. Dickes. $8\frac{3}{8} \times 5\frac{7}{8}$ in.

28A *Insect Changes*, 1847. Binding, after a design by Holbein, blocked in gold, brown and black on fawn cloth. $6\frac{7}{8} \times 4\frac{3}{4}$ in.

28B *Sentiments and Similes of William Shakespeare*, 2nd edition, 1857 (similar to 1st edition, 1851). Black papier mâché binding with terracotta portrait medallion, overlaid on crimson paper. $7\frac{7}{8} \times 6\frac{1}{8}$ in.

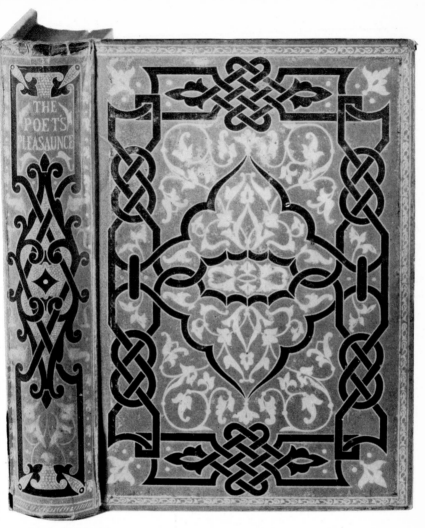

29 *The Poets' Pleasaunce*, 1847. Binding design printed in black and grey on yellow paper boards. 9 × 6 in.

A.D. 1367. The Black Prince, during his government of Aquitaine, which he began in great prosperity, fortifying Bourdeaux, coining money, &c., is applied to by Don Pedro, the dethroned king of Castille, to reinstate him in his dominions, in consequence of which request, the prince passes into Spain with a considerable army, and gains the great victory of Najara.

THUS, as ye haue harde, clin betwyxed togyder of bothers maters, and lefte talkyng of the prynces maters: for it was Kyng Petrus entcion to haue batayle, and so entended to ordre his felde and people. Don Telto, and his brother Don Sancho, were getyng renomed in their hoost, for the journey that they had made before, as ye haue herde. The prince, the friday, the seconde day of Aprell, disloged fro' Logrono and auaunced forwarde, arayoged in batayle redy to fyght, for he knelle well that Kyng Henry was nat farr thens. And so that day he auaunced two leages, and at thre of the day he ca'e before Nauarret and ther tokle his logyng. Than the prince sent forthe his currours to knolue his enemyes and to knolue where they were loged; and than they departed fro' the hoost and rode so forwarde that they salue all their enemyes hoost, who were also loged before Nauarret. So

they brought report therof to the price, and in the euenyng the prince caused secretly to be shelued through all the hoost, that at the first sounynig of the trumpettes euery man to apparell hymselfe, and at the seconde to be armed, and at the thirde to kepe a horssebacke and to folowe he marshalls baners with the penon of Saynt George; and that none on payne of dethe auaunce before them, without he be commaunded so to do.

In this maner as the prince had done the same friday, in sendyng out his currours, so dyde Kynge Henry on his parte, to knolue where the prince was loged; and whan he had true report therof, than the kyng called Sir Bertram of Guesclin, and tokle counsayle and aduyse holue to perseuer. Than they caused their peple to suppe, and after to go to rest to be he more fresscher, and at the hour of mydnyght to be redy apparelled and to brathe to the felde, and to ordayne their batayles, for he knelue well the next day he shuld haue batayle. So that myght the Spanyardes tokle their ease and rest, for they had well byberyoully so to do, as plenty of brede and other thynges; and the Englysshemen had great defaut, therfore they had great desyre to fyght, outher to wynne or to lese all. After mydnyght the trumpettes sounded in

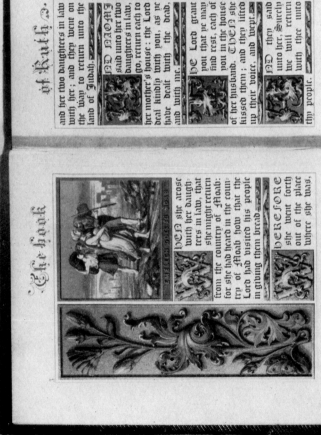

31 *The Book of Ruth*, 1850. Illuminated in chromolithography, in 10 or more colours, by H. Noel Humphreys. $6\frac{1}{4} \times 4\frac{1}{2}$ in.

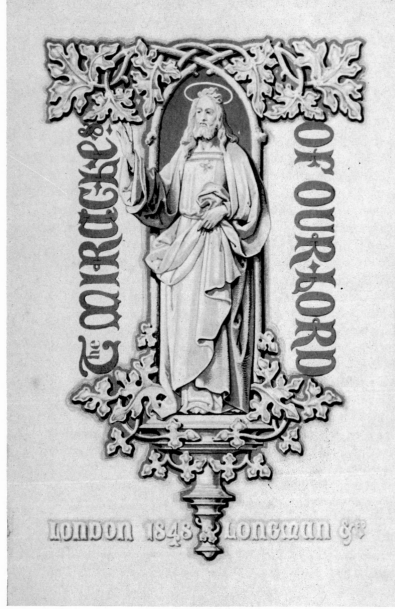

32 *The Miracles of Our Lord*, 1848. Title-page drawn by H. Noel Humphreys, chromolithographed in gold, grey and black. $6\frac{1}{2} \times 4\frac{1}{2}$ in.

Specimens of Tile Pavements, 1858, was a remarkable collection of fifty drawings of tiles printed by lithography in up to four colours, with hand-colouring added, published by Basil Pickering; and *A Handbook of the Art of Illumination*, 1866, containing many reproductions of manuscripts in wood-engraving, some of them being also reproduced in chromolithography, was published by Bell & Daldy.

Shaw's skill in copying medieval illuminated letters was also used in a magnificent work that deserves mention for its own sake, particularly as it was not printed by Whittingham. This was W. S. Gibson's *The History of the Monastery founded at Tynemouth*, etc., published for the author by Pickering at six guineas in two large quarto volumes in 1846. It was printed by Peter White & Son, of Devonshire Square, within Bishop's Gate, London, in excellent style. Chapter or section headings are in black letter, printed in red, and the typography throughout is first-class. Initial letters were drawn by Henry Shaw after models in specific manuscripts, and were fully coloured and gilded by hand. In addition, each volume contains lavishly hand-coloured full page plates by Shaw, as well as lithographed facsimiles of charters, etc., etchings of architectural views, and small wood-engravings.

It is probable that the design of the book was controlled by the author, in conjunction with Henry Shaw; his Preface contains the admirable sentiment 'It was his [the author's] wish that the volumes in which he has endeavoured to preserve the historic annals of Tynemouth monastery, should, by the aid of decorative art, be produced in a novel and elaborate style, in keeping with the character and beauty of their subject.' No other book of similar qualities printed by Peter White is known to the present author, nor, indeed, from any other press except that of Whittingham's.

Shaw also drew embellishments, which were engraved on wood, for some gift books, e.g. for a lavishly decorated edition of the *New Testament*, first published by Longman in 1865 (see pl. 46), and for *Two Centuries of Song*, Sampson Low, 1867.[1] Both volumes are unusual examples of mid-Victorian commercial book design,

[1] See Chapter 13, p. 112. This book was supervised by Joseph Cundall.

and in both books the superb letterpress machining of Richard Clay made a vital contribution.

The Victoria and Albert Museum has a collection of about ninety-five pages of facsimiles of medieval manuscripts by Henry Shaw, mostly on vellum: they must represent many years of work, but they were never published. A drawn title-page in the collection, bearing the words 'Choice Leaves from Rare Illuminated Manuscripts by Henry Shaw F.S.A., A.D. MDCCCLXV', suggests that a book was intended.

Shaw was not really an original designer: but he carried painstaking and faithful draughtsmanship almost to the point of genius. Much of Shaw's work, being reproductive, became unnecessary when photography was able to replace it: but Shaw's pages are a great deal pleasanter to look at than any modern printing of colour photography.

When Shaw began producing books, no method of colour printing had been evolved which could produce results comparable to hand-colouring. Baxter obtained his patent in 1835, and from then on was producing colour prints which must have nearly come up to Shaw's standards: but no contact between Shaw and Baxter is known to have occurred. Baxter's colour plates for the *History of the Orders of Knighthood*, 1842, mentioned in Chapter 5, p. 31, are similar in subject to many of the plates in Shaw's books and form an interesting comparison, in which it would be difficult to say if either process is superior to the other.

Henry Shaw's books were not by any means the last to have hand-coloured plates, but they were (with Silvestre's *Paléographie Universelle*, 1841, to be mentioned later, and there are probably others) among the last magnificent ones, and worthily mark the end of a rich, beautiful, impractical and essentially English period of book illustration.

Books printed in colour by the Chiswick Press are few, but fine. Beside the two works of Henry Shaw described above, there are only Byrne's *Euclid*, 1847, and *Songs, Madrigals and Sonnets*, 1849.

The First Six Books of the Elements of Euclid, 1847, by Oliver

II Opening from *Songs Madrigals and Sonnets*, 1849. Printed in colour from wood blocks and type by the Chiswick Press and 'Collins & Co.' Edited by Joseph Cundall. 5⅜ in. x 4⅛ in.

Byrne, Surveyor of Her Majesty's Settlements in the Falkland Islands, and published by Pickering, is one of the oddest and most beautiful books of the whole century. It is based on the theory that by means of colour (in the words of the author's Preface) 'the Elements of Euclid can be acquired in less than one third the time usually employed, and the retention by the memory is much more permanent; these facts have been ascertained by numerous experiments made by the inventor, and several others who have adopted his plans'. The result is a decided complication of Euclid, but a triumph for Charles Whittingham.

Each proposition is set in Caslon italic, with a four line initial engraved on wood by Mary Byfield: the rest of the page is a unique riot of red, yellow and blue: on some pages letters and numbers only are printed in colour, sprinkled over the page like tiny wild flowers: elsewhere, solid squares, triangles, and circles are printed in gaudy and theatrical splashes, attaining a verve not seen again on book pages till the days of Dufy, Matisse and Derain. This dashing experiment in teaching Euclid was apparently never repeated.

A year later, the Chiswick Press produced *Songs, Madrigals and Sonnets*, an anthology edited by Joseph Cundall and published by Longman, Brown, Green & Co., in which coloured decorations 'of an Italian character of design' (according to Cundall's editorial note) are printed as borders to every page. In all there are seventy pages, size $5\frac{3}{8} \times 4\frac{1}{8}$ in., of which sixty-two are printed from wood blocks in four or five colours, as well as type in black. Messrs Longman's ledgers for this book survive and show that two thousand copies were printed. They also show that Absolon was paid £36 for 'drawing and designs' and that the colour blocks were engraved by 'Collins & Co.' (presumably Gregory, Collins & Reynolds; see Chapter 5, p. 33) who also printed signatures B and C, while Whittingham printed D and E, as well as the prelims and all the text.

One-quarter share in the profits was to be paid to Joseph Cundall, but it is doubtful if there were any, since, in January 1851, forty bound copies and no less than one thousand six hundred and forty-two copies in sheets were sold to H. G. Bohn. It is a charming

little volume and deserved a greater success: it is now a collector's piece (pl. II).

Whittingham seems to have printed no further books in this vein. Chromolithography was already stealing the market for colour, and lithographic presses were never installed by the Chiswick Press during Whittingham's lifetime.

Designed by J. A. Montagu

Designed by Thomas Williams Designed by Charlotte Whittingham

Four devices designed for the Chiswick Press and William Pickering. Engraved by Mary Byfield.

8
Early lithography and Owen Jones

LITHOGRAPHY IS described as a 'planographic' process: the printing surface is flat. Aloys Senefelder (1771–1834) discovered[1] in 1798, in Bavaria, that certain kinds of local stone had an affinity for both grease and water. If the surface of the stone was polished, it could be drawn on in greasy ink, and it held that image. If the surface of the stone was then wetted, and inked with an inking roller, the ink was repelled by the water, but held in those places already drawn on in ink. Senefelder later discovered that certain kinds of zinc plate also have this property. The implications for the printing industry were tremendous, but were only slowly realized. Lithography's first task in the field of books was to offer a new medium for illustration. Drawing on stone was much easier than engraving on wood or etching on copper and could be done with pen, brush or pencil. It was also possible to draw on paper with greasy ink and transfer the design to the stone: and it was then found that a design on copper could also be transferred to a stone or zinc plate and more copies printed than could be obtained from the copper before it wore out. The greater ease with which printing surfaces could be made on stone than on copper or steel meant that larger plates could be produced; and from the 1840s onwards in Britain a series of enormous folios and quartos of coloured plates were produced which could never have been made in any other way.

The first book published in Britain with a lithographic illustra-

[1] The discovery was not made by accident. Senefelder, a would-be author, had become interested in printing methods, in order to print his own plays cheaply. His account of the experiments that led to the invention was translated and published in English by Ackermann in London as *A Complete Course of Lithography*, etc., 1819, and is well worth reading.

tion seems to have been John Thomas Smith's *Antiquities of Westminster*, printed by Bensley for the author: the title-page is dated June 9, 1807, but the dates of publication on the plates begin at January 1, 1804. Pages 48–50 contain a description of the new process, which the author had watched. The description states: 'Three hundred impressions were taken off, and the stone laid by for the night, when the pressmen left work, without sufficiently attending to the state in which it was left. For want of washing with water to keep it moist, the ink with which the drawing was made became dry, and the balls too tenacious, so that when they were applied to the stone, they tore up from the stone pieces of the drawing in the attempt to remove them.' Consequently only the first three hundred copies of the book contain the lithograph: the same subject, with two figures added, was also etched and the etched version (dated November 19, 1806) inserted two pages later on. Since there are also one or two wood-engravings, the book contains every process of illustration then in use. The copper plates, including a supplement of sixty-two published the following year, are so varied in technique that they must demonstrate practically every effect possible to that medium. A considerable number are beautifully hand-coloured. The range of tone in some of the aquatinted and mezzotinted plates (e.g. the doorway, facing p. 41) is so great that they are surprisingly close to photographs.

The next thirty years or so may be called the experimental period of lithography. The leading lithographer in Paris, Godefroi Engelmann (1788–1839), sent Graf and Coindet to open a business in London in 1827 called Engelmann, Graf, Coindet & Co.,[1] but was not able to make it pay and closed it again in 1830. London's first successful lithographer was Charles James Hullmandel (1789–1850). Born in London, he learned lithography from Senefelder before setting up as a lithographer and publisher in London some time in 1818. By ceaseless experiment and practice he revealed the enormous new possiblities which lithography offered to artists and did more than anyone else to establish it in England. For further

[1] See Bigmore & Wyman, *A Bibliography of Printing*, 2nd edn., 1945, vol. 1, pp. 199–200.

information the reader is referred to the excellent notes by Mr Michael Oliver in Major Abbey's *Travel, in Aquatint and Lithography*, 1956, particularly (for Hullmandel) that on pp. 146–151 of volume I.

Progress in the development of colour printing by lithography is shown by the plates in J. D. Harding's *Sketches at Home and Abroad*, published by Tilt in 1836, and T. S. Boys' *Picturesque Architecture in Paris, Ghent, etc*, 1839, both printed by Hullmandel.

The first of these uses only one colour in addition to black, the second four: they initiated a whole series of collections of topographical sketches drawn on stone, tinted with one or more lithographic tints and sometimes, in addition, coloured by hand.

The technique is called 'lithotint' (the name given to the process patented by Hullmandel in 1840), since the earliest plates by this method were imitations of wash drawings on tinted paper, with highlights added. Neutral tints, and not colours, were used, often with very great skill and subtlety. Plates were often issued separately to subscribers, at monthly or other intervals, and then collected in books: but these are not really books, they are collections of prints. The term 'chromolithography' (a title coined by G. Engelmann for the process patented by him in Paris in 1837) is used for full colour printing by lithography.

In sheer size, the culmination of the lithotint was David Roberts' *The Holy Land, Syria, Idumea, Arabia, Egypt and Nubia*, a vast work comprising one hundred and twenty-four plates (on pages measuring 24 × 17 in.) published first in parts, between 1842 and 1845, and then in three volumes, the last of which was dated 1849. The plates are lithographic reproductions by Louis Haghe (1806–85) of drawings made on the spot by David Roberts, R.A., of which Ruskin wrote (in *Praeterita*): 'They were the first studies ever made conscientiously by an English painter, not to exhibit his own skill, or make capital out of his subjects, but to give true portraiture of scenes of historical and religious interest. They were faithful and laborious beyond any outlines from nature I had ever seen . . .'; and also: 'He was like a kind of grey mirror; he gave the greatness and richness of things, and such height and space, and standing of wall

and rock, as one saw to be true; and with unwearied industry, both in Egypt and Spain, brought home records of which the value is now forgotten in the perfect detail of photography, and sensational realism of the effects of light which Holman Hunt first showed to be possible.'[1]

The technical quality of the lithography is high, and gives the plates their most satisfying quality: yet to turn over plate after plate is to be aware of the truth of Ruskin's phrase 'a kind of grey mirror'.

The potentialities of lithography were being explored in yet another important way during the late 'thirties. In 1834, a young Welsh architect, Owen Jones (1809–74), visited Spain, and became fascinated by the Alhambra Palace – in which, at that time, visitors could actually choose their own suites of rooms and install themselves. In company with a French architect, Jules Goury, Jones made detailed drawings of the Palace. Goury died of cholera in Granada in August 1834, and Jones returned to England, where he soon began preparing the drawings for publication. His aim was not like Harding, T. S. Boys, Edward Lear and other topographical artists, to produce artistic general views: he wished to provide an exact and detailed record of particular coloured decorations consisting largely of flat bright colours in geometric patterns. He could not find any printer able to meet his requirements: eventually, with help from the lithographic firm of Day & Haghe, he set up his own lithographic press in John Street, Adelphi (close to Charing Cross), trained his own workmen, and printed and published the work at his own expense. By 1842, he had moved his press to 9 Argyll Place, off Regent Street.

Volume I was published in ten parts between 1836 and 1842; Volume II was published in two parts, each containing twenty-five plates, in 1846. Volume I, published as a whole in 1842, cost £12 10s. on small paper ('Folio Columbier'), £21 on large paper ('Folio Grand Eagle'); the parts of Volume II cost £5 5s. Folio Grand Eagle, £4 4s. Folio Columbier, and (in 'a separate edition for the use of Manufacturers') £3 3s. Folio Imperial.

[1] Quoted in Abbey, *Travel*, pp. 131 and 341, where a full account of *The Holy Land* is given.

The two volumes were published together at £36 10s. It is said that Jones had to sell part of a Welsh estate left him by his father to pay the costs of printing.

The page size, large paper, was 25⅝ × 19¼ in., which makes a very big book. As was the fashion in illustrated books, there were two title-pages, one ornamental (lithographed in colours), the second typographical. The text was printed by Vizetelly Brothers and illustrated with woodcuts engraved by the young Henry Vizetelly; the hundred and four plates included copper or steel engravings of plans, elevations and views (with the ornamentation rendered in infinitely laborious detail), a few lithographs on zinc, and sixty-nine chromolithographs on stone. The chromolithographs were the first of their kind to be produced in England, the forerunners of a great new industry. They were mostly printed in up to six or seven printings, including much gold. Many were representations of three-dimensional details; one, printed in at least eleven colours, with embossing, reproduced a ceiling painting; another, a vase. The rest portrayed mostly flat patterns, where colours did not overlap. Compared with later chromolithographs, some may be a little crude, but all are magnificently vigorous.

In Volume II, Jones' mastery of his new art is complete; page succeeds page of blue, scarlet and gold, and the foundations are laid, not only of a new kind of book illustration, but of a new school of designers, the pilers-on of reproduced ornament.

Jones was a man of Brunel-like energy (Brunel was, incidentally, among the subscribers to the *Alhambra*) but although the *Alhambra* was a triumph of printing, it was not a commercial success. There was no attempt to make the plates 'popular' and while their interest would be mainly for designers and architects, not many of those could be expected to pay so large a sum for so limited a subject. The work was taken over by Longmans in 1848 and offered at a reduced rate; and copies still remaining were sold at the auction sale in 1854 mentioned below, on p. 69.

The *Alhambra* lithographs seem to have been the first on which Jones worked, but they were not his first plates to be published. In 1841 John Murray published a lavishly illustrated edition of J. G.

Lockhart's *Ancient Spanish Ballads*, for which Owen Jones designed, and presumably printed, four chromolithograph title-pages in Moorish style, and also drew borders, ornamental letters and vignettes (pl. 20), which were printed letterpress in colours. Nearly every page is surrounded with a woodcut border, printed in red and yellow, red and blue, yellow and blue, or plain purple, yellow, red, green, grey, etc.; there are also numerous (and very attractive) wood-engraved illustrations and decorations by William Allan, David Roberts, William Simson, Henry Warren (whose son Albert was articled to Jones), C. E. Aubrey, Louis Haghe, William Harvey, and others. The letterpress pages were printed by Vizetelly & Co. (the printers of the *Alhambra* text) (see below, Chapter 15, p. 125) and it must have been – after Baxter's *Pictorial Album* of 1837 – the most colourful and lavish book, produced for the gift book market, that London had yet seen. The edition was of two thousand and twenty-five copies,[1] and the price was £2 2s.: a second edition of two thousand copies was published in 1842, with some slight differences among the illustrations. A further edition of one thousand five hundred copies was published in 1856, printed by Bradbury & Evans, with all the title-pages, and most of the decorations and borders, completely redesigned.

For *Ancient Spanish Ballads*, Owen Jones probably designed the binding, an arabesque design blocked in gold on cloth, and almost certainly the elaborate endpapers, printed in red, blue and gold which appear in the 1842 (but not the 1841) edition.

There is a disharmony between Owen Jones's colour plates and coloured borders, and the wood-engraved illustrations, which are of an earlier style; but the book as a whole is a splendid achievement both of illustration and printing; and the clearness of the typography makes it a pleasant one to read. In addition, there is at least one good poem in the book – 'The Wandering Knight's Song'.

While at work on the *Alhambra*, Owen Jones also printed *Designs for Mosaic and Tessellated Pavements by Owen Jones, Archt.* (ten chromolitho plates), published by John Weale for J. M. Blashfield

[1] Information on editions was kindly supplied by Mr John Murray in 1961.

in 1842; eighty-two plates for Henry Gally Knight's *The Ecclesias-tical Architecture of Italy* (of which three were chromolitho), pub-lished by Bohn in two volumes in 1843; and some chromolitho plates for Weale's *Quarterly Papers on Architecture*, Volume II, 1844.

Views on the Nile, a folio published in 1843 containing thirty lithotint plates 'drawn on stone by George Moore from Sketches taken in 1832 and 1833 by Owen Jones and the late Jules Goury', was not printed by him.

No doubt Jones was also working on some of his own later books; between 1844 and 1851 he illuminated at least thirteen, after which there was a gap until the completion in 1856 of his *chef d'oeuvre*, *The Grammar of Ornament*. He had in fact founded a new industry, and was for several years the chief supplier of that characteristic early Victorian product, the chromolithographed illuminated gift book.

Vignette by Owen Jones, engraved on wood and printed in two colours, from *Ancient Spanish Ballads*, 1841.

9
The 'illuminated' gift book

THE 'ILLUMINATED BOOK' was essentially a gift book, whose text was often, but not always, taken from the Bible, and whose pages were decorated in colour, in a style closely or distantly resembling that of a medieval manuscript. Gothic lettering, either drawn or set in type, and gold printing were normal ingredients; but the description 'illuminated' was also given to any gift book in which text and coloured illustrations were combined.

The fashion for illumination can be called part of the Gothic Revival. Illuminating was also, even more than water-colour painting or needlework, a highly suitable occupation for Sundays. But all through the latter half of the century it was also a subject for serious study and pleasure.

One of the earliest serious works of scholarship relevant to the subject was Thomas Astle's *The Origin and Progress of Writing*, of which the second edition appeared in 1803. Among the thirty-one etched plates is an attempt to reproduce a great illuminated initial and borders from a page of the Lindisfarne Gospels. Astle was concerned with showing the shapes of the letters rather than the glories of the total result, and performed a notable service in so doing. But his illustrations, even those that are simply hand-coloured, are in no sense facsimiles. The introduction of chromolithography was a great aid to art scholarship. Its earliest uses in this field were probably in Germany: it was used, for example, for Zahn's work on Pompeii (Berlin, 1828) and for Boetticher's *Die Holzarchitectur des Mittelalters* (Berlin, 1836–42).

In France, it was used, with hand-colouring in addition, for Count Bastard's enormous and magnificently illustrated *Peintures des Manuscripts*, published in Paris from 1832 to 1869. Then there was Henry Shaw's *Illuminated Ornaments of the Middle Ages*, 1833

(mostly etched, but superbly hand-coloured); and the same artist's *Alphabets, Numerals and Devices of the Middle Ages*, 1845, and *A Handbook of the Art of Illumination*, etc., 1866; Midolle's extremely odd *Ecritures Anciennes* and other lettering books lithographed at Strasbourg, 1834–6, and his *Receuil ou Alphabet*, Ghent, 1846; and Silvestre's *Paléographie Universelle*, Paris, 1841, a monumental work in four folio volumes, containing three hundred and one plates, chromolithographed and hand-coloured, the best of which are superb and technically superior to Owen Jones's *Alhambra* plates. Silvestre's great work was reprinted in England by Hanhart, in 1850 (see below, p. 83).

Other works published in England which reproduced manuscript pages with varying degrees of fidelity, but with scholarly intentions, were Henry Noel Humphreys' and Owen Jones's *Illuminated Books of the Middle Ages*, 1844; J. O. Westwood's *Palaeographia Sacra Pictoria*, 1843–5, and the same author's *Anglo-Saxon and Irish Manuscripts*, 1868 (see below, p. 97). All are magnificent examples of chromolithography. These large and expensive volumes were followed by many more popular introductions to the subject, usually containing plates in line for colouring. One of the earliest, and certainly the prettiest, was Noel Humphreys' *The Art of Illumination*, with text printed by the Chiswick Press, 1849 (see p. 75). A bigger book, with one hundred chromolitho plates by Day & Son, was Tymms and Wyatt's *The Art of Illuminating – What it was – What it should be – and How it may be practised*, 1860. There was also a host of cheap do-it-yourself manuals, mostly provided with a few chromolitho reproductions of illuminated initials and writing, of varied quality. A periodical, *The Illuminator's Magazine*, published by Barnard & Son, with excellent chromolitho plates by Day & Son, with many contributions by Noel Humphreys, ran from October 1861 to 1862: the bound volume contains one hundred and ten pages and twenty-nine plates. (*The Illuminated Magazine*, edited by Douglas Jerrold, of which two volumes appeared between May 1843 and April 1844, had nothing to do with illumination, and some very feeble gold lettering on the title-page seems the only justification for the title.)

Henry Shaw (see Chapter 7, above) was essentially a scholar and antiquarian; in all his works he was trying to portray accurately the arts of the past. Owen Jones was a designer, concerned with utilizing the arts of the past in a scholarly way for the embellishment of the present. Noel Humphreys (see Chapter 10, below) was a popularizer, with an astonishing gift for absorbing the art of the illuminated manuscripts he had studied in Italy and recreating out of them modern pages which were not direct copies yet were full of vitality and richness.

In *Illuminated Books of the Middle Ages*, 1844, Noel Humphreys and Owen Jones collaborated in a folio of straightforward (and lavish) colour reproduction of manuscripts; in *The Art of Illumination*, 1849, Noel Humphreys produced an exquisite small handbook for students intending to practise the art themselves.

No other work by either man consisted merely of reproductions of manuscripts (except the relevant pages in Jones's *Grammar of Ornament*, 1856). Both used the medieval art of illumination as a source of inspiration and material for exploiting the new art of chromolithography, for which it was admirably suited, and set a fashion in decorative printing which kept chromolithographers busy for many years. Illuminated manuscripts provided themes not only for book design but for the designers of chromolithographed music covers, from the 1840s onwards, and the publishers of religious mottoes, and Christmas cards, which later became a considerable industry.

The enthusiasm for the art of illumination generated by Owen Jones, Noel Humphreys, and their assistants and imitators created a small body of informed but largely antiquarian taste. It did not have much influence on the art of lettering as practised up and down the country: no artist of originality made lettering his special field, or made any important contribution to formal lettering or type design in Britain until William Morris, aided by Emery Walker, founded the Kelmscott Press in 1891. Morris himself had practised the writing and illumination of manuscripts in the early 1870s, and had bought and studied original medieval manuscripts. Owen Jones seems to have had little feeling for the alphabet (judging, for

example, by his *One Thousand and One Initial Letters*, 1864, and his *Seven hundred and two Monograms*, 1864) but had a considerable feeling for book design as a whole, and the pair of pages which is the basic element of the book. The books he designed in the 'sixties (see Chapter 11, p. 94) show an advance which Humphreys never made; they certainly influenced Walter Crane, and are a link with the decorative Kelmscott pages of the 'nineties.

However, to the student of book design, the illuminated gift books of the middle and late nineteenth century are of great interest. They were, of all Victorian books, the ones most carefully and consciously designed in every detail, including the bindings: they contained some of the colour printers' most dazzling pages; they were very much of their age.

Besides the illuminated books proper, which were decorated all through, it became the fashion in the 'forties to issue small books, of pocket size, with 'illuminated' title-pages, printed in gold and colours from wood blocks or by lithography. The publisher and printer H. G. Clarke of Old Bailey was one of the first in this field; he produced, for example, Bishop Heber's *Palestine, and other poems* in 1843, page size $5 \times 3\frac{3}{8}$ in., with a title-page printed in gold, red, blue, green and black by Gregory, Collins & Reynolds (see Chapter 5, p. 33); in 1844 he issued Miss Bremer's *The Bondmaid* with a title chromolithographed in gold, red, blue and black by R. Newbery; and in 1845 Miss Pardoe's *The City of the Sultan*, in three volumes, with pictorial ornamented titles printed in gold and colours by Gregory, Collins & Reynolds. James Burns produced, in 1843, a pocket book of meditations, *Eucharistica*, with a highly elaborate title-page printed from wood blocks in gold, two reds, blue and green; and before 1847 Darton & Clark published Cowper's *Poems*, $4\frac{7}{8} \times 3\frac{1}{4}$ in., with a very rich title-page chromolithographed by C. Graf.

If the first of the true 'illuminated books' was *Ancient Spanish Ballads* in 1841, published by Murray, the second seems to have been *The Sermon on the Mount*, 1844, published by Longman, and illuminated by Owen Jones. It consisted of thirty-two pages $6\frac{3}{8} \times 4\frac{1}{2}$ in., printed on stiff card, an unpleasing characteristic of

most of the small illuminated books, but necessary to make them thick enough to bind. *The Sermon on the Mount* was reprinted, with a different title-page, in 1845.

In both editions the illustration on the first page, in addition to being lithographed in green, red, blue, black and gold, is also hand-coloured – already an anachronism, but one which took many years to die out. Apart from the first page, there are no illustrations. The text is written in black letter, surrounded by a coloured border printed in green, red, blue, black and gold. The borders on every opening are different; all are floral except one. There is an unpleasing thinness in the designs, and the lettering of the text is inclined, in places, to look amateurish.

The Sermon on the Mount was issued in two sorts of binding: in a 'richly brocaded silk cover, manufactured for the purpose' at 21*s*. (they exist in both red and gold); and in polished brown morocco, by Hayday, blind stamped, with a hand-lettered paper quatrefoil label inlaid on front and back, at 25*s*.

Longman also published in 1844 a secular illuminated gift book, *The Prism of the Imagination*, by Baroness de Calabrella, for which Owen Jones provided gold borders round every page and a series of illuminated chromolithographed title-pages in his 'Alhambra' style. This book was followed by a series of Oriental illuminated books which will be described in Chapter 15.

By now, the illuminators seem to have been in full employment. At the end of 1844 Longman published *The Illuminated Calendar and Home Diary for* 1845, a very handsome volume measuring $10\frac{3}{8} \times 6\frac{3}{4}$ in., designed (although his name does not appear in it) by Henry Noel Humphreys (1810–79), whose work is described in detail in the next chapter. It begins with four pages printed in the unmistakable style of the Chiswick Press, in red and black black-letter, describing the *Hours of Anne of Brittany*, a manuscript in the Bibliothéque Royale from which the illuminations in the calendar were copied. The final paragraph states: 'The present is an attempt to render mechanism an auxilary of art, as far as it is now practicable, and to point the way to greater and higher efforts. The flower borders are printed entirely by the lithographic press of Mr Owen

Jones, and it is believed are excellent specimens of that delicate process. The figure subjects are coloured by hand.'

There follow forty-eight pages, as usual of thick card, with chromolithograph borders of flowers and insects and hand-coloured lithographed reproductions of pages from the *Hours of Anne of Brittany* – charming and colourful, but, when compared with the original, a certain amount of 'Victorianization' in the drawing is evident. The whole treatment has, however, the vigour and naturalness characteristic of Humphreys and not of Owen Jones.

Next year, Longman produced a second *Illuminated Calendar*, for 1846. It appeared with a highly elaborate binding design, blocked in gold on red and blue paint on white cloth, taken, as explained in the Introduction, from the 'Hours' of the Duke of Anjou, which manuscript also furnished the illustrations of the new calendar. The lithography, presumably again printed by Owen Jones, is in nine colours, apparently with no hand-colouring, and represents a decided advance in delicacy and finish. There is, as previously, a historical introduction, printed letterpress in black letter by the Chiswick Press, and this time signed 'H.N.H.'

It was proposed, in the 1845 *Calendar*, that the *Illuminated Calendar* would be published annually. In fact, no new edition appeared after 1846, but unsold 1846 sheets were corrected by means of pasted-down strips and re-issued for 1848.

In 1845, John Murray, who had already had a success with *Ancient Spanish Ballads* decorated by Owen Jones, published an illuminated *Book of Common Prayer* (pl. 21). Like the *Ancient Spanish Ballads*, every page is surrounded by a border designed by Owen Jones, printed letterpress in one or two colours, and there are also eight chromolithograph title-pages by him, as well as other initials and decorations. In addition there are numerous woodcuts of Old Master paintings, drawn on wood by George Scharf, Jun., under the superintendence of Lewis Gruner, himself to become a noted chromolithographer, and three charming woodcut illustrations by J. C. Horsley, surrounded by two-colour borders.

Again like *Spanish Ballads*, the book was well printed by Vizetelly Brothers, and must have been a considerable undertaking,

F

since it consists of over five hundred pages, all printed in two or three colours. The edition consisted of four thousand copies: publication was in eight parts, sold at about 5s. each part.

The twelve Calendar pages (pp. xx–xxxi), and the Horsley drawings already mentioned, are surrounded with borders of flowers, foliage and fruit, quite different in style from the largely insensitive and formalized borders of Owen Jones: it is tempting to attribute them to Noel Humphreys, although he is not mentioned.

Murray's *Book of Common Prayer* is one of the important examples of Owen Jones's commercial decoration, but it made a loss for the publishers.[1] It was reprinted in 1863 in fewer colours, and omitting the colour title-pages.

In 1845,[2] a notable example of illuminated printing was published by Joseph Cundall. This was *A Booke of Christmas Carols*, consisting of thirty-two pages drawn and lithographed by John Brandard (1812–63), who specialized in music covers, and colour-printed by Hanhart; the text was overprinted, in Old Face, by Whittingham at the Chiswick Press (pl. 8). It was bound in leather, or in embossed and colour-printed paper on boards. Cundall published several more small illuminated books, including *The Creed, The Lord's Prayer and the Ten Commandments*, 1848, and *Words of Truth and Wisdom*, [1848], both chromolithographed by F. Dangerfield.

In 1846 Longman published Gray's *Elegy*, illuminated by Owen Jones: the first secular book wholly illuminated by him, the first with the name of a New York publisher (Wiley & Putnam) on the title-page as well as that of the English publisher, and the first to be issued in a special kind of binding chiefly used for illuminated books. The binding is in brown leather deeply embossed to imitate carved wood: the design, which is overall, consists of holly leaves and 'Gray's Elegy' in gothic lettering in a panel on the front, and holly leaves and Owen Jones's monogram on the back, and must have been built up underneath the leather as well as being embossed on it. There is no gold (or colour) on the sides, but the flat edges and 'squares' are tooled in gold and the edges of the paper are gilt.

[1] Information kindly supplied by Mr John Murray in 1961.
[2] Date from *Index to the British Catalogue of Books*, 1858.

The binding was executed by Remnant & Edmonds, who had for several years specialized in fancy binding for Albums and Gift Books. The illuminations, in Owen Jones's characteristic spidery style, are chromolithographed in two blues, two reds, black and gold.

In 1848 Longman also published a different kind of illuminated book, *Flowers and their Kindred Thoughts*, printed and designed by Owen Jones. The page size is larger, 10×7 in., and there are thirty-four pages of stiff card. Each opening consists of a bunch of flowers, in colour, entwined with the words they symbolize (e.g. 'Modesty', 'Fascination', 'Childhood'), faced by some religious verses (by M. A. Bacon) printed in gold. The lettering and curls are typical of Owen Jones, but the chromolithographed flowers are beautifully enough drawn for one to suspect the hand of Noel Humphreys. The colophon only states 'designs by Owen Jones'.

The binding of *Flowers and their Kindred Thoughts* is in heavily embossed leather, like the Gray's *Elegy* of 1846. Owen Jones's next book was *The Song of Songs*, published by Longman in 1849. It too appeared in an embossed leather binding, and was illuminated in the familiar Owen Jones style, without illustrations. It was chromolithographed in two reds, two blues, a green, gold and black. The combination of cramped gothic script and coldly formalized ornament makes unsympathetic and illegible pages, which must have prevented any purchaser of the book from reading it. It is probably the most unsuitable setting the *Song* has ever received.

Longman published two more illuminated books by Owen Jones in 1849. *The Preacher* was in a larger format ($11\frac{1}{16} \times 7\frac{3}{4}$ in.) and appeared both in 'carved' (see pl. 24 and Chapter 17, p. 151) wooden binding and in blind stamped crimson leather, the same design by Owen Jones being used for each. There are thirty-four chromolithographed card pages; the style of Owen Jones's illumination is here more elaborate, and therefore slightly more convincing purely as abstract ornamentation, but it is also even more illegible than usual. It is sad to see the noble language of Ecclesiastes so obscured. *Holy Matrimony*, 1849, was a much smaller book, measuring $4\frac{3}{4} \times 3\frac{3}{5}$ in., and consisted of the Wedding Service

written out and illuminated in forty-eight chromolithographed pages.

Owen Jones had yet a fourth book out in 1849, *The Works of Horace* (pl. IIIB), with a Life by Canon H. H. Milman, published by John Murray. It is a continuation of the *Ancient Spanish Ballads* and *Book of Common Prayer* style: the pages of the Life are surrounded by decorated borders cut on wood and printed in colours, and the Books of the Poems are prefaced by eight chromolithographed title-pages in a roman or classical style, of which the colour schemes are unusual and attractive. The book also contains monochrome decorations by Jones and drawings from the antique by George Scharf, Jun. The letterpress printing was again by Vizetelly Brothers: the chromolithography was presumably executed by Owen Jones's own establishment. The edition was of two thousand five hundred copies and it was published at £2 2s. Like the *Prayer Book*, it made a loss.[1]

Owen Jones's next two illuminated books were *Fruits from the Garden and Field* (pl. 23), 1850, and *Winged Thoughts*, 1851, both similar in general style and appearance to *Flowers and their Kindred Thoughts* and published by Longman. Both were bound in blind stamped leather, and both contained extremely bad verse by M. A. Bacon, with facing chromolithographed drawings, presumably by Owen Jones (the former says 'designs by Owen Jones', the latter 'Owen Jones direxit'). Both owe whatever virtues they possess to the indefinable qualities of skilful Victorian chromolithography, which perhaps we appreciate the more since we know that this particular sort of craftsmanship has disappeared and will never be revived. Some of the plates in *Winged Thoughts* are very fine indeed. As might be expected, in those days before binoculars, large birds which can be seen on the ground, like the swan, peacock and pheasant, are much better drawn than the lark, the nightingale and the swallow.

Owen Jones must already have been thinking of, and probably

[1] Information kindly supplied by Mr John Murray in 1961. A letter from H. Vizetelly to John Murray dated February 12, 1849, states that this book, which was the cause of some complaints by Murray against the printer, was 'taken by my brother under his sole charge'. See footnote on p. 127 (chapter 15).

working on, his magnum opus, *The Grammar of Ornament*, to be published in 1856; but he had also become involved in the Great Exhibition, for which he was appointed Superintendent of the Works, and designer of the interior and exterior colour scheme. No detailed illustration of his colour scheme is known, comparable with the coloured plate, No. xx, showing Crace's designs for the 1862 Exhibition in *The Illuminator's Magazine*, 1861–2; but the results can be studied in Dickinson's coloured lithographs portraying the Great Exhibition. According to the Victoria & Albert Museum's *The Great Exhibition of* 1851, compiled by C. H. Gibbs-Smith, London, 1950: 'The colour scheme of the inside was red, light blue, yellow and white. Most of the vertical flat surfaces were blue; the rounded parts yellow; and the undersides of the girders red. The hanging banners giving the name of country or class of material were red, with white lettering and borders. The exterior was white or stone colour, picked out in blue ... Owen Jones ... also designed the surrounding railings.'[1]

The scheme was, naturally, criticized by *The Times*, and Owen Jones had to defend it at a meeting of members of the Royal Institute of British Architects; but it seems to us today to have been admirably successful.

Owen Jones published no more illustrated books of his own until his great *Grammar of Ornament* in 1856 (see below, p. 89); but on December 9, 1854, *The Illustrated London News* carried the following announcement:

'Mr Owen Jones is offering the remaining copies of his many beautiful publications to public competition. The hammer of the auctioneer will, on Monday next, commence dispersing his "Alhambra", and other works at the highest prices which John Bull may be willing to pay for them. Mr Shaw's exquisite works sold so well under the hammer of Messrs Sotheby & Wilkinson, that we have little fear for Mr Jones's labours under the hammer of Mr Hodgson. Mr Jones's services to art have not been suffi-

[1] This passage is based on the full description in the Introduction to the 1851 Exhibition Catalogue.

ciently appreciated: and hitherto the prices of his works have
been too high for the pockets of many who have waited eagerly
for some such public distribution as Mr Jones has now ventured
to make of his many labours.'

A design by W. Harry Rogers, engraved on wood by Joseph Swain, from
Spiritual Conceits, by W. Harry Rogers, London, 1862.

10
Henry Noel Humphreys, author and illustrator

IN 1847, Noel Humphreys saw published no less than three books containing his own illustrations: *Parables of Our Lord*, *The Poets' Pleasaunce*, and *Insect Changes*. Henry Noel Humphreys, born in Birmingham in 1810, had spent some years in Italy and had become deeply impressed by Italian art and, above all, by the illuminated manuscripts he had seen in Italy. In about 1840 he returned to England and in that year published, through Charles Tilt, *Rome and Its Surroundings*: it contained illustrations by 'eminent artists', but not by himself. His next published work seems to have been *Illuminated Illustrations of Froissart*, published by William Smith in two volumes in 1844. The illustrations, after manuscript drawings, somewhat crudely lithographed and hand-coloured, are poor compared with his later work.

In 1844 he must have been working on the *Illuminated Calendar* for 1845, published by Longman and already mentioned, followed by another for 1846.

In 1846 he published, through William Smith, his first book on coins, *The Coins of England*, written and illustrated by himself and a striking example of popular book design. It was immediately successful: a second edition appeared the same year, and a sixth by 1849. The illustrations included some rich woodcut initials and twenty-four chromolithograph plates of coins printed in copper, silver and gold against a royal blue background. Noel Humphreys also rarely neglected a chance to decorate the outsides of his books. *The Coins of England* had a binding elaborately counterfeited to look like crimson moiré silk, with heavy brass hinges and corners – all in paper on boards.

The binding of one of his 1847 books, *Parables of Our Lord,* was even more unusual. It was the first of the so-called 'papier maché' bindings, contrived to look like carved ebony, and described in Chapter 17, p. 151. They were cast in a black plaster composition, over papier maché, often reinforced with metal. The result was splendidly gothic and impressive. Such books could hardly be put on shelves to scratch other bindings or chip against their own kind: they could only lie and be admired on tasselled piano-covers or drawing-room table-cloths.

Parables of Our Lord cost 21s.,[1] and consisted of thirty-two pages richly illuminated and chromolithographed, with a colophon on the last page which reads: 'In designing the ornaments to the sacred parables contained in this volume, the illuminator has sought to render them in each instance appropriate. The work of illumination was commenced on the first day of May of the Year of our Lord MDCCCXLV and terminated on the tenth day of Feb[ry] MDCCCXLVI. HNH.' No name of printer is given. On a further page inserted at the end, the symbolism of the various borders is explained, and the artist's intentions are further expressed in the words: '. . . it has been the aim of the designer to render the ornamental borderings of each page appropriate to the text, and to avoid all mere arbitrary or idle ornaments; and he has thought it more suitable that the garments of gold and many colours in which he has arrayed them, should at all events be *new,* rather than embroidery borrowed from old missals or other sources of conventional ornament, however quaint or beautiful; and therefore, however far the illuminator may have fallen short of his intention, the designs will be found to be strictly original, fresh, and full of the purpose alone to which they are devoted.'

These claims are justified. There is an originality and power in the illuminations entirely lacking in Owen Jones's work. Noel Humphreys has captured some of the medieval Flemish illuminators' spirit but has added to it an inventiveness and artistry of his

[1] Copies bound in morocco cost 30s. Messrs Longman's accounts for this book survive and show that 2,000 copies were printed, of which 1,000 were sold to Appleton & Co. in New York, with a cancelled title-page. A second edition was made in the same year.

own, based on an artist's feeling for the strange intricacies of flower and leaf, backed by a naturalist's knowledge. The same powers are shown in his black and white borders for *The Poets' Pleasaunce*. This is a sort of anthology of the English poets' writings on flowers, compiled by Eden Warwick, published by Longman and finely printed by Vizetelly Brothers. Every page is surrounded by a repeating wood-engraved border, but the remarkable feature of the book is Noel Humphreys' thirty full-page borders introducing each flower (pls. 27, 47). They are probably the most original and powerful black and white decorations to appear in any Victorian book. Apart from the designs themselves, the engravings also are of superb quality: twelve are signed by Vizetelly and thirteen by William Dickes, who later became a Baxter Patentee and a pioneer of cheap colour printing. *The Poets' Pleasaunce* was issued in a very pretty binding, copied from a grolieresque design shown in pl. 8 of Shaw's *Encyclopaedia of Ornament*, 1842, printed on bevelled paper boards (see p. 150, Chapter 17 and pl. 29).

Noel Humphreys' third book of 1847 was *Insect Changes*, written and illustrated by himself, and the first of his several works on entomology. It is a small children's book, published by Grant & Griffith, and containing thirty-two pages printed letterpress on cheap paper, of which eight are illuminated in ten or twelve colour chromolithography, drawn in the style of the *Hours of Anne of Brittany* (pl. 26). The letterpress printing, by William & Ogilvy, is conspicuously poor and in telling contrast to the work being done by the Chiswick Press or the Vizetellys at that time; but *Insect Changes* cost only 6s. The binding was in fawn cloth with a design after Holbein printed in black, brown and gold (pl. 28A). Although slight, *Insect Changes* is, for its day, an unusual and pleasing little book.

The flow continued. In late 1847 or early 1848 Longman published another illuminated book in a black papier maché binding, *The Good Shunamite*, consisting of twenty pages, in approximately the same size ($6\frac{3}{8} \times 4\frac{1}{2}$ in.) as the *Parables*, illuminated 'in the Studio of Lewis Gruner', and probably printed in the establishment of Owen Jones, whose style the illuminations resemble. Gruner was

the author and artist of several large and notable books on ornamental design: his masterpiece was probably *Specimens of Ornamental Art*, 1850 (see p. 85).

In 1848 Longman published *The Miracles of Our Lord*,[1] illuminated by Noel Humphreys, in the same size and same style of papier maché binding as the *Parables*. There are thirty-two illuminated pages, and, as in the *Parables*, each pair of facing pages is alternately in rich, hot colours and in cold, soft colours, including 'grisaille' pages in black, grey and gold, and extremely striking combinations of pink, blue and silver. Also as previously, Noel Humphreys prints some 'Remarks of the Illuminator' at the back, on Christian art and symbolism and with descriptions and explanations of his designs.

The *Miracles* certainly has a more successful title-page (pl. 32) than the *Parables*, and the main illustrations demonstrate his masterly sense of design. He is still largely dependent on plant forms but now also introduces figures. The technique of the chromolithography has also advanced.

The *Miracles* was followed in 1848 by yet another book illuminated by Noel Humphreys, *Maxims and Precepts of the Saviour*, consisting of thirty-two illuminated pages, $6\frac{1}{2} \times 4\frac{3}{8}$ in., chromolithographed in up to about twelve colours. The illuminator has used the precepts 'Behold the fowls of the air' and 'Consider the lilies of the field' as a theme for his borders, into which he has introduced some of the brilliantly coloured birds and flowers which had only recently been discovered and published – such as the *Lilium Superbum* (North America, 1783), the *Butterfly Oncidium* (Trinidad, 1824), the sky-blue *Marica* (Brazil, 1818), and *Baker's Loelia* (Mexico, 1835), as well as Toucans, Macaws, Kingfishers, Rainbow Thrushes, etc.

The colophon at the end states: 'The illuminator began his work Sept[r]. 1, A.D. 1847 and finished April 6, 1848' and one can imagine Noel Humphreys' pride on first seeing the printed results and knowing that nothing like them had ever been printed before.

In 1849, Longman published at least four illuminated books: two

[1] Messrs Longman's ledgers show that 1,952 copies were printed.

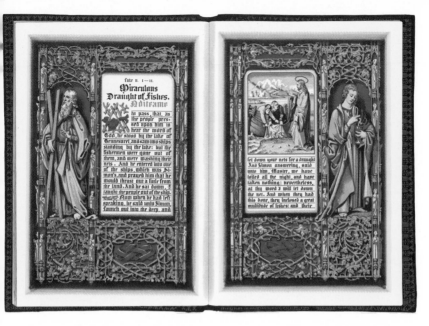

IIIA Opening from *The Miracles of Our Lord*, 1848. Illuminated by H. Noel Humphreys and chromolithographed in about 12 colours. 6½ in. x 4½ in.

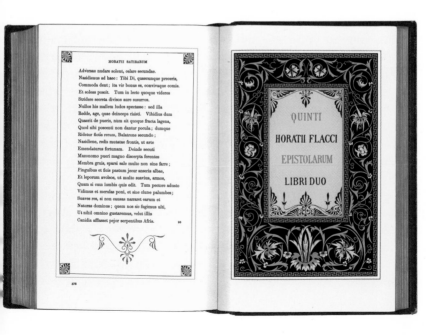

IIIB Opening from *Horace*, 1849, decorated and illuminated by Owen Jones. The right-hand page is chromolithographed. 8⅜ in. x 5½ in.

described above, by Owen Jones, Joseph Cundall's *Songs, Madrigals & Sonnets* (see p. 51) and *A Record of the Black Prince*, by Noel Humphreys. The *Black Prince* is one of the most successful of all the gift or table books of this period. The binding is the most elaborate yet of the black papier maché kind, helped by the slightly larger size ($7\frac{5}{8} \times 5\frac{1}{2}$ in. overall), with sides about $\frac{1}{4}$ in. thick, pierced to show a crimson paper background. There are over one hundred pages of text, set in the plump black-letter of Figgins and printed letterpress by Vizetelly Brothers: many pages are embellished with initials and decorative wood-engravings printed in black and in red, and there are six splendid chromolithographed illustrations in the text, marvellously enhanced by the surrounding black type. The book sold at 21*s.*, the usual price of Noel Humphreys' illuminated books, and 1,000 copies were printed.[1]

Noel Humphreys had another book out in 1849, this time published by Bohn: *The Art of Illumination and Missal Painting. A Guide to Modern Illuminators.* The binding again broke new ground and must, when new, have been one of the prettiest publisher's bindings ever issued, but it is rarely seen today in anything approaching its pristine state. It was in white leather, with a border blocked in gold on blue, and, on the front, an extremely rich and pretty design printed in chromolithography on paper, inset and lined in gold. The white leather and paper panel both become easily worn, which is no doubt why this kind of binding was rarely used: but for gay colourfulness it could hardly be surpassed. The inside lives up to the outside. The sixty-four pages of text ($6\frac{3}{4} \times 4\frac{1}{2}$ in.) were printed by the Chiswick Press in Caslon Old Face, and have the typographic style that only Charles Whittingham could achieve at that time; in addition there are twelve fine chromolitho reproductions of manuscripts, exquisitely printed in up to at least fourteen colours, with the same plates provided also in outline 'to be coloured by the Student according to the theories developed in the Work'. On the last page of the book Noel Humphreys outlines the qualities required by an illuminator, in a passage that deserves quoting at length: 'He must be acquainted with Botany, and also

[1] Messrs Longman's ledgers.

possess a knowledge of what may be termed the poetry of flowers, that is to say, their association, their symbolism, and their properties. Entomology, too, with its train of glittering flies, and painted caterpillars; those gorgeous worms, that in the tropics shine like creeping jewels, must have formed one of his pursuits. In short, Natural History in general, and the associations and emblematic character of various substances, plants, and animals, must form a portion of the education of an illuminator. He must thoroughly understand the laws of colours, and also their symbolism, and above all, he must possess a thorough knowledge of the history of decorative art in all ages. ... He must be a poet too, in feeling, if not literally, and he must be familiar with the most beautiful fancies of the poets of all ages. In legendary love he must be an adept, and the exquisite dreamings of fairy-land must have filled his fancy. To treat sacred subjects, he must be familiar with all the symbolism of early Christianity, and the legends of its early martyrs. To treat poetic subjects, he must know the songs of the Troubadour and Trouvere, and the metrical and prose Romances of the age of Chivalry must have been a favourite study. He must delight in researches connected with the costumes, the weapons, and the armour of all ages; and the history and practice of art in all its departments must fill his happiest thoughts, and occupy his sweetest leisure. The massive monuments of architecture, the immortalized marble of the sculptor, the breathing canvass [sic] of the Raphaels and Correggios, must have fed his greedy taste and formed the high standard of his artistic dream of excellence; and then, so prepared, and with the aid of assiduous application, the illuminator may lift his art to the high position which legitimately belongs to it; but which the poor productions of the last century and a half have tended so greatly to lower; reducing that which should be an exquisite art, to a routine of the most vulgar mechanism.'

In those loving words, Noel Humphreys was outlining the ideals which he came close to realizing in himself.

In 1850, Longman published The Book of Ruth illuminated by Noel Humphreys, similar in format to Maxims and Precepts of the

Saviour. An innovation, for this series, was that the text was set in black-letter and overprinted on the chromolithographed pages by a letterpress printer, Vizetelly & Company. The chromolitho-graphed borders are perhaps the best Noel Humphreys ever did: at least, the skill and beauty of his medieval Flemish and Italian masters is most nearly approached. He has returned to simplicity. As before, openings are alternately in golds and greys, and in full colours. On the coloured pages, there are borders, generally of flowers and butterflies, and small illustrations of the story. The binding was in brown blind-stamped leather, or cloth, simply blocked in gold.

In 1851, Longman published *Sentiments and Similes of William Shakespeare*, by Henry Noel Humphreys. The author's preface states: 'When I first thought of producing an example of book decorations, as the result of my studies in the "Art of Illumination", I at once selected the present subject, as the vehicle to receive my projected embellishments; for to what purpose could the latest refinements in decorative printing be more appropriately devoted than the embellishment of a series of selections from the writings of our immortal Shakespeare? With this feeling I have gathered together some of the gems of thought of our great poet, and endeavoured to range them worthily in a fitting casket – to enshrine them, as it were, in a reliquary as rich as a combination of the typographic and lithochromic arts could form . . .

'Recent progress in various kinds of printing has enabled the press to rival the art of the illuminator himself, and the highly enriched bordering round the first page of this book is entirely the result of this new application of art . . .

'An unlimited number of separate printings have been employed, with the desire to make it one of the most perfect works of an artistic character ever produced by mere mechanical means.'

The single colour plate in *Sentiments and Similes* is in fact very fine, and is superior in quality to the chromolithography of Noel Humphreys' early books. It appears to be printed in not more than fourteen colours. Messrs Longman's ledgers for this book survive, and show that the plate was printed in Paris by Engelmann &

Graf, who charged £70 for one thousand copies (shipping expenses were £6 13s. 2d.) and took a half share, with Longman, in the profits. Vizetelly's charge for printing the rest of the book (108 pages in gold and black) was £143 6s. 9d.; H. N. Humphreys received £23 for 'drawings' and Dickes £6 4s. 6d. for 'drawing initials and engraving'.

The heavy gold ruling on the text pages does not make for legibility, but at least the poetry is set in a roman type, and the general effect is not unpleasing. The binding is a further advance in the papier maché style: the black frame is set in a border of leather, with a gold background showing through the strap-work, and a terracotta oval relief of Shakespeare's head inset in the centre: his initials in terracotta are inset on the back. The book was sufficiently successful to warrant a second edition in 1857, when the text was reset and printed by Spottiswoode, and slight modifications made in the binding.

Noel Humphreys, when over fifty, produced one more illuminated book, *The Penitential Psalms*, in 1861. It is similar in format and style to the others: it is an older man's work, with some very beautiful pages. Strangely, it contains neither date, nor name of publisher or printer, and the first edition omits the name of Noel Humphreys himself.

Noel Humphreys' illuminated books are rich and consistent examples of Victorian gothic design, and are among the best examples of chromolithography of the century. No lithographer is mentioned in any of them: but most of them were probably printed under the supervision of Owen Jones at 9 Argyll Place. Noel Humphreys is not known to have had a connection with any other lithographer except the less ambitious and less skilful H. Woods, who printed the colour plates of *Coins of England* and *Insect Changes*.

After 1851, Noel Humphreys devoted himself increasingly to writing and to providing decorations for publishers of wood-engraved gift books.

In 1852 he produced *Ten Centuries of Art*, a not very interesting work written by himself with fourteen plates printed by Day & Son, and the text pages printed by Vizetelly: typographically it has

just a little more style than the average of its period. Then in 1853 he produced *The Origin and Progress of the Art of Writing*, a hundred and seventy-six page popular history written by himself, with twenty-eight plates from his own hand, of which thirteen are chromolithographs, mostly by Day & Son: the text was printed, with the utmost lack of character, by Robson, Levey & Franklyn, of Great New Street & Fetter Lane, and the book published by Ingram, Cooke & Co. It was given one of the elaborate black papier maché bindings, rather surprising for a book clearly intended to be read and used. The *History of Writing* (as the title was abbreviated on its spine) sold sufficiently well to permit a second edition, published in 1855, in the same format and binding, by Day & Son. In 1855 was also published, by David Bogue, Noel Humphreys' *The Coinage of the British Empire*, another work of successful popularization, also with a fine papier maché binding (pl. 25) and twenty-four plates, of which twelve are chromolithographed in gold, silver and copper.

During this decade Noel Humphreys also found time to write and illustrate *River Gardens*, 1857, *Ocean Gardens*, 1857, and *The Butterfly Vivarium*, 1858, in uniform format and all illustrated with wood-engravings printed in two colours and hand-coloured – an indication that colour printing was still not fully established; he also wrote three works of fiction: *Stories by an Archaeologist and his Friends*, 1856, finely printed by the Chiswick Press for Bell & Daldy; *Diamonds and Dust*, 1856, vilely printed by T. C. Newby for T. C. Newby; and *Goethe in Strasbourg: a dramatic Nouvelette*, published by Saunders, Otley & Co. in 1860 and printed (in the Basle type) by Whittingham & Wilkins. Then there was another work of laborious compilation, with thirty-two large hand-coloured lithographs drawn by himself, *The Genera and Species of British Butterflies*, 1859, which was followed by a similar work on British Moths. During this time he also illustrated at least three botanical works by other authors: drew coloured decorations for the *Rouman Anthology*, 1856 (see p. 126); and provided monochrome decorations for many books, including Tupper's *Proverbial Philosophy*, 1854; *Rhymes & Roundelayes in Praise of a Country Life*, 1857; *The*

Poetical Works of George Herbert, 1857; *The Shipwreck*, by W. Falconer, 1858; Thompson's *Seasons*, 1859; the *Poems* of Goldsmith, 1859; and Wordsworth's *White Doe of Rylstone*, 1859.

His decorations for Goldsmith's *Poems* were printed in two colours, and are among the most elaborate and successful of all his work of this kind. This was the edition with Birket Foster's illustrations printed in colours by Evans, described in Chapter 15. He also illustrated at least one of Routledge's New Toy Books, *A Little Girl's Visit to a Flower Garden*, printed in colours by Edmund Evans.

There is an integrity and originality in Noel Humphreys' work as a designer which makes the similar work of his contemporaries, like T. Macquoid, T. Sulman and Harry Rogers, look feeble. The width of his learning, in the fields of natural history, arms and armour, coins and jewellery, was obviously great. But his ability and industry did not apparently bring him affluence. He died intestate in 1879, and letters of administration were granted to his son Noel Algernon: he left under £800.

Illustration by R. Barnes, engraved on wood by J. D. Cooper, from Mrs Barbauld's *Hymns in Prose for Children*, London, 1865.

I I

The advance of
chromolithography

OWEN JONES did not for long retain the lead in chromolithography
in England which he had established with his *Alhambra*. One of his
earliest rivals was Michael Hanhart, who had been manager of
Engelmann's London office until it was closed in 1830, and who
then founded his own business, M. & N. Hanhart, in Charlotte
Street, with his sons. Hanhart did a steady trade in all kinds of
lithography and was the first and chief printer of chromolitho-
graphed music covers, which began to appear in 1840 and are
among the richest examples of Victorian graphic art.[1] His first
important chromolithographed book was probably Augustus
Welby Pugin's *Glossary of Ecclesiastical Ornament and Costume*,
published by Henry Bohn in 1844, which was even richer in colour
than the *Alhambra*, and a bit easier to handle, although not small:
the page size is $12\frac{1}{2} \times 9\frac{3}{4}$ in., and the book is over 2 inches thick.
There are two hundred and thirty-eight pages of letterpress text
(illustrated with wood-engravings and printed by G. Norman of
Maiden Lane) followed by seventy-three chromolithographs of
church vestments, symbols, emblems and ornamentation, all
drawn by Pugin, lithographed by H. C. Maguire and printed by
Hanhart. To the ordinary man, there must have been a certain
monotony about many of the *Alhambra* plates, consisting as they
apparently did of endless variations of blue, gold and red fretwork:
but Pugin's plates show gothic alphabets, shields, endless varieties
of patterns for diapering, for stoles, for maniples, for copes, sacred
monograms, conventional forms of Lions, Mitres, Altars, every-

[1] See A. Hyatt King, 'Some Victorian Illustrated Music Titles', with eight
reproductions in colours, *The Penrose Annual*, vol. 46, London, 1952.

thing of the most rich and colourful that the Tractarians desired to see restored to the churches of England. In presenting flat colours and gold, chromolithography is superb: this is one of the outstanding colour books of the Victorian period.

Pugin's Introduction, 'of Symbolism in Art', is also significant: he writes 'Ornament, in the true and proper meaning of the word, signifies the embellishment of that which is in itself useful, in an appropriate manner. Yet, by a perversion of the term, it is frequently applied to mere enrichment, which deserves no other name than that of unmeaning detail, dictated by no rule but that of individual fancy and caprice. Every ornament, to deserve the name, must *possess an appropriate meaning*, and be *introduced with an intelligent purpose* and on *reasonable grounds*.' This belief in the functional nature of ornament was shared by Owen Jones and most of the influential group of designers and architects associated with the Great Exhibition of 1851: although Pugin did not at all approve of the design of the Crystal Palace. He died, after a mental breakdown, in 1852, at the early age of forty-two.

A second edition of *The Glossary of Ecclesiastical Ornament* appeared in 1846. Pugin illustrated and Hanhart printed a second work of coloured illustrations, but containing only thirty-one plates, *Floriated Ornament* (pl. 34A), which appeared in 1849.

Pugin's wide interest in design in many fields gives special interest to his earlier book, *The True Principles of Pointed or Christian Architecture*, published by John Weale in 1841. The design of this book was almost certainly at least supervised by Pugin. The best thing about it is Pugin's own drawings, reproduced both by etched plates and wood-engraving. Two illustrations of patterns are printed from wood blocks in red and yellow. The book has been carefully produced, but the typography, using a 'modern' text face, is feeble, especially when compared with Pickering's and Whittingham's books of this period. The printer was W. Hughes of Gough Square.

The same typographic feebleness appears in Ruskin's *The Seven Lamps of Architecture*, published by Smith, Elder in 1849 and printed in Modern by Spottiswoodes & Shaw of New-Street-

Square, London. The binding, presumably designed by Ruskin, shows an effective use of blind stamping on cloth, and the book is illustrated with fourteen etchings of which Ruskin wrote: '[they] were not only, every line of them, by my own hand, but bitten also by myself, with savage carelessness, out of which disdain some of the plates came into effects both right and good for their purpose, and will, I say, be always hereafter valuable'. Valuable, in a true sense, they certainly are, but the first edition can still be obtained in London today for a few shillings.

Another fine folio, with colour plates mostly executed by Hanhart, was William Warrington's *The History of Stained Glass*, 1848. It contains twenty-six magnificent chromolithograph plates, drawn by Warrington (who designed some of the windows in the House of Lords) and printed in up to eight colours. Stained glass, with its black lines defining areas of bright colour, was an excellent subject for the new medium, and Warrington's plates (some of which are dated 1843 and 1844) are beautiful and highly skilful examples.

Also in 1848 there appeared Matthew Digby Wyatt's *Specimens of the Geometrical Mosaic of the Middle Ages*, published by himself. It is a folio, containing twenty-one plates drawn by Wyatt and chromolithographed by Day & Son in up to eight colours; admirable decorative use is made of authentic mosaics in the six-colour title-page (pl. 33).

In 1850, Henry Bohn published an English edition of Silvestre's *Paléographie Universelle*, first published in Paris in 1841 (see above, p. 61). The English edition contains two hundred and ninety-six plates in two folio volumes, with the text, translated into English and considerably corrected by Sir Francis Madden of the British Museum, in two small quarto volumes. As far as can be told from a comparison of the French and English volumes, the plates were not redrawn, but reprinted by Hanhart either from the same stones or plates or from offsets from the originals.

It is a work of mixed chromolithography, in up to four printings, with hand-colouring to the same degree of perfection as was obtained on Henry Shaw's plates, but Silvestre's are generally

much larger. Its scope is truly universal, since Silvestre reproduces examples of the palaeography of Mexico and Peru, as well as of numerous Oriental and all the main European countries, including Scandinavia. In its day, this work of fantastic labour was a great contribution to scholarship, and even now it is more satisfying to look at than most modern reproductions, though it lacks the authority of photography.

Another fine work with chromolithographs was *Divers Works of Early Masters in Christian Decoration*, etc. edited and published by John Weale, two volumes folio: it is dated 1846 on the title-page, and many of its plates are dated much earlier, but on page 27 a reference is made to the recent publication of Warrington's *Stained Glass*, whose text is printed on paper watermarked 1848.

Divers Works is not entirely a chromolithograph book, but it is an interesting and ambitious production, with some fine pages. In Volume I, the letterpress text is illustrated with copper plate engravings and etchings printed among the type, always a noble form of extravagance, as well as with wood-engravings; the twelve chromolithographs (including some magnificent very large folding ones) were printed at 9 Argyll Place under the superintendence of Owen Jones. Volume II contains a lithotint frontispiece, more chromolithographs, chromolithographs printed from zinc, and some exquisitely hand-coloured copper plates. Many of the colour plates in this work had already appeared in Weale's *Quarterly Papers on Architecture* (see above, p. 33).

The tremendous interest at this period in the art of illumination is shown by yet another large and lavish work on the subject, Noel Humphreys' *The Illuminated Books of the Middle Ages*. It was originally published in twelve monthly parts, each part with three full plates and other smaller ones, at 21s. a part (15 × 11 in.) or at 21s. a part Large Paper, 21½ × 15 in., and was then published as a complete volume by Longman in 1849, prefaced by a typical, and illegible, illuminated title-page by Owen Jones, who on the letterpress title is credited with the execution and printing of the plates; the author of the text, and artist of the plates, was Noel Humphreys. It is a magnificent folio volume, containing sixty-seven separate

chromolithograph illustrations pasted down on heavy card pages. The execution of the chromolithography, and the large number of colours used, made it certainly the finest specimen of lithographic colour printing so far published in Britain; but it is to be feared that some of the drawings do not copy their originals with sufficient fidelity. However, this book, considered simply as a specimen of chromolithography, was surpassed both in size and quality by Lewis Gruner's *Specimens of Ornamental Art*, published at twelve guineas by Thomas McLean in 1850. Gruner's volume contained eighty plates measuring $24\frac{3}{4} \times 19$ in.; a short text, by Emil Braun, with descriptions of the plates, was published separately. Many of the plates are monochrome, some are in only two colours: but the best of the polychromatic ones are the finest yet seen in Britain; some very big and bold details of flowers and fruit from nature, and of friezes and wall paintings in Italy; some finely drawn and superbly coloured representations of entire walls and ceilings, the craftsmanship to produce which must have rivalled that of the original artists, who include Giotto and Michelangelo. The drawing is by Gruner, but no lithographer or printer is mentioned on the plates.[1] The expressed purpose of the work was to provide examples of design and ornament for industry; it was dedicated to Prince Albert; and it is one of the most impressive achievements of mid-Victorian colour printing.

A smaller book of this time which deserves not to be forgotten, with beautiful chromolitho plates, comparable to Pugin's coloured books, is E. L. Blackburne's *Sketches Graphic and Descriptive, etc. for a History of the Decorative Painting applied to English Architecture During the Middle Ages*, quarto, 1847. Its twenty-four plates show tiles, decorative motifs, painted walls, ceilings and other architectural details, printed in many colours and without any hand-colouring, by Day & Son, lithographers to the Queen.

It should be remembered, incidentally, that nearly all the books mentioned in this chapter were issued in parts to subscribers, and

[1] Some or all were probably printed by Winckelmann & Sons of Berlin. See *Reports by the Juries*, Exhibition of the Works of Industry of All Nations, 1852, p. 698, 'Lithochromy'.

individual plates are often dated, and were issued, several years earlier than the date of final publication in bound form. The dates given are, unless otherwise stated, the dates on the title-pages but, as has been seen, these are not always reliable.

If the most attractive of the great chromolithograph folios appeared during the 'forties, the heaviest certainly came during the 'fifties; and they must be among the most remarkable monuments of Victorian industry and craftsmanship in any field. Brought into existence like the Pyramids by slow and immensely painstaking labour, too big and heavy ever to be easily looked at, and now, because their gutta-percha bindings have cracked, all too often loose-leaved and tattered wrecks, they are still magnificent.

The first two such works to be produced in the 'fifties were directly connected with the Great Exhibition.

The first was *The Industrial Arts of the Nineteenth Century*, by Matthew Digby Wyatt, published in two volumes by Day & Son, in 1853. The page size was $18\frac{7}{8} \times 13$ in., and the two volumes contained one hundred and sixty plates. The author, later to become the first Slade Professor of Fine Art at Cambridge University, was Secretary of the Executive Committee of the Commissioners to the 1851 Exhibition, and he conceived the idea of a publication in which the most beautiful objects shown in the Exhibition should be reproduced 'by the best means of graphic representation available in the present day', to quote his own words.

A postscript to Digby Wyatt's Introduction gives some interesting details of the gigantic undertaking this book proved to be. Wyatt writes: '. . . the present Work is the most important application of Chromo-Lithography to assist the connection which should subsist between Art and Industry which has yet appeared; and, further, . . . it has been produced upon a scale of magnitude, and with a degree of rapidity, unexampled in this or any other country . . . A knowledge the circumstances . . . mitigate the severity of the atrabilious critic . . . In the month of April 1851 the present publication was not even thought of . . .'

He continued: 'No less than twenty talented draftsmen were immediately set to work in making elaborate studies, under the

Author's constant superintendence.' The names mentioned include Noel Humphreys and Millais, then aged twenty-two.

He then gives an admirably clear description of the processes of chromolithography, thanks three of the lithographic artists (Francis Bedford, Sliegh and Vintner) by name, and continues: 'It was originally intended to divide the work into thirty-eight parts, each containing four plates, to be delivered to the public at intervals of a fortnight. The work was also issued in five divisions, each comprising eight parts; and, in order to render these divisions of equal extent, it was found necessary to increase the number of parts to forty, embracing, in the whole, one hundred and sixty plates. The first number appeared on the 1st of October, 1851, and the last will have been published on the 7th of March, 1853.' (The chromolithographed title-pages to both volumes are dated March 15, 1853.)

'We may add a few details of the printing-office ... The greatest number of printings for any one subject has been fourteen, and the average number seven. The edition printed has amounted to 1,300 copies. Hence, to keep pace with the demand (each colour requiring a separate impression), the printer has had to pull the work through the press no fewer than 18,000 times, on an average, per week, amounting in the whole period to 1,350,500 pulls, after every one of which the stone requires to be carefully cleaned, and the paper readjusted for "register" ... it has required 1069 stones, weighing in all about 25 tons ... the weight of paper consumed in the lithographic department has not been less than 17,400 lbs.'

The nearly three hundred and fifty pages of letterpress text were printed by George Barclay. No decorated initials or other ornamentation were used, perhaps from a commendable appreciation that the amount of decoration in the objects illustrated rendered further ornament superfluous; but the pages show no sense of typographic style at all, a pity in such a large and important book devoted to Art and Design. The text type is a modern, with a needlesssly condensed display face for the headings.

The plates nearly all carry the name of the artist who made the original drawing, as well as the lithographer, who made the colour

separations and drew them to stone (over half were lithographed by Francis Bedford). Since in the full technical description given by Digby Wyatt no mention is made of photography, it can be assumed that no use was made of it, in which case this is one of the last books of its kind entirely carried out by the craftsman's unaided hand and eye. In general, the more complicated and colourful subjects, e.g. textiles and ceramics, come out best; but nearly all the plates have a graphic quality, and a freshness of colour, which has been lost by most modern reproductive processes.

The labour of getting *The Industrial Arts* through the press in under two years is the more remarkable when we discover that another folio by Digby Wyatt was also going through Messrs Day & Son's lithographic presses at the same time: his *Metal-work and its Artistic Design*, published by Day in 1852. It contained fifty chromolithographed plates, some magnificently rich, and all lithographed by Francis Bedford, prefaced by some eighty pages of text on the theory, practice and history of metalwork: the whole was designed entirely to provide a basis for good design in the metal industries. Digby Wyatt in his Preface starts with a reference to the 'admirable, though too brief, remarks upon the subject of metalwork contained in Mr Pugin's *True Principles of Christian Architecture*' and continues: 'In acknowledging the correctness of the undeniable proposition, that every material, insomuch as it differs in organic constitution, should vary correspondingly in the form and proportion into which it should be wrought, an admission was made, that the ordinary system of copying in metal forms proper for stone, and in stone forms proper for metal, wood, &c., was as contrary to the true canons of good taste, as it was subversive of any prospect of consistent originality.'

While working on *Metal-Work* (and on the *Industrial Arts*, and being secretary of the Executive Committee of the Great Exhibition) Digby Wyatt must also have been working on Paddington Station: Brunel had offered him the commission in a letter dated January 13, 1851, in the words: '. . . Now, in this building which, *entre nous*, will be one of the largest of its class, I want to carry out, strictly and fully, all those correct notions of the use of metal which

I believe you and I share (except that I should carry them still farther than you) and I think it will be a nice opportunity.

'Are you willing to enter upon the work *professionally* in the subordinate capacity (I put it in the least attractive form at first) of my *Assistant* for the ornamental details? Having put the question in in the least elegant form, I would add that I should wish it very much . . .'[1]

The next chromolithographed folio was the masterpiece of them all: Owen Jones's *The Grammar of Ornament*, published by Day & Son in 1856.

The original edition contains one hundred folio plates (and a gothic illuminated title-page) all drawn on stone by Francis Bedford, and about one hundred and fourteen pages of text, consisting of essays on the various kinds of ornament, and references for the plates, by Owen Jones, J. O. Westwood, J. B. Waring, and Digby Wyatt. To us today, inundated with photographic references for almost every work of art or kind of decoration in the world, *The Grammar of Ornament* is still a superb picture-book: but in the 1850s it was the first time in England that anything like so many illustrations of ornament had ever been assembled in colour in one work, and certainly the first time in England that any systematic and serious reproductions in colour of historical ornament had ever been printed, apart from Owen Jones's *Alhambra*, and works by Digby Wyatt and Noel Humphreys already mentioned. The new possibilities of chromolithography in the field of art-scholarship had already been shown on the Continent – e.g. in Germany by Zahn's and Boetticher's works already mentioned, and in France by the works on the history of writing by Count Bastard (1832 onwards) and Silvestre (1841), and on the Middle Ages and Renaissance by Lacroix and Seré (1848–51); but Owen Jones's book was by far the most ambitious in scope yet attempted. His theories of ornament and design, fully expounded in the text, are too long to quote here, but a short passage from his Preface deserves remembering: 'All, therefore, that I have proposed to myself in forming

[1] Brunel's letter is quoted in full in L. T. C. Rolt's *Isambard Kingdom Brunel*, London, 1957.

the collection which I have ventured to call the *Grammar of Ornament*, has been to select a few of the most prominent types in certain styles closely connected with each other, and in which certain general laws appeared to reign independently of the individual peculiarities of each. I have ventured to hope that, in thus bringing into immediate juxtaposition the many forms of beauty which every style of ornament presents, I might aid in arresting that unfortunate tendency of our time to be content with copying, whilst the fashion lasts, the forms peculiar to any bygone age, without attempting to ascertain, generally completely ignoring, the peculiar circumstances which rendered an ornament beautiful, because it was appropriate, and which as expressive of other wants, when thus transplanted, as entirely fails.'

The *Grammar of Ornament* contains one hundred plates of ornamentation from many countries and periods. Many of the plates contain over twenty, some over sixty numbered examples. The differences in scale, in colour, and in style make the pages varied and exciting. The portrayal of detailed ornament, e.g. in an Indian rug, or a Persian tapestry, by a hand process perhaps almost as laborious as that of the original artist's, gives a keener appreciation of their true nature than is possible by screened photographic reproductions. And the texts by Owen Jones and his colleagues, in particular the thirty-seven Propositions listed in the 'General Principles in the Arrangement of Form and Colour, in Architecture and the Decorative Arts, which are advocated throughout this Work', make it a vital document in any consideration of philosophies of design in the Victorian period.

The *Grammar of Ornament*, first published in parts at 14s. during 1856, was sold in one volume at £19 12s.; by 1863 it was being 'remaindered' at £12 12s. In 1856, a 'New and Universal' edition was announced, with one hundred and twelve plates, in quarto size, to be published in thirty fortnightly parts at 3s. 6d. each, or the complete volume at £5 5s. The volume was dated 1868. Further reprints in quarto size were issued, the last being in 1910.

There were two further great works of chromolithography produced during the 'fifties, both by J. B. Waring (1823–75), an archi-

tect, a Swedenborgian, and, in his own later estimation, a prophet.

The larger (indeed one of the largest chromolitho books ever produced) was *The Arts Connected with Architecture illustrated by examples in Central Italy from the 13th to the 15th Century*, by J. B. Waring, published in 1858 by Vincent Brooks (who in 1867 amalgamated with Day & Son). The page size is $23\frac{1}{4} \times 16\frac{3}{4}$ in., so it is slightly smaller than Lewis Gruner's *Specimens of Ornamental Art*. It starts with a fine ornamental coloured title-page and contains forty-one plates with accompanying text. Waring drew all the plates himself and Vincent Brooks lithographed them. Some of the plates, e.g. of marble inlays, are in only one or two colours, and others are straightforward reproductions of patterns in flat colours, like plates in the *Grammar of Ornament*, but there are several plates of stained glass windows and frescoes which were more ambitious (since they represent depth, shadows and perspective as well as design and colour) and were perhaps the finest chromolithographed colour plates yet produced in Britain.

The second work was *Art Treasures of the United Kingdom*, edited by J. B. Waring, published also in 1858 by Day & Son: it illustrated objects in the Art Treasures Exhibition at Manchester in 1859, in the categories of Sculpture, and the Ceramic, Vitreous, Metallic, Textile and Decorative Arts. Each section was also published separately with sixteen or so coloured plates, wood-engravings and introductory essays. The page size is $15\frac{1}{4} \times 11$ in.

Nearly all the plates were lithographed by Francis Bedford, who also (as stated on the plates) used photography for some of them: that is to say, he drew from photographs. Some of the objects illustrated were both hideous and uncolourful, and it is difficult to find anything attractive in them: but some of the plates, especially in the textile section, are brilliantly colourful and exciting. The text, printed by Cox & Wyman, has no typographical attractions.

The works of chromolithography so far described were all true books, consisting of text and plates. There were also many collections of chromolithographed plates – for example, views of the Great Exhibition – published in book form but which need not be considered here, since they were not really books. In addition,

however, there were many works published during the 'fifties and
'sixties containing topographical plates, accompanied by a text,
which may be counted as books, even though the *raison d'être* of the
publication was the plates.

Normally these works were published to subscribers in fort-
nightly or monthly parts, sometimes in plain and coloured versions;
and some works, first issued in folio size, proved popular enough to
be reissued in smaller formats. A good example of this kind of work
is William Simpson's *The Seat of War in the East*. Simpson, at that
time an artist employed by Day & Son, was sent out by the Pall
Mall printsellers, Paul and Dominic Colnaghi, 'Publishers to Her
Majesty', to report the Crimean Campaign. He sent back eighty-
one sketches, which were lithographed and printed by Day & Son,
in two or three colours, and published at intervals, within a month
or so of the sketches being received. They were then issued in two
volumes, in 1855 and 1856. Some sets were hand-coloured, and the
two volumes, bound as one, were sold at £12 plain, and £20 col-
oured.[1] Simpson avoided illustrating the more gruesome aspects of
the war, but made magnificent pictures of the wild and rocky
coasts, the barren uplands, and scenes of the soldiers' lives in
trenches and redoubts, some of them grim enough. The best of
them, in the hand-coloured versions, are among the most beautiful
topographical plates of the century.[2]

Colnaghi also issued both volumes in octavo format, in the same
years as the folios, in a cloth binding designed by Digby Wyatt, at
£1 1s. each. These plates were lithographed, like the larger ones,
in two and three colours, in the 'lithotint' style.

War artists were, of course, already at this time in competition
with photographers: but no way of printing photographs direct on to
book pages had yet become commercially practicable. Roger Fen-
ton's photographs of the Crimean War, for example, were pub-
lished singly, as actual photographs, by the Manchester printseller

[1] See Abbey, *Travel*, pp. 206–209. In 1961, the two volumes, uncoloured,
could be obtained in many second-hand bookshops for £1 or £2; the coloured
version is rare and much more expensive.

[2] Some of Simpson's adventures while making the sketches are described in
The Autobiography of William Simpson, R.I., London, 1903.

Thomas Agnew. The number of prints that could be taken safely from the negatives was untruthfully said to be no more than two hundred,[1] possibly to stimulate sales. Until a satisfactory method could be found of engraving photographs or transferring them on to lithographic plates, they could be used in books only by the cumbersome method of sticking them down, a method which was, however, much used. It was introduced by Fox Talbot for his book *The Pencil of Nature*, 1844–6; and Mr Gernsheim has counted over four hundred and fifty books published between then and 1875, in Britain alone, containing real photographs pasted down. Such photographs tended to fade or be discoloured by the adhesives used. The 'Carbon', 'Autotype', 'Woodburytype', 'Heliotype' and other patents covered processes for printing photographs which would not fade, and these too were used for pasting into books.

From 1842, publishers of books and illustrated magazines frequently drew on daguerreotypes as source material for illustrations. A book in which systematic use of photography was made in the reproduction of works of art was *The Treasury of Ornamental Art*, published by Day & Son in 1856. It contains seventy-one chromo-lithographed plates (page size 10 × 7 in.) and the title-page includes the words 'Illustrations of objects of Art and Vertu photographed from the originals and drawn on stone by F. BEDFORD.' According to the Introduction, the objects were first photographed, 'the unerring fac-similes thus obtained being then copied on stone, with an amount of care and attention dictated solely by the endeavour to carry the art to its extremest limits.' The resulting chromo-lithographs do not, however, have any displeasingly mechanical look, since they were still true drawings. A similar method was used for the larger plates in the *Art Treasures of the United Kingdom*, 1858, described above.

The first book in which photographs were actually transferred on to lithographic stones (and in which the term 'photolithographs', first used in 1853,[2] occurs) seems to have been J. Pouncy's *Dorset-shire Photographically Illustrated*, containing eighty plates, pub-

[1] H. & A. Gernsheim, *Roger Fenton*, London, 1954, p. 24.
[2] See H. & A. Gernsheim, *The History of Photography*, London, 1955.

lished by Bland & Long, London, in 1857. The title-page announces 'The detail and touch of nature faithfully reproduced by a new process on stone, by which views are rendered truthful, artistic, and durable'. Despite the author's claims of fidelity and truthfulness, he has improved on the camera's eye by drawing in human figures where he thought they were lacking, with ludicrous results; but it was, technically, a step forward.

From this time on, the impact of photography can be often detected in lithographic plates. It can clearly be seen, for example, in *The Ladies' Equestrian Guide: or, the Habit and the Horse, A Treatise on Female Equitation*, by Mrs Stirling Clarke, first published by Day in 1857 and reprinted in 1860. The title-page carries the words: 'With Illustrations lithographed by Messrs Day & Son, from Photographs by Herbert Watkins'.

Of the many beautiful topographical plates produced by chromolithography during the 'fifties and 'sixties, and published in book form, yet with dubious claims to be considered as books rather than collections of plates, mention will be made of only two, as typifying the rest: Lieutenant S. Gurney Cresswell's *Sketches of the North-West Passage*, 1854, and Carlo Bossoli's *The Beautiful Scenery...of the Crimea*, 1856. Both are folios, the former containing eight, the later fifty-two plates; and both are described bibliographically in J. R. Abbey's *Travel, in Aquatint and Lithography*, London, 1956, to which the reader must in any case turn for information on topographical illustrations of the period up to 1860.

Owen Jones's next book after *The Grammar of Ornament* was an illuminated version of Thomas Moore's *Paradise and the Peri*, published by Day & Son in 1860 (pl. 36A). According to the colophon, it was illuminated by Owen Jones and Henry Warren, and drawn on stone by Albert Warren. The same team also produced *Joseph and his Brethren* in 1865 and *Scenes from the Winter's Tale* in 1866 (pl. 37), all chromolithographed by Day & Son. The books vary in page size; all consist of text, decoration and illustrations within rectangles and designed as pairs of facing pages. In all the books the text is drawn, but not in black letter. From six to thirteen colours are used on each page; the total number of colours is

greater, and many subtle colours are used, beside the normal rich reds and blues. There are many styles of ornament, from floral to geometric, but nearly all the design is formal, not naturalistic. Jones is exploiting the new medium of chromolithography to the full and, since even the text is drawn, his pages owe nothing to the traditions of book design which are based on engraving: but since the text is drawn to imitate the regularity of type, there is no obvious link with the manuscript tradition either. Here is a new conception of the Book Beautiful, which prefigures the Kelmscott openings of thirty years later. There is also, in some of the floral borders, a general resemblance to certain of William Morris's wallpaper designs. Jones had in fact, since his work on the Great Exhibition, and his designing of the Egyptian, Greek, Roman and Alhambra Courts when the Crystal Palace was moved to Sydenham, been much engaged on interior decoration, for example for Alfred Morrison (16 Carlton House Terrace and Fonthill), James Mason (Eynsham Hall,) and the Palace of the Viceroy of Egypt; and had also, from 1858 and probably earlier, designed many patterns for wallpapers, now in the Victoria and Albert Museum.

Paradise and the Peri was issued in a cloth binding blocked in gold and also in a heavily embossed leather binding like some of the previous illuminated books, at £2 12s. 6d.; the other two seem to have been published only in cloth, blocked in gold and colours.

In 1861–2 appeared, in parts, the *Victoria Psalter* (pl. 36B), so-called because Queen Victoria accepted the dedication. Owen Jones probably considered it his masterpiece. It is an illuminated edition of the Psalms, making one hundred and four pages, on fifty-three leaves, $16\frac{1}{2} \times 12\frac{1}{4}$ in. The text is set in Old Face, but where words or sentences are drawn in, a thin modern roman is used, or else gothic lettering in many fantastic variations. The letters which are drawn do not show any feeling for the letter shapes we know, and are frequently tortured into extreme illegibility.

The decorative borders, different on every page, are regular and formal like typographical borders, and achieve a certain dignity and richness; but the restricted range of colours (three shades of blue, three of red, gold and black, on a cream background) have a partic-

ularly gloomy cumulative effect. Compared with the Italian warmth
of Noel Humphreys' illuminations, these pages seem designed for
black-coated Victorians in Welsh chapels.[1]

Much more colourful was Owen Jones's tribute to the Princess
from Denmark who came over to marry Edward, Prince of Wales,
in 1863. *A Welcome to Alexandra* consists of eight leaves, chromo-
lithographed on one side only by Day & Son, illuminating a poem
by the Poet Laureate, Alfred Tennyson; and although the lettering,
partly in uncial style, with 'runic' interlacings, is in its details mostly
unpleasing, the general effect is of youth and gaiety and makes it
the most charming of all Owen Jones's illuminated books. It was
sold at 21*s*. in an exotic cloth binding of red, gold and white, the
Danish colours.

The marriage of the Prince of Wales was also celebrated by the
publication of *The Wedding at Windsor*, one of the finest chromo-
lithograph folios of the 'sixties. It consisted of a detailed text by
W. H. Russell, *The Times*' war correspondent, and forty-three plates
drawn by, or under the superintendence of, Robert Dudley,
chromolithographed by Day & Son. Some of the plates of the wed-
ding presents attain perhaps the highest point of faithful representa-
tion yet achieved by chromolithography in England; but the illus-
trations of the arrival of the Royal Yacht at the Nore, and off
Gravesend, and the processions and ceremonies in London, are
more fun. It was issued in large quarto size at £5 5*s*., and there
were two hundred and fifty large paper copies at £10 10*s*.: but the
plates in each appear to be identical.

W. H. Russell and Robert Dudley also collaborated on *The
Atlantic Telegraph*, published by Day & Son in 1866, an eye-witness
account of the laying of the first Atlantic cable by the *Great Eastern*.
With its twenty-five lithotinted plates, it is a fitting contemporary
tribute to a fine achievement. A large paper hand-coloured edition
was also published.

Owen Jones's later works included *A Sunday Book*, *c*. 1863, with
thirty-two illuminated pages, published at 5*s*., and *One Thousand*

[1] The original painted pages for this work are in the Victoria & Albert
Museum; the blues in particular are very much brighter than those printed.

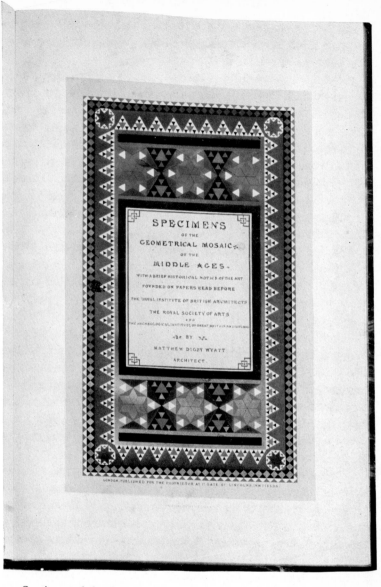

33 *Specimens of the Geometrical Mosaic of the Middle Ages*, 1848. Title-
page drawn by M. Digby Wyatt, chromolithographed in six colours
by Day & Son. $19\frac{1}{2} \times 13$ in.

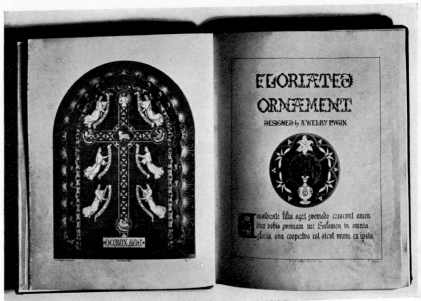

34A *Floriated Ornament*, 1849. Title-page opening with designs by A. W. Pugin, chromolithographed by M. & N. Hanhart. $12\frac{3}{4} \times 10\frac{3}{8}$ in.

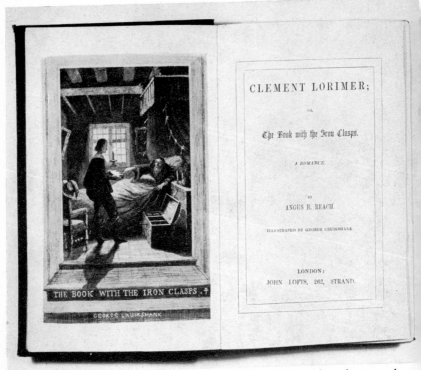

34B *Clement Lorimer*, 1849. Title-page opening: frontispiece drawn and etched by George Cruikshank. Perhaps below the norm of mid-Victorian typography, with lines of type not even parallel.

THE TASK

A POEM

BY WILLIAM COWPER.

ILLUSTRATED BY BIRKET FOSTER.

LONDON:
JAMES NISBET AND CO. BERNERS STREET.
MDCCCLV.

35 *The Task*, 1855. A carefully designed title-page, set in modern face types, with a wood engraving by Birket Foster. Printed by R. & R. Clark. 8 × 5⅝ in.

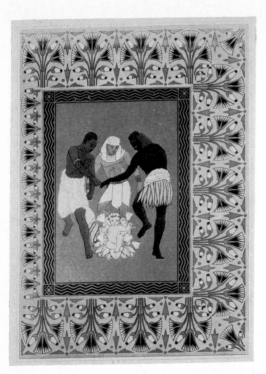

36A *Paradise and the Peri*
(1860). A page by Owen
Jones, chromolitho-
graphed in ten colours
by Day & Son. $12\frac{7}{8} \times 9\frac{1}{4}$
in.

36B The *Victoria Psalter*
(1861), drawn by Owen
Jones and chromolitho-
graphed in three reds,
three blues, gold and
black by Day & Son.
$16\frac{1}{2} \times 12\frac{1}{4}$ in.

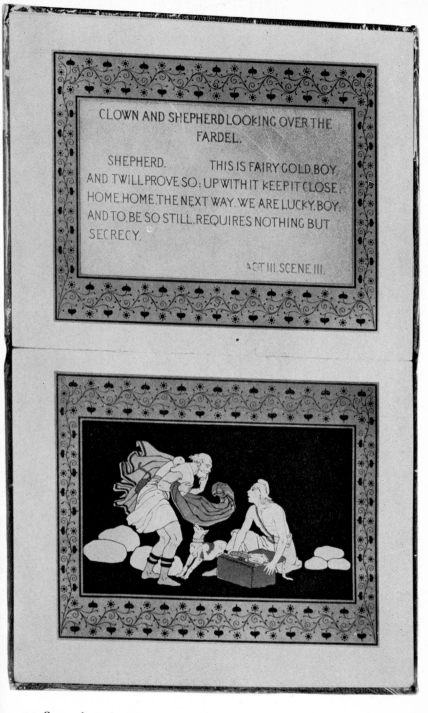

37 *Scenes from the Winter's Tale* (1866), designed by Owen Jones and chromolithographed by Day & Son in ten colours. $11\frac{1}{8} \times 8\frac{1}{2}$ in.

THE LIFE

OF

CHARLOTTE BRONTË,

AUTHOR OF
"JANE EYRE," "SHIRLEY," "VILLETTE," &c.

BY

E. C. GASKELL,

AUTHOR OF "MARY BARTON," "RUTH," &c.

"O my God,
Thou hast knowledge, only Thou,
How dreary 'tis for women to sit still
On winter nights by solitary fires
And hear the nations praising them far off."
AURORA LEIGH.

SECOND EDITION.

IN TWO VOLUMES.

VOL. I.

LONDON:
SMITH, ELDER, AND CO., 65, CORNHILL.
1857.

The right of translation is reserved.

38A *The Life of Charlotte Brontë,* 2nd edition, 1857. Haphazard typography. $7\frac{3}{4} \times 4\frac{3}{4}$ in.

THE

POETS OF THE WEST

A SELECTION OF FAVOURITE AMERICAN POEMS
WITH MEMOIRS OF THEIR AUTHORS.

ILLUSTRATED BY F. O. C. DARLEY, JASPER CROPSEY, J. M. HILL,
BIRKET FOSTER, ETC.

LONDON:
SAMPSON LOW, SON & CO. 47, LUDGATE HILL.
1859.

38B *The Poets of the West,* 1859. A good title-page, set mostly in Old Face, printed by R. Clay. $8\frac{1}{2} \times 5\frac{7}{8}$ in.

PARABLES FROM NATURE,

BY MRS. ALFRED GATTY,

AUTHOR OF " PROVERBS ILLUSTRATED," " WORLDS NOT REALIZED,"

AND " THE FAIRY GODMOTHERS."

WITH NOTES ON THE NATURAL HISTORY,

AND ILLUSTRATIONS BY C. W. COPE, R. A., H. CALDERON,

W. HOLMAN HUNT, W. MILLAIS, OTTO SPECKTER,

G. THOMAS, AND E. WARREN.

LONDON:

BELL AND DALDY, 186, FLEET STREET.

1861.

39 *Parables from Nature*, 1861. A Chiswick Press title-page in red and black. The bell was superimposed on the dolphin and anchor when George Bell took over many of Pickering's copyrights. $7\frac{5}{8} \times 5\frac{1}{8}$ in.

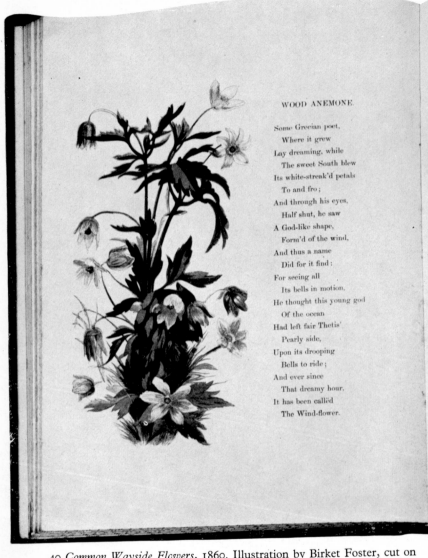

WOOD ANEMONE.

Some Grecian poet,
 Where it grew
Lay dreaming, while
 The sweet South blew
Its white-streak'd petals
 To and fro ;
And through his eyes,
 Half shut, he saw
A God-like shape,
 Form'd of the wind,
And thus a name
 Did for it find :
For seeing all
 Its bells in motion,
He thought this young god
 Of the ocean
Had left fair Thetis'
 Pearly side,
Upon its drooping
 Bells to ride ;
And ever since
 That dreamy hour,
It has been call'd
 The Wind-flower.

40 *Common Wayside Flowers*, 1860. Illustration by Birket Foster, cut on wood and printed in six or eight colours by Edmund Evans. $8\frac{5}{8} \times 6\frac{5}{8}$ in.

41A *Favourite English Poems*, 1859, edited by Joseph Cundall. Wood engraved illustrations after T. Creswick, R.A. $8\frac{3}{4} \times 6\frac{1}{4}$ in.

41B *Enoch Arden*, 1866. Wood engraved illustration after Arthur Hughes. $8\frac{5}{8} \times 6\frac{1}{2}$ in.

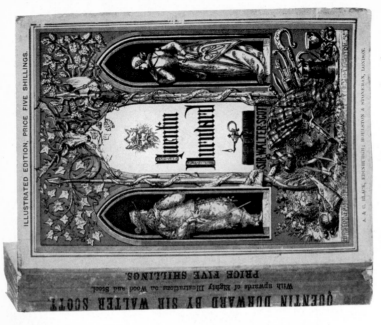

42B *Quentin Durward*, 1853. Paper on boards, cover designed by John Leighton, cut on wood by H. J. Leighton and printed in red, khaki and black. Uncoloured canvas spine. 10 × 6⅞ in. *Constance Meade Collection, Oxford.*

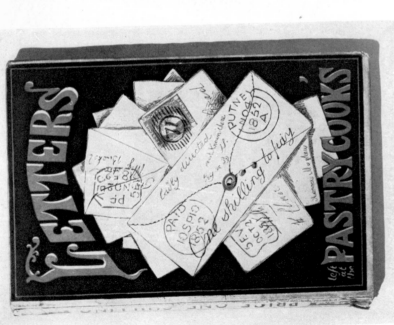

42A *Letters Left at the Pastrycook's*, 1853. Paper on boards, cover cut on wood and printed in red, blue and black by Edmund Evans. 6¾ × 4¼ in. *Constance*

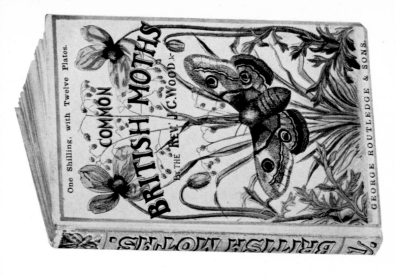

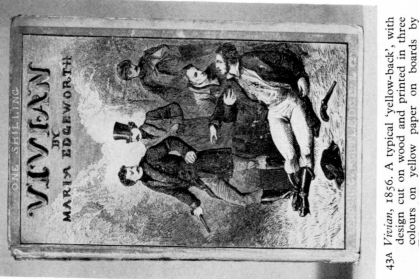

43A *Vivian*, 1856. A typical 'yellow-back', with design cut on wood and printed in three colours on yellow paper on boards by Edmund Evans. $6\frac{3}{4} \times 4\frac{1}{4}$ in. *British Museum*.

43B *The Common Moths of England, c.* 1870. Paper on boards, design cut on wood and printed in red, green and black by Edmund Evans. $6\frac{1}{2} \times 4$ in.

44 *The Poems of Oliver Goldsmith*, 1859. Illustration by Birket Foster, decorative lettering by H. Noel Humphreys, engraved on wood and printed in colours by Edmund Evans. 8¾ × 6¼ in.

45 *Odes and Sonnets*, 1859. A page designed by John Sliegh, engraved on wood and printed in two blues, green, pink, and red by the Dalziels at their Camden Press. $8\frac{1}{2} \times 5\frac{7}{8}$ in.

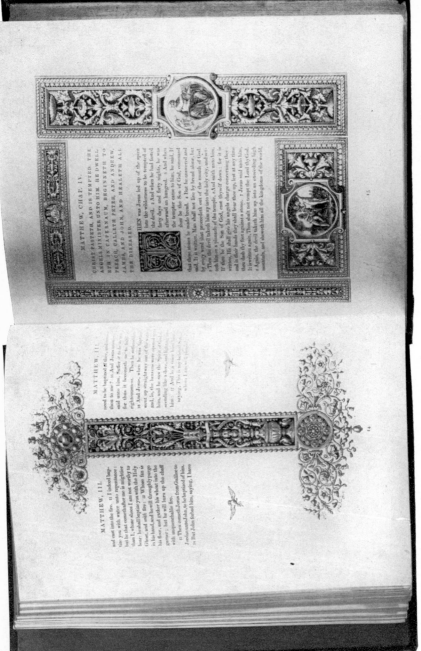

46 *The New Testament*, 1865. Decorations adapted from MSS. and drawn on wood by Henry Shaw. Printed by R. Clay. 9¼ × 7¾ in.

47 *The Children's Friend*, Sept. 1, 1865. Left-hand page designed on wood by T. Macquoid, right-hand reprinted from one of the borders by H. Noel Humphreys in *The Poets' Pleasaunce*, 1847. 8⅛ × 6¼ in.

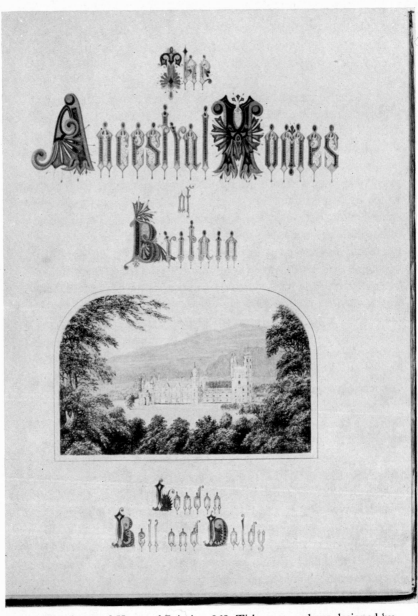

48 *The Ancestral Homes of Britain*, 1868. Title-page perhaps designed by A. F. Lydon, engraved on wood and printed in about eight colours by Benjamin Fawcett. $10\frac{3}{4} \times 8\frac{1}{2}$ in.

and One Initial Letters and 702 *Monograms*, both published in 1864. The *Initial Letters* were mostly, if not all, taken from the *Victoria Psalter* and were, it is to be feared, much copied by amateur illuminators.

Jones made some binding designs for books which he did not illustrate, including *A Treasury of Pleasure Books for Young Children*, published by Grant & Griffith and Joseph Cundall, 1850 (for which he also designed endpapers), and Birket Foster's *Pictures of English Landscape* published by Routledge in 1862 (pl. 58B). The twenty-three or so books which he himself designed, and others which he helped illuminate or print in colours, are a formidable achievement, both artistically and technically. In the application of decoration to books, he was a forerunner of William Morris; yet he gives no sign, in any of his pages, that he really cared for literature.

The uses of chromolithography to art-scholarship were shown by two volumes published in England during the 'sixties: the first was *Byzantine Architecture*, by Texier and Pullan, published by Day & Son in 1864 at six guineas. The page size was $16\frac{5}{8} \times 11\frac{3}{8}$ in., and the work included seventy plates, of which the majority are views, plans or details lithographed in two colours, with no apparent use of photography; there are also thirteen plates of mosaics or frescoes chromolithographed in up to ten or more colours.

The second work was J. O. Westwood's *Facsimiles of the Miniatures & Ornaments of Anglo-Saxon & Irish Manuscripts*, published by Day & Son, in an edition of two hundred copies only, in 1868. The page size was $22\frac{1}{2} \times 14\frac{5}{8}$ in. and there were fifty-four plates, drawn on stone by W. R. Tymms from Westwood's original copies. These include four pages from the Book of Kells, of which Digby Wyatt is recorded in the Introduction as saying ' . . . some of the ornaments of which I attempted to copy, but broke down in despair. Of this very work, Mr Westwood examined the pages as I did, for hours together, without ever detecting a false line or irregular interlacement.' The chromolithographs, many of which are in twelve and more colours, are rich and pleasing, but cannot be accepted as reliable facsimiles. Drawing is inaccurate and colouring is in some plates too garish, in other, not nearly as bright as

H

the originals. The chromolithographs made nearly forty years later by William Griggs, sometimes from the same originals, are very much better.[1]

None of the later illuminated books produced by Day & Son are equal to the works of Owen Jones and Noel Humphreys, but they are all of considerable interest. One of the biggest was *The Sermon on the Mount*, 1861, illuminated by two Liverpool architects, W. and G. Audsley, and chromolithographed for Day & Son by W. R. Tymms. It consists of twenty-seven leaves, 22 × 17 in., and sold at £8.8s. The decoration is mostly floral, but also partly calligraphic and geometric: the pages are much more colourful than Owen Jones's, but less disciplined. The size of this book alone is enough to make it one of the outstanding monuments to the Victorian passion for illumination. A smaller version, in royal quarto size, and in a polychromatic binding, was produced subsequently. In 1861 the Audsleys also produced a small *Guide to the Art of Illuminating*, with four chromolithograph plates, published by George Rowney; by 1868 it had reached its twelfth edition. In 1865, Day & Son issued an illuminated edition of Byron's *The Prisoner of Chillon*, by the Audsleys, richly polychromatic, and richly muddled in its mixture of decorative styles, the total effect being most attractive. As in *The Sermon on the Mount*, all the pages are right-hand only: the conception of a book being made up of pairs of pages is ignored.

The Audsleys' next book was *Polychromatic Decoration as applied to Buildings in the Medieval Styles*, published by Sotheran in 1882, with thirty-six extremely fine plates chromolithographed by Firmin-Didot in Paris. George Audsley had been co-author, with J. L. Bowes, of *Keramic Art of Japan*, 1875, containing some remarkable colour plates also printed by Firmin-Didot, and author of *The Ornamental Arts of Japan*, 1882–4, two folio volumes with chromolitho plates by Lemercier which may, as part of the general revival of interest in Japanese art at that time, have given some inspiration to the first production of *The Mikado* in 1885.

[1] In George F. Warner's *Illuminated Manuscripts in the British Museum*, London, 1902–3.

Audsley's *The Art of Lithography*, 1883, is nothing more than a very short historical and technical essay, preceding the progressive proofs of a chromolithograph in twenty-two colours printed by Lemercier of Paris.

The Audsleys' last work was a portfolio of one hundred chromolitho plates, printed by Firmin-Didot, called *The Practical Decorator and Ornamentist*, published by Blackie in 1892: it was an extension of their *Polychromatic Decoration* and very similar in style to Christopher Dresser's *Studies in Design* which Cassell had published with sixty colour plates in 1874–6.

Several works published by Day & Son were illuminated by women. These included Mrs H. A. Hoskyns Abrahall, who illuminated *English Minstrelsy* and *The Songs of Shakespeare*, which, it was claimed, sold over 1,300 copies; Mrs W. H. Hartley, whose *The May Queen* appeared in 1861; and Helen Baker, who illuminated *The Better Land*, 1867. In a higher category is Louisa Anne Meredith's *Some of my Bush Friends in Tasmania*, published by Day & Son in 1860: it contains eleven large chromolithograph plates of Tasmanian flowers, berries and insects, and some delicately drawn monochrome borders, also lithographed: the text is printed from type. Both drawing and printing combine to make a very handsome book, published at only 21s.

Another large book with chromolitho plates of unusual merit was *Shakespeare's Songs and Sonnets*, illustrated by John Gilbert and published by Sampson Low in 1862. This book, edited and probably designed by Joseph Cundall, is described on p. 114 (Chapter 13).

Walter Severn's *The Golden Calendar*, published by Day & Son in late 1863 or 1864, contains twelve plates of the months in which chromolithography, etching and letterpress type all appear together, a *tour de force* which is surprisingly successful. The page is $14\frac{1}{4} \times 10\frac{7}{8}$ in., and chromolithographed arrangements of the month's flowers are cut away to reveal etched scenes. This book, issued at £2 2s., appeared in a binding in which gold blocking is combined with inlays of chromolithography on paper.

The Promises of Jesus Christ, illuminated by Owen Jones's assistant, Albert Warren (Day & Son, 1866), is very much in the

Owen Jones style, but has a pleasantly individual binding design (pl. 56A): Albert Warren specialized in bindings and many signed by him have been identified.[1]

A series of illuminated books with a character of their own, and almost the only series not printed and published by Day & Son, were those illuminated by Samuel Stanesby. He produced at least eleven between 1857 and 1865, published by Griffith & Farran, and mostly chromolithographed by Ashbee & Dangerfield. They were small books with every page chromolithographed, and highly decorated bindings. Some title-pages or frontispieces (e.g. *The Bridal Souvenir*, 1857, *Shakespeare's Household Words*, 1859, and *The Wisdom of Solomon*, 1861) contained pasted-down photographs in the middle of chromolitho decoration.

The market for illuminated books printed by chromolithography was now having to face competition from the wood-engravers: the majority of artists seem in fact to have preferred that medium. Chromolithography sales dwindled; and in 1868 the firm of Day & Son was wound up. The goodwill was taken over by Vincent Brooks, who continued to run the business as 'Vincent Brooks, Day & Son'. In the 1870s, developments in cylinder litho printing (and the extension of photographic methods) revolutionized the process.

To describe adequately the progress of chromolithography on the Continent and in the United States during this period would require, and certainly deserves, a separate volume. Chromolithographs by Winckelmann of Berlin and The Imperial Printing Office of Vienna were awarded Prize Medals at the Great Exhibition of 1851. Engelmann of Paris also exhibited chromolithography but received no award. Some pages of Count Bastard's great work on manuscripts, mentioned above, were exhibited and much admired, but were inadmissible for award (and strictly, according to the Report, for the Exhibition) because they were largely finished by hand.

[1] See Sybille Pantazzi, 'Four Designers of English Publishers' Bindings, etc.' in The Papers of the Bibliographical Society of America, vol. 55, 2nd quarter, 1961, who lists 11; the author has since seen a further 13.

The praise given to the Imperial Austrian Printing Office's chromolithography by A. Firmin-Didot, the eminent French typographer, and Joint Reporter (with Charles Whittingham) on the 1851 Jury in Class XVII, caused some heart-searching in Paris: one of the results was *Les Arts Somptuaires*, published in two volumes of text and plates in 1858 by Hangard-Maugé, a chromolithographer who had set himself the goal of producing a work to surpass the Austrians' best. *Les Arts Somptuaires* contains three hundred and twenty-four plates of superb quality, representing medieval art of every kind, many in from fifteen to eighteen colours. Notable chromolithography by Hangard-Maugé also appeared in *Catacombes de Rome*, 6 volumes, Paris, 1851; *Monographie de la Cathédrale de Chartres*, Paris, 1856; and *Historie de l'Art Egyptien*, 3 volumes, Paris 1878.

Another masterpiece of French chromolithography of this period is *L'Imitation de Jesus-Christ*, published by Curmer in 1856 and printed by Lemercier, in which over four hundred pages are decorated in almost every known style of ornamentation in up to fourteen colours.

But probably the finest work of all at this time was being produced by Engelmann & Graf, to whom the most scholarly illustrations seem to have been entrusted. Examples of this firm's work of outstanding beauty are the colour plates in *Statuts de L' Ordre du Saint-Esprit*, 1853; *L'Architecture du V au XVII Siècle*, 1858; and *Paroissien Romain*, n.d., a Breviary, mostly illustrated with woodcuts in the style of the fifteenth century, but with nine colour plates of a quality which seems to surpass, in lithographic technique, anything comparable ever produced in Great Britain. The blending of the colours is so complete that it is virtually impossible to distinguish the number of printings.

The mechanical perfection which chromolithography, as a reproductive art, finally attained in France, can be studied in the books by George Audsley mentioned above, with plates by Firmin-Didot and Lemercier; the work in England of William Griggs at the turn of the century was also outstanding.

The progress of chromolithography in America awaits its own

historian. It was often introduced into individual towns by crafts-men who had emigrated from Europe. Philadelphia seems to have been the earliest place to encourage the new art. An annual gift book, *Leaflets of Memory*, published by E. H. Butler & Co. of Philadelphia, was using printed colour, as well as hand-colouring, from 1844 onwards. The annuals for 1849 and 1850 each contain four decorative pages designed by Devereux, drawn on stone by Dreser, and chromolithographed by T. Sinclair in at least eight colours, of a quality equal to the very best work then being produced in Europe. T. Sinclair also printed some fine chromolithographed designs by M. Schmitz for *Illuminated Gems of Sacred Poetry*, published in Philadelphia by Lindsay & Blakiston (n.d.). Another chromolithographer, Max Rosenthal, is said to have come to Philadelphia in 1849; and chromolithography by P. Duval was used in *A New Universal Atlas . . . of the World*, published by T. Cowperthwait & Co., Philadelphia, 1853. *Godey's Lady's Book* was also published in Philadelphia and, around 1851, was importing illuminated pages, printed from wood blocks, from B. Dondorf in Frankfurt-am-Main.

In the second half of the century, an important lithographic business was established in Boston by Louis Prang, who emigrated from Germany in 1850. He specialized in Christmas cards, in which trade he became a rival of Raphael Tuck and De La Rue in England[1]; he also published *Parallel of Historical Ornament*, *c.* 1864–7, a series of folio cards similar to Owen Jones's *Grammar of Ornament*.

[1] See G. Buday, *The History of the Christmas Card*, London, 1954.

Letterpress printing
and yellow-backs

THE CHIEF new feature of the 'fifties in British book design was the 'yellow-back' or 'mustard-plaster' novel, and other series of cheap books, both fiction and non-fiction, sold in wrappers or paper boards. By making books attractive and cheap, publishers discovered a vast new reading public – to which both the spread of education, and of the railways, contributed. Publishers found a great new outlet when W. H. Smith's first railway bookstall was established at Euston on November 1, 1848.

The first railway novels were actually the 'Parlour Novelist' series, and were started by Simms & McIntyre in Belfast in 1846, as described in Chapter 3. The following year the same publishers were offering the Parlour Library at the unheard of price of 1s. in paper boards, or, a little later, 1s. 6d. in cloth. Their initiative, and the good taste with which the books were produced, were richly rewarded. George Routledge (1812–88) was first off the mark among the London publishers and started his Railway Library in 1849, directly imitating the Parlour Library in both design and price. This venture, too, was enormously successful, and by 1898 had issued one thousand three hundred titles. The profits are indicated by the fact that in 1853 Routledge contracted to pay Bulwer-Lytton £2,000 a year for ten years' rights to reprint his works, and at the end of ten years was ready to renew the contract.

The early wrapped or paper-board series usually had a standard decorative border or all-over design, with the title and author dropped in, in type. Most of these were remarkably well designed, sophisticated, and expensive-looking (pl. 13); several are illustrated in *XIX Century Fiction*, volume 2, pls. 1, 6, 7, 14 and 15. The

quality of the printing inside could not be high: cheapness was all.

Yellow-backs were totally different: they were pictorial, and much more vulgar. The style seems to have originated in the office of the wood-engraver and printer Edmund Evans (1826–1905), whose career is described in Chapter 15. In 1853 he was given a cover design to cut on wood and print for the publishers Ingram, Cooke & Co. The book was Mayhew's *Letters Left at the Pastry Cook's* (pl. 42A) and the design, extremely undistinguished, was in blue and red on white paper. The suggestion was made that a coloured paper would be preferable and when a yellow glazed paper was used by Evans, the practice soon became universal. Evans became the chief wood block colour printer in London and a high proportion of this work came to him; he frequently found himself engraving and printing rival covers of the same title for competing publishers. He has recorded that the drawings for yellow-back covers were supplied by nearly all the popular artists of the day, for example Birket Foster, John Gilbert, 'Phiz', George Cruikshank, Harrison Weir, Kenny Meadows, John Absolon, W. S. Coleman, Charles Keene, F. S. Skill, Albert H. Warren, Charles H. Bennett, Walter Crane, A. W. Cooper, D. H. Friston, E. H. Corbould, William McConnell, Matt Stretch, W. Rainey, A. Chantry Corbould, R. Caldecott, John Sturges and many others; and that his own (Evans's) job was to convert a monochrome drawing into a three-colour job by selecting and cutting areas for printing in red and blue over the black – 'The Red being engraved in gradation to get the light tints, such as faces, hands, etc; the Blue block being engraved to get the best result of texture, patterns or sky, and the blue being crossed over the red to get good effects of light and shade. There were generally only three printings used – Black, Blue and Red, or Black, Green and Red; the very most was made of each block by engraving, so as to get the best result for the money.'[1]

The idea of using yellow glazed paper for book covers was not in any case a new one: it had been used for novels by Simms & McIn-

[1] E. Evans in his unpublished autobiography.

tyre, e.g. for *The Black Prophet*, by W. Carleton, 1847, overprinted with a strikingly handsome design in red and gold (illustrated in *XIX Century Fiction*, volume 1, no. 495b, pl. 8), and for *The Poets' Pleasaunce*, Longman, 1847 (see pp. 73, 150 and pl. 29). Yellow paper had also been used for the covers of novels and other works issued in parts.

But the pictorial yellow-backs became something quite new and characteristic of Victorian books from the mid 1850s until almost the end of the century. Most yellow-backs are surprisingly poor in design, particularly with regard to their lettering. The excellent wood letter then available was hardly used; the decorative types and rich 'fairground' lettering which were exploited on children's Toy Books and on some magazine covers, such as *The Illustrated London Almanac*, in the 1860s, are hardly ever seen on yellow-backs. Edmund Evans's own file of proofs, of over five hundred book covers, is preserved in the Constance Meade Collection in the University Press at Oxford; there are also illustrations and much information on yellow-backs in Sadleir's invaluable *XIX Century Fiction*.

In 1854 William Pickering died – a bankrupt through having lent all his money to back a friend's business venture which failed. Through the strenuous efforts of his other friends, especially Charles Whittingham, all the creditors were paid in full. The Aldine and other series were acquired by Bell & Daldy, who incorporated the Anchor and Dolphin sign with their Bell. William Pickering's son, Basil Montague Pickering, set up on his own as bookseller and publisher and continued the association with the Chiswick Press, who printed, for example, a most beautiful Catalogue for him in 1858. He died in 1878.

An event of purely typographic interest was the cutting of the face known as 'Basle Roman', for Charles Whittingham: its first use in a book appears to have been in a volume of religious verse called *The Wife's Manual*, by the Rev. William Calvert in 1854.[1] It is based on the kind of roman used in the early sixteenth century by Froben, Erasmus's friend and printer, at Basle: since it was not

[1] A. F. Johnson, *Type Designs*, second edn, 1959, p. 83.

used for historical reprints, its exact purpose in the 1850s is obscure, since it was surely too mannered for Whittingham to hope to find many customers for it. It was used for odd books like *Goethe in Strasbourg*, a 'dramatic nouvelette' by Henry Noel Humphreys, published by Saunders, Otley & Co. in 1860; later it attracted the eye of William Morris, who used it for *A Tale of the House of the Wolfings*, 1889, and *The Roots of the Mountains*, 1890. It seems to have been cut in only one size, 10/11 pt, with no italic.

In 1860 Charles Whittingham retired from business, leaving the Chiswick Press in the hands of John Wilkins, who had been his first apprentice, his overseer, and now his partner. The imprint 'Whittingham & Wilkins' continued from 1860 to Wilkins' death in 1869. Charles Whittingham then formed a partnership with B. F. Stevens and John Wilkins' son: on April 21, 1876, he died, and was buried in Kensal Green close to Pickering. The Chiswick Press (which continued in business until 1962) was then acquired by George Bell, the publisher, and came in 1885 under the able management of Charles Jacobi.

It is probably true that after the death of Pickering and the retirement of Whittingham, no new ideas in book design came from the Chiswick Press: but it continued to function admirably on the supplies of know-how and decorative wood blocks built up in earlier days. Good examples of its style in the 'sixties are the catalogues produced for the South Kensington Museum, for example J. C. Robinson's *Italian Sculpture of the Middle Ages*, 1862. The title-page in particular is a demonstration of basic typographic style, but no other printer in the country could have emulated it at that time. A liberal use of Chiswick Press initials and head and tail pieces enlivens the text, in which the old-fashioned 'f' for 's' is retained.

Chiswick Press tailpiece incorporating the initials of Whittingham and Wilkins.

Italian Sculpture of the Middle Ages and Period of the Revival of Art.

A DESCRIPTIVE CATALOGUE *of the Works forming the above Section of the Museum, with additional Illustrative Notices.*

BY

J. C. ROBINSON, F.S.A.

MEMBER OF THE ACADEMY OF FINE ARTS OF FLORENCE, AND OF ST. LUKE AT
ROME, ETC.; SUPERINTENDENT OF THE ART COLLECTIONS
OF THE SOUTH KENSINGTON MUSEUM.

Published for the Science and Art Department of the Committee of Council on Education.

LONDON:
CHAPMAN AND HALL, 193, PICCADILLY.
1862.

A Chiswick Press title-page of 1862 (*reduced*).

13
Joseph Cundall, publisher and book designer

AFTER PICKERING, the publisher with the most devoted concern for book design in mid-nineteenth century England was Joseph Cundall. His career is particularly hard to follow, since he worked a great deal on his own, as a sort of freelance behind the scenes, and many books which he edited and designed bear other publishers' imprints.

As described in Chapter 6, Cundall became publisher of Henry Cole's Home Treasury in 1843, at the age of twenty-five, and continued as a publisher on his own account at 12 Old Bond Street[1] until 1849. Besides children's books, he published 'art' books, a phrase which then implied books containing examples of art or intended to be works of art themselves, such as illuminated books. He used about a dozen printers, but the majority of his books were printed by Charles Whittingham. Some were published jointly with Pickering and other publishers (e.g. Henry Cole's *Durer's Passion*, 1844, pl. 7A).

Among the few general books he published were *The History and Antiquities of Foulsham, in Norfolk*, 1842, by the Rev. Thomas Quarles (perhaps undertaken by Cundall because he was himself a Norfolk man, and, one hopes, at the expense of the author). The book carries at the back the lists of Tilt and Bogue, for whom Cundall had worked, and also of James Burns, one of the few other publishers whose books were always well printed. Two illustrated books, which might have been intended for both children and

[1] His first child, Sarah Maria, was born at 12 Old Bond Street on February 25, 1846, but his second child, Joseph Henry, to whom Henry Cole was godfather, was born at 12 Camden Cottages in May, 1847, according to Cundall's entries in a family Bible now in the possession of Mrs Beatrice M. Cundall.

adults, were *Village Tales from the Black Forest* by Berthold Auerbach, 1846, and *Village Tales from Alsatia*, by A. Weill, 1848. Cundall's first illuminated book seems to have been *A Booke of Christmas Carols* [n.d., 1845], with borders drawn and lithographed by John Brandard after illuminated MSS in the British Museum and printed by Hanhart; the text was printed by Whittingham (pl. 8). It appeared in an elaborate embossed and colour-printed paper binding, in the French style, and in embossed red leather. Cundall also published a small illuminated edition of *The Creed, the Lord's Prayer and the Ten Commandments*, chromolithographed by F. Dangerfield, and *Words of Truth and Wisdom*, also chromolithographed by Dangerfield, both in 1848.

Cundall at this time acted as publisher for the Etching Club, and produced several handsome volumes for them. These included a folio edition of Gray's *Elegy* in 1847, and *L'Allegro* in 1849, in which the text was printed by Whittingham on the same thin sheets as the etchings (beautifully printed by Gad & Keningale), which were then pasted down on heavy card pages. Other Etching Club titles included *Etch'd Thoughts*, *The Deserted Village*, and *The Songs of Shakespeare*.

In 1849 appeared the first book edited, and presumably designed, by Cundall, but published by someone else. This was *Songs, Madrigals and Sonnets* (see p. 51 and pl. II) printed in colour by Whittingham and Gregory, Collins & Reynolds, and published by Longman. Cundall probably proposed this book to Longman, and was due to receive a quarter share in the profits, but, as shown in Chapter 7, p. 51, there were none.

In 1849, Cundall moved to 21 Old Bond Street and into partnership with Addey; they seem to have been principally children's book publishers. The bankruptcy sufferred by Cundall about this time is mentioned in Chapter 6. In 1851 they published *The Story of Jack and the Giants*, illustrated by Dicky Doyle, for the wood-engraving firm of the Dalziels, who had commissioned the illustrations. In 1851, Cundall & Addey exhibited examples of books and colour printing at the Great Exhibition, and bindings for some of their books by Hayday were awarded a medal. An illuminated book

published by them in 1851 was *The Church Catechism*, with twelve plates lithographed by Leighton Brothers (one of their few essays in chromolithography) and text printed by Whittingham.

In 1852 Cundall removed to 168 New Bond Street, where he remained until 1868. In 1852, Addey & Co. ('late Cundall & Addey') published *The Village Queen*, by T. Miller, a thin quarto with four very good colour plates, probably printed from wood by Leighton: a book presumably initiated by Cundall. Addey & Co.'s imprint occurs at least until 1854.

At 168 New Bond Street, Cundall entered the photographic business, while also continuing as an editor, author, publisher and book-producer. He had already in 1847 become a founder-member of the Photographic Club,[1] and in 1853 became a founder-member of the Photographic Society, now the Royal Photographic Society of Great Britain. At Cundall's new premises, named 'The Photographic Institution', the second photographic exhibition ever held in Great Britain was arranged by Philip H. Delamotte, whose manual, *The Practice of Photography*, was published by Cundall in 1853. Cundall himself wrote and published in 1854 a small thirty-two page instruction book, *The Photographic Primer*, bound in yellow paper with an elaborate design printed in red from a woodcut by John Leighton, and containing a remarkable frontispiece described as 'A Facsimile of a Photographic Picture of Birds, showing the Difference of Tone produced by various Colours': it is in fact a Leighton Brothers woodcut, printed in several tones of brown, and embossed.[2]

One of the few books with Cundall's own photographs, published in 1854 at the Photographic Institution, was *Twenty Views in Gloucestershire, photographed by Joseph Cundall*, in folio size. Another was *A Photographic Tour among the Abbeys of Yorkshire*, by P. H. Delamotte & J. Cundall, folio, Bell & Daldy, 1859.

During the 1850s, as described in Chapter 11, p. 93, many books published in Britain contained original photographs pasted

[1] For information on Cundall as a photographer I am very grateful to Mr Helmut Gernsheim.

[2] There are copies in the British Museum and St Bride's Printing Libraries.

IVA Opening from *The Poets of the Woods*, 1853, edited by Joseph Cundall. Letterpress printed by the Chiswick Press, illustrations by J. Wolf, chromo-lithographed by M. & N. Hanhart. 9⅞ in. x 7 in.

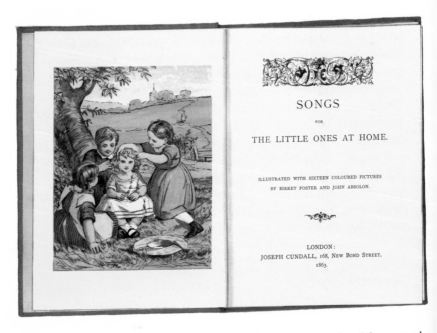

IVB Title-page of 1863. The illustration by J. Absolon was printed from wood blocks by Edmund Evans: the letterpress by Richard Clay. 7⅜ in. x 5¼ in.

in as illustrations. Such books included editions of the poets, in the elaborate gift-book bindings of the 'sixties; but, as far as I know, Cundall never used photographs to illustrate his literary gift-books. One of Cundall's clients at 168 New Bond Street was 'Lewis Carroll', the author of *Alice*, who entrusted Cundall with the printing of many of his negatives.[1]

In the 1850s, the business was trading as Cundall, Howlett & Co. (Robert Howlett took the famous photograph of Brunel in front of the *Great Eastern*'s launching chains, and the photographs used for Frith's painting *Derby Day*), then Cundall, Howlett & Downes, then Cundall, Downes & Co.; and later it changed again to Cundall & Fleming,[2] but details of the business are lacking. Books with pasted-down 'Autotypes' (a kind of printed photograph, which was non-fading) supplied by Cundall & Fleming were published in 1868 and 1870.

How much time Cundall devoted to photography is not clear, but he continued a very considerable literary and publishing activity, some of which was anonymous. From 1850, for example, he was compiling and editing 'Little Mary's Books', a sixpenny paper-covered series published by David Bogue: Cundall's initials appear after the forewords of some of the titles. From 1852 to 1854 he edited and published a children's monthly periodical, *The Charm*, which consisted of straightforward text and wood-engraved illustrations, without colour; and from time to time he published small books for children, such as Amy Meadows' *Happy Days of Childhood*, 1854, with illustrations by Harrison Weir and Birket Foster, and *Songs for the Little Ones*, 1863, with illustrations after B. Foster and Absolon printed in colour by Edmund Evans (pl. IVB).

Most of Cundall's work, however, was in the field of illustrated gift books for adults. It can be inferred that Cundall was a craftsman who preferred to do his work as a creator of books himself, rather than employ others to do so, and therefore remained in a small way of business: he would mostly find other publishers to

[1] H. Gernsheim, *Lewis Carroll, Photographer*, London, 1949.
[2] The Chiswick Press ledgers show that this partnership was dissolved in 1872, at which date Cundall moved to Barneil, Berrylands, Surbiton Hill (BM Add. MS.41936 p. 30).

finance his propositions and would work for a share of the profits. His closest connection seems to have been with Sampson Low,[1] but between 1853 and 1867 he also edited and produced books for George Bell, Thomas Bosworth, Bell & Daldy, David Bogue, George Routledge, William Kent, and Ward, Lock.

A few of these books bear Cundall's name on the title-page, with the name of another publisher, usually Sampson Low; others carry his initials at the end of a foreword, or his monogram (designed by W. Harry Rogers, see p. 117) on the verso of the title-page; others, e.g. *The Poetical Works of Edgar Allan Poe*, Sampson Low, 1858, carry the legend 'Under the superintendence of J O S E P H C U N-D A L L' at the end of the list of illustrations, which may mean that in this case he was merely paid to commission the illustrators and engravers. He is also thanked in the Preface of *Two Centuries of Song*, Sampson Low, 1867, for his help in art-editing this book – for which Henry Shaw was commissioned to draw decorations and borders.

Three of the earliest contain no mention of Cundall at all, but are identified as his work in *Sabbath Bells*, 1856. These are *Poetry of the Year*, 1853, *The Poets of the Woods*, 1853, and *Feathered Favourites*, 1854: their existence makes it tempting to assign other unidentified but attractive books in similar vein to his hand. Cundall's son Herbert Minton Cundall, in his *Birket Foster*, 1906, lists some half a dozen further titles, illustrated by Birket Foster, which he says were supervised by his father, but bibliographical mistakes in this work make it not wholly reliable.

All these books are illustrated and, in most of them, the illustrations and decorations are the *raison d'être* of the book. They are all well above the general level of gift book design of the period, but there is no close uniformity of style. It can be inferred that Cundall chose Old Face when he could obtain it, and knew how it should be used. Nearly all the books look as if they have been designed, although it is impossible to know how much; the well-arranged

[1] 'He assisted us in bringing out many of the finely illustrated works for which our house has been well known. I am glad to recall his name and cheerful presence ...' E. Marston (Sampson Low's partner) in *After Work*, London, 1904.

title-pages in books printed by Richard Clay, for example, may be due to Cundall or to the taste of the printer. There are books printed by Clay with good title-pages, in which there is no reason to suppose Cundall had any hand.

It is a creative act, however, to go to a good printer rather than a poor one, and Cundall obviously chose the best printers when he could.

It can also be inferred that Cundall believed in colour: he produced at least eight ambitious colour-printed gift books in nine years, on top of all his other activities.

Of these, *Poetry of the Year*, *Sabbath Bells*, *Poems of Oliver Goldsmith*, *A Book of Favourite Modern Ballads*, and *Shakespeare's Songs and Sonnets*, are outstanding among all the gift books produced in Britain during the period. *Poetry of the Year*, 1853, is an anthology of seasonal verse, illustrated with twenty-two half-page chromolithographs, printed by Hanhart and Day, pasted down on the type pages: the colour plates are after paintings by contemporary artists including Birket Foster, T. Creswick, David Cox and Harrison Weir, and it is the earliest book I can recall in which chromolithography is used to reproduce paintings for book illustration. It was later reprinted, with an additional chromolitho title-page by Vincent Brooks, for Charles Griffin.

In 1853 there appeared *The Poets of the Woods* (pls. IVA, VIIIA), in emerald green cloth (a characteristic cloth of that period) published by Thomas Bosworth. It was an anthology of poems, printed by Charles Whittingham, with twelve delicate circular chromolithographs of birds by Hanhart, after water-colours by Joseph Wolf, mounted in gold borders. There is no mention of Cundall anywhere, but *Sabbath Bells*, 1856, contains Cundall's monogram and a note saying that its Poems have been selected by the Editor of 'The Poetry of the Year' and 'The Poets of the Woods'. In 1854, Bosworth published *Feathered Favourites*, also in green cloth and in every way uniform with *The Poets of the Woods*.

In 1855, there appeared *Examples of Ornament*, edited by Joseph Cundall, and published by Bell & Daldy, a small folio containing twenty-four plates, of which six are chromolithographed by Francis

Bedford, and printed by Day & Son; the book is a foretaste in miniature of Owen Jones's *Grammar of Ornament*, 1856, and a sign of the interest in the various historic styles of ornament exploited at the Great Exhibition and its re-incarnation at Sydenham. The plain typographic title-page is set in Modern and, although printed by G. Barclay, would not have disgraced the Chiswick Press.

Sabbath Bells, 1856, with Cundall's monogram on the verso of the title-page, was Edmund Evans's first book with illustrations engraved and printed by him in full colour (after Birket Foster's drawings): with the Chiswick Press initials (hand-coloured) it is a very pretty book indeed (pl. V). It is described in Chapter 13. A later edition bears Cundall's own imprint.

The Poems of Oliver Goldsmith, 1859, shows Edmund Evans's colour printing of Birket Foster at its best, and also has a large number of delicate two-colour decorations by Henry Noel Humphreys. There is no mention of Cundall in the book, but his son says it was produced by him, in *Birket Foster*, 1906. A second edition appeared in 1860 with additional colour engravings, including one of Goldsmith's tomb at the end of the Preface. This book is still fairly easy to find and, in good condition, is one of the gems of Victorian book production (pl. 44).

Favourite Modern Ballads, 1860 (pl. VI) is the third of Evans's early colour printing masterpieces. (A fourth, *Common Wayside Flowers*, also illustrated by Birket Foster, and in a superbly decorated and elaborate binding, also appeared in 1860, and is one of those which one would like to link with Cundall, but there is no evidence.) It contained about fifty colour engravings after various artists including Birket Foster, C. W. Cope, William Harvey and Samuel Palmer, mostly in much larger sizes than the Goldsmith illustrations, and not always so delicate; it also contained decorations by Albert Warren. The Preface is signed 'J. C.' This book is for some reason now rare. Further details about it, and the other books printed in colour by Evans, are given in Chapter 15.

Shakespeare's Songs and Sonnets, 1862, is quite different from the others, being a thin folio, with ten chromolitho reproductions, by Vincent Brooks, of water-colours by John Gilbert. The colour

SABBATH BELLS

CHIMED BY THE POETS.

"Sundays observe: think when the Bells do chime,
'Tis Angels' music." GEORGE HERBERT.

ILLUSTRATED BY BIRKET FOSTER.

LONDON:
BELL AND DALDY, 186, FLEET STREET.
1856.

THE SABBATH.

OW still the morning of the hallow'd day!
Mute is the voice of rural labour, hush'd
The plough-boy's whistle, and the milk-maid's song.
The scythe lies glittering in the dewy wreath
Of tedded grass, mingled with fading flowers,

9

V Title-page and page from the first edition of *Sabbath Bells*, 1856, edited by Joseph Cundall. The illustrations by Birket Foster were printed from wood by Edmund Evans, the letterpress by the Chiswick Press. 8¾ in. x 6¼ in.

plates, lithographed in ten or twelve colours, are extremely vivid and fresh. The text is printed with thirty-two woodcuts of Gilbert's drawings, engraved and printed in two colours by Edmund Evans, and the Foreword is signed 'J. C.' The whole book is infinitely gayer than the conventional black and white books of the 'sixties with which it was competing.

If Cundall was responsible, as I think, for the conception and design of all these books, then he made a remarkable contribution to Victorian book design in the second half of the century.

In addition to the titles already mentioned, which all contained colour printing, Cundall either published, or produced, more than twenty other books, between 1851 and 1862, illustrated with black and white wood-engravings or etchings. At least twelve were printed by Richard Clay. One of the pleasantest of these was *Rhymes and Roundelayes in Praise of a Country Life*, 1857, published by Bogue: the second edition, also in 1857, carried Cundall's monogram on the verso of the title-page. It was printed by Clay and illustrated with wood-engravings after various artists, including Birket Foster (who appeared in most of Cundall's books at this time) and Henry Noel Humphreys.

In 1862, Cundall was appointed Superintendent of the *Illustrated Catalogue* of the International Exhibition held that year in London – a job that was presumably no sinecure. The catalogue was published in four volumes, totalling approximately three thousand pages, and was printed by five English printers (Clay, Clowes, Edmund Evans, Petter & Galpin, and Spottiswoode) with additional contributions by Leighton, Vincent Brooks, the Imperial Printing-Office in Vienna and the Printer to the Court of Prussia (the pages composed in Vienna and Berlin compare very unfavourably with the English ones). Cundall's name, incidentally, appears among the Guarantors of the Exhibition for the sum of £100, as do those of Owen Jones and Digby Wyatt. (Henry Cole and Richard Clay were down for £300, Day & Son for £1,000, and Miss Burdett Coutts for £3,000.)

In 1866, Cundall became Superintendent for examples and publications at the South Kensington Museum (now the Victoria

& Albert). He continued writing and editorial work; he edited *Illustrated Biographies of the Great Artists*, thirty-nine volumes, 1879–91, and wrote *Hans Holbein*, 1879; *Annals of the Life and work of Shakespeare*, 1886; *On Bookbindings ancient and modern*, 1881[1]; and *Wood Engraving: A Brief History from its Invention*, 1895. He died at Wallington on January 10, 1895, leaving a wife,[2] daughters Maria Stenning and Rose, and four sons, Joseph Henry, Herbert Minton, Edward George, and Frank. His will was proved for £1,142 10s. 9d.

The only personal note in his obituaries is that 'despite persistent asthma, he was of a bright and sanguine nature, and this greatly endeared him to his friends'. There is also, in one of the Chiswick Press ledgers, a description of a visit he paid, as a young man, accompanied by his wife, to Charles Whittingham, in which it is stated that he had red hair.

From what we can see in the books we know that he produced, he was a man of considerable originality and taste, whose part in the history of Victorian book design has never been given the recognition it deserves.

There were, of course, other gift books of distinguished design published during the 'fifties, illustrated with wood-engravings and very similar in style to Cundall's, with which his name cannot be linked. There is no probability, but there is a possiblity, that he had something to do with some of them. Examples are *The Poetical Works of George Herbert*, published by James Nisbet in 1857; *Gertrude of Wyoming*, Routledge, 1857; and *The Poets of the West*, Sampson Low, 1859 (pl. 38B). The *Herbert* was printed in Edinburgh by R. & R. Clark; the others in London by Richard Clay. All have title-pages set in Caslon, and text pages in either Caslon or Old Style.

It was rare for books to be set in Caslon or Old Style. The normal text face, used for every kind of book, was 'Modern'. An

[1] Mentioned by T. J. Cobden-Sanderson in his *Journal* as a book he read before deciding to take up book-binding.
[2] His first wife, Sarah Ranson, whom he married in 1845, died in 1868. In 1870 he married Emily Anne Thompson, who survived him and died in Jamaica in 1911.

example of a better-than-average book set in Modern is Cowper's poem *The Task*, published by James Nisbet in 1855, with illustrations by Birket Foster, engraved on wood by Edmund Evans. The title-page (pl. 35) is only remarkable because it is a great deal better than most title-pages of its period; this was probably because the book was printed by R. & R. Clark, the Edinburgh firm which had been founded by Robert Clark (1825–94) in 1846. Clark had from the beginning set out, in his own words, to 'give the finest possible service and the highest possible quality of work and to charge the highest possible price',[1] and he maintained high standards of press-work, and to a certain extent, of typography, in book-printing throughout the second half of the nineteenth century.

[1] As quoted by the late Dr William Maxwell, then Managing Director of R. & R. Clark, in a letter to the author dated April 15, 1949.

Two devices used by Joseph Cundall in some of his books. The left-hand one is drawn and signed by W. Harry Rogers.

14
Books of the 'Sixties

THE 'SIXTIES are famous for a proliferation of gift books illus-
trated with wood-engravings, many of them much bigger and
less charming than the dainty volumes so far mentioned. The period
has been the subject of two well-illustrated monographs, Gleeson
White's *English Illustration: 'The Sixties'*, 1855–70, 1897, and
Forrest Reid's *Illustrators of the Sixties*, 1928. The artists and
engravers have had so much attention that we can now afford to
look at other things, for example the bindings of their books, which
in some ways are more attractive than their contents; but first it is
necessary to explain how the movement or fashion started.

During the late 'fifties and 'sixties, wood-engraving became a
considerable industry, supplying the demands of the rapidly grow-
ing newspaper and magazine business. *Punch*, founded in 1841,
and *The Illustrated London News*, founded in 1842, are the best-
known purely through the accident that they have survived so long;
but there were numerous others, and it was natural, in a period of
rapidly increasing population and growth of literacy, that new
magazines should constantly be appearing: for example, *Once a
Week*, edited by Dickens, started in 1859, *The Cornhill* and *Good
Words* in 1860, *Fun* in 1861, *London Society* in 1862, *The Church-
man's Family Magazine* in 1863, and *The Sunday Magazine* in
1865. All these, and of course many more, used wood-engravings:
the acreage of wood engraved per week throughout the 'sixties
must have been prodigious.

To meet the demand, firms of engravers were organized and if a
large block was required urgently by a newspaper, for example, it
might be divided up so that four or more engravers could work on
it simultaneously. The two firms producing the best work were
those of the Dalziel Brothers, and Edmund Evans. The Dalziels,

George[1] (1815–1902) and Edward (1817–1905), Tynesiders by birth, had been active in London from the early 'forties, and went into printing when they established their Camden Press in 1857; Evans was a printer from 1851. Both firms also originated books, which were published for them by normal publishers, so that it is true to say that a large part of the fashion for wood-engraved gift books in the 'sixties was devised by the wood-engravers themselves. Routledge became the publisher for the series of 'Dalziels Fine Art Gift Books', issued in demy quarto size at a guinea (or more, if bound in morocco). Some of these were:

Birket Foster's *Pictures of English Landscape*, 1862.
Millais's *The Parables of Our Lord*, 1864.
Home Thoughts and Home Scenes, 1865.
A Round of Days, 1866.
Wayside Posies, 1867.

Numerous other books of wood-engravings, in different formats, also originated with the Dalziels.

Edmund Evans was always more interested in colour, and his activities in this field are discussed in the next chapter.

It is beyond the scope of the present work to discuss the considerable merits of the illustrators of the 'sixties, who have in any case already been much written about. In the main they conceived their work as pictures on their own, rather than as parts of a book. It is enough to define the characteristic gift book of the period as being bound in cloth, elaborately blocked in gold, usually on front, spine and back, with perhaps colour inlays, and containing a miscellany of verse illustrated often by a miscellany of artists, whose original drawings had often actually been drawn on to the wood block itself, and interpreted with great fidelity (nevertheless, interpreted) by a professional engraver, whose name was given at least equal prominence to that of the artist in the list of contents. This definition deliberately excludes the straightforward illustrated book, where a text of prose, or poetry, was given to a single artist to illustrate; this kind of book existed before, and continued to exist after, the 'sixties.

[1] See *The Brothers Dalziel*, London, 1901.

The wood-engraved books of the 'sixties are monuments, as they were intended to be, to the skill of the engravers, and also to the skill of the printers in machining the blocks on paper. But as books, many of them fail, because they were designed without much interest in the words.

The problem of integrating text with illustrations was neglected and, indeed, many of the illustrations were made with no particular text in mind, or were used with different texts. Again, the demand for illustrations attracted many artists who were not good book illustrators, and who did not trouble to study the special problems of that art.

On the other hand, many of the engravings are themselves works of art. *A Round of Days* and *Wayside Posies*, for example, while not good examples of book illustrations, contain wonderful pictures, especially those by J. W. North (1841–1924). He captured effects of light and atmosphere in a painterly fashion most unusual at that time. Pinwell and Walker also contributed fine plates to these volumes. Those who have been able to compare the original drawings with the engravings all agree that the loss in reproduction was considerable. Some instructive comparisons are shown by both Gleeson White and Forrest Reid.

A strong, if not predominating, element in the illustrations of the 'sixties was the work of the Pre-Raphaelite group. It is of course of great importance: but it is an importance that was not, on the whole, directly relevant to the progress of book design, the subject of this book. Dante Rossetti's designs for commercial bindings during the 'sixties are mentioned in Chapter 17, p. 157.

The gift books of the 'sixties did not, of course, consist only of books with wood-engravings in black and white. They included the illuminated books of Noel Humphreys, Samuel Stanesby, and others, and the colour-illustrated books of Joseph Cundall, Edmund Evans, the Leightons, and others, all described elsewhere in this book. The normal price of an illustrated gift book at this time was 21s. in cloth (31s. 6d. in morocco), which was expensive, when mechanization had brought the price of reasonably long novels down to 1s.; but some cost more. An edition of *Lalla Rookh*,

for example, published by Longman in 1861, with sixty-nine illustrations on wood by Tenniel, cost five guineas: it contained over four hundred pages, including five ornamental title-pages by Thomas Sulman, of which the first was printed in colours and gold. Its complete lack of any typographical distinction, despite the fact that it was printed by Clay, can be seen at a glance, especially when it is compared with books of the Chiswick Press or Joseph Cundall of the same period.

We must, however, give some attention to the course of normal book illustration, which runs throughout our period, and to the techniques employed.

Copper and steel etchings continued to be used, although being rapidly displaced by wood-engravings. They were used by 'Phiz' for his illustrations to Dickens, of which the last were *Bleak House*, 1853, *Little Dorrit*, 1857, and *The Tale of Two Cities*, 1859; but *Great Expectations* (edition of 1862), and *Our Mutual Friend*, 1864–5, were illustrated with wood-engravings after Marcus Stone, and *Edwin Drood*, 1870, contained wood-engravings after Luke Fildes.

Etched illustrations were normally inserted as 'plates', of which there would be only a small number: there was no attempt to achieve harmony between them and the text pages. If smaller illustrations, decorative initials, and vignettes were required on the text pages, they had to be engraved on wood, which could be printed with the type. Surtees's novels, for example, contained both wood-engravings in the text, and etched plates, e.g. *Mr Sponge's Sporting Tour*, 1853, and *Handley Cross*, 1854, both illustrated by John Leech.

Occasionally, however, a book was designed with the text over-printed from type on to pages already printed from copper or steel plates, as had been done in the works of the Etching Club published by Cundall in the 1840s (see Chapter 13); for example, the very handsome edition of Milton's *L'Allegro and Il Penseroso*, published by Bogue in 1855. This consisted of twenty-four large pages of etchings on steel by Birket Foster, with the poems set in Caslon and printed in red. The effect is superb. No name of printer is

mentioned, but it was probably Clay, who printed Goldsmith's *The Traveller* for Routledge in 1868, with etchings on steel by Birket Foster on every page. The velvety blacks and the silvery middle tones of the etchings are beyond anything that the wood-engravers could achieve; their juxtaposition with the type is particularly effective, and makes the pages graphically exciting. The titles of both books have clearly been designed by someone with taste, and, although his name is nowhere mentioned, it is at least a reasonable guess that both were supervised by Joseph Cundall.

The Poetical Works of Oliver Goldsmith was published in 1866 by Charles Griffin, with small etchings by various artists printed on the same pages as the letterpress text. Although the typography of this volume is not distinguished, the juxtaposition of etchings and type gives the same brilliant effect.

Etching, like wood-engraving, was usually carried out by professional craftsmen; but a few illustrators always etched their own plates. The greatest of these was George Cruikshank. In 1852 he was sixty, but still active and prolific. Some of the best illustrations he ever did are in *Cruikshank's Fairy Library*, the first three parts of which were published by Bogue in 1853 and 1854; the fourth, published by Routledge, was drawn and appeared in 1864. The illustrations are so good that we can forgive him (although Dickens would not) for rewriting the stories himself on temperance lines. These, and most of Cruikshank's illustrations, were drawn and etched by himself on copper.

The most original of the younger men was 'Dicky' Doyle, aged twenty-six in 1850: he had, like Cruikshank, the faculty of producing memorable images. In Ruskin's *The King of the Golden River*, 1851, a great writer and great illustrator met. Other splendid drawings by Doyle appeared in *The Juvenile Calendar*, 1850 (p. 22), *The Story of Jack and the Giants*, 1851, and *The Scouring of the White Horse*, by Thomas Hughes, 1859. His famous cover for *Punch* had been first used in 1849.

In 1850, Tenniel was twenty-nine, and drew for *Punch* for the first time in that year. He contributed illustrations, always on wood, to many gift books during the 'fifties and 'sixties, but nothing he

ever did was as good as his illustrations for *Alice's Adventures in Wonderland*, 1865.[1] As Forrest Reid points out, Victorian publishers do not seem to have noticed that Tenniel was essentially a humorous artist with a flair for drawing animals.

John Leech was thirty-three in 1850. His best illustrations were for Surtees' novels, which appeared during the 'fifties, and were, as mentioned above, both etched and on wood.

H. K. Browne ('Phiz') was thirty-five in 1850 and continued as Dickens's illustrator until he was discarded in 1860: and when Trollope was offered his services, he remarked: 'I think you would possibly find no worse illustrator than H. Browne.'[2] So far had taste swung from the early days of the Queen's reign.

Charles Keene, perhaps the finest draughtsman of them all, was twenty-seven in 1850; the greatest part of his output was for *Punch*, and *Once a Week*, in whose pages he illustrated *A Good Fight* (the first version of Reade's *The Cloister and the Hearth*) and Meredith's *Evan Harrington*. Keene illustrated a number of books,[3] mostly forgotten, but including *Robinson Crusoe*, 1847, and Douglas Jerrold's *Mrs Caudle's Curtain Lectures*, published by Bradbury, Evans in 1866: it has a chromolithograph frontispiece, which makes one wish Keene had done more coloured illustrations, and a large number of small woodcuts; the entire book is printed on green paper. Keene's drawings have an additional value rare at any time, but especially during the 'sixties: like Bewick, and Daumier, Keene drew ordinary people in ordinary life.

[1] The extraordinary story of the publication and withdrawal of the first edition of *Alice* is told in Percy Muir's *English Children's Books*, 1954. Cf. also R. L. Green, *The Lewis Carroll Handbook*, London, 1962.
[2] M. Sadleir: *Trollope, A Commentary*, London, 1945.
[3] See W. H. Chesson's bibliography in Joseph Pennell's *The Work of Charles Keene*, 1897; and Forrest Reid, *Illustrators of the Sixties*, pp. 111–133.

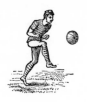

15
Colour printing from wood: Vizetelly and Edmund Evans

BAXTER'S BUSINESS, as we have seen, was the manufacture of colour prints, either for pasting on to various products, such as needle cases, or for individual sale, for people to collect in scrapbooks, and to frame; he did very little work for book publishers. His patent had been obtained in 1835.

Charles Knight, working independently, had produced large and successful colour plates from woodblocks by a method patented in 1838, and used in the plates for *Old England*, 1844–5, and *Old England's Worthies*, 1847, but then abandoned.

The greatest difficulty in printing in colour from wood lay in the engraving, so it was to be expected that the earliest experiments would originate in the workshops of engravers. After Baxter and Knight, the next important colour work came from Henry Vizetelly (1820–94). Vizetelly was apprenticed in 1835 to G. W. Bonner, 'a second-rate wood-engraver'[1] (but the master of W. J. Linton), where he worked seventy-two hours a week, and regarded it as a matter of course. After Bonner's death in 1836, Vizetelly became a pupil of John Orrin Smith, who had been a pupil of W. Harvey, himself a pupil of Bewick. In 1841, when he had come of age, Henry Vizetelly went into partnership with his elder brother James, who had set up as a printer and engraver, while not yet of age, at Peterborough Court, Fleet Street, after their father's death. In 1841 the parental firm, Vizetelly, Branston & Co., failed, one result of which was that Lockhart's *Ancient Spanish Ballads* (see above, p. 58), entrusted by John Murray to Vizetelly, Branston & Co., was transferred to the sons. Apart from the many wood-

[1] Henry Vizetelly, *Glances Back Through Seventy Years*, London, 1893.

engravings in this book engraved by H. Vizetelly, S. Williams, Orrin Smith and others, it was a large and complicated printing job for a small firm, and seems to have been carried out with conspicuous success. The contact with both Owen Jones and John Murray continued: the Vizetellys printed the letterpress text for Jones's and Goury's folio *Views on the Nile*, 1843, and for *The Book of Common Prayer*, 1845 (described above, p. 65), the latter including coloured borders and initials. In 1845 they printed another gift book in colour, Louisa Stuart Costello's *The Rose Garden of Persia* for Longman. No doubt Owen Jones's *Alhambra* had been instrumental in showing publishers and artists that there were other veins of decoration, even richer than the gothic, waiting to be exploited for the illuminated book market: *The Rose Garden* was the first of several Oriental ventures.

Miss Costello had already published *Specimens of the Early Poetry of France* (Pickering, 1835), illustrated by herself with hand-coloured etchings after illuminated manuscripts, and was now attempting to introduce the poetry of Persia, in her own translation, to an English audience. Every page is surrounded by a wood cut border in colour and there are several pages of Persian decoration printed in red, blue and gold, drawn by the author and engraved and printed by the Vizetellys. It is certainly a triumph of letterpress colour printing. The binding, a Persian design printed in gold and blue on a rose background on paper-covered boards, is also exceedingly pretty.

Most of the subsequent incursions into Oriental decoration were made by Stephen Austin of Hertford, who became a specialist in Oriental types, and whose firm remains today one of the leading Oriental printers in Britain.

One such book was *The Gulistan*, printed and published by Stephen Austin in 1852, with four reproductions of Persian manuscripts chromolithographed by Hanhart. The translator of this work, E. B. Eastwick, refers somewhat unkindly in his preface to 'Such scraps of Orientalism as Miss Costello's "Rose-Garden", which is about as satisfactory to the Eastern *scholar* as the tinkling of money, heard afar off, to the destitute; or the smell of distant viands to the starving.'

The most lavish of the Oriental illuminated books was *Sakoontala*, printed and published by Austin in 1855. The borders on ordinary pages are printed in four colours: there is a title-page, at the end of the Introduction, of extraordinary richness, and numerous other decorations and borders printed in colours. The decoration was drawn, from manuscripts in the British Museum, by T. Sulman, Jun., and engraved by George Measom. Mr Stephen Austin was able to achieve, by letterpress, results indistinguishable from chromolithography: one wonders how his costs worked out.

The binding of *Sakoontala* was also remarkable, a rich design blocked in gold on leather; it is one of the few commercial editions to have been issued with gauffered edges.

In 1856, Stephen Austin published the *Rouman Anthology*, another very lavishly produced illuminated edition; its scholarly text lifts it out of the ordinary gift book class. Its borders, decorations, and initials, printed in gold and up to five colours from wood, were designed, in a vaguely Danubian vein, by Noel Humphreys. The effect is rich, but not entirely successful: the best thing about it is the superb quality of the machining.

The next books with colour printing by the Vizetelly brothers after *The Rose Garden of Persia* seem to have been for children.

In 1846, they printed *Hunters and Fishers*, by Mrs Percy Sinnett, for Chapman & Hall, a small book with four not very good colour plates printed from wood in four or five colours, with bright colours touched in by hand, and other books were produced in the same format. In 1847, for the same publishers, they produced Thomas Miller's *The Country Year Book*, a book for boys which is a charming example of the best ordinary commercial production of the period. It is a small octavo, profusely illustrated with wood-engravings by Henry Vizetelly after drawings by Birket Foster (see below, p. 131), who was then aged twenty-two. Some of the illustrations, almost Foster's earliest independent signed work, show a strong influence of Bewick, with whom his family were friendly.

The Country Year Book was first issued in four parts, *Summer*, *Autumn*, *Winter* and *Spring:* each part had a frontispiece and decorative title printed in colours from wood blocks. In some

copies, the two plates for *Spring* are hand-coloured, but the rest are all printed: they are, perhaps, the first in which Vizetelly reproduced painting by the superimposition of translucent colours. *The Country Year Book* was later republished in one volume, probably from the original sheets, by Henry Bohn.

Three notable illustrated books published in 1849 were printed by the Vizetelly brothers, although two (Milman's *Horace*, described on p. 68, and Noel Humphreys' *A Record of the Black Prince*, described on p. 75) contained also chromolitho plates. The third was *Gavarni in London*, published by Bogue, illustrated with twenty-four illustrations drawn by Gavarni on wood, and engraved by Henry Vizetelly: the engravings are enriched by chiaroscuro blocks engraved and printed in one and two neutral tints.

In 1849 Henry Vizetelly quarrelled with his brother James,[1] and the firm split: Henry set up in business on his own at Gough Square, Fleet Street, and his brother continued as 'Vizetelly & Co.' at Peterborough Court, Fleet Street.

In 1850 Vizetelly & Co.'s imprint was on Noel Humphreys' exquisite chromolithographed *Book of Ruth* (see pl. 31), although it can only have applied to the letterpress text. In 1850, Henry Vizetelly engraved and printed a beautiful small book illustrated by Birket Foster, *Songs for Children* (pl. 16), and in 1851 the first edition of Ruskin's *The King of the Golden River*, illustrated by Richard Doyle, both without colour. In his autobiography, Vizetelly says he also 'engraved two or three of Mr Ruskin's own sketches for some of the minor illustrations to *The Stones of Venice*; but I regret to say not to the great art critic's entire satisfaction'.

[1] A letter from H. Vizetelly to John Murray dated February 12, 1849, states: 'You have perhaps become aware that the business carried on by myself and brother has been for some time past crippled through pecuniary difficulties, originally arising from circumstances totally independant of its regular trading engagements & by the occurrence of which I am myself unfortunately the chief sufferer, although no party to them. The result is that after making arrangements with the Creditors of the firm by which I sacrifice everything that I am possessed of, I have determined never to again resume business in connection with my brother on any consideration whatever . . . and it is my intention shortly to engage in business as a printer and Engraver either in conjunction with a new partner or else on my own account alone.' No mention is made of these circumstances in Vizetelly's autobiography.

In 1851 he printed, and Bogue published, a notable gift book, *Christmas with the Poets*, which, it has been suggested, 'must have contributed considerably to the popular revival of the "Old Christmas" atmosphere'[1] and to the new trade in Christmas cards, and which contained two or three poems rather too robust for mid-Victorian critics. Nevertheless, according to Henry Vizetelly, the book was selected by the Trustees of the British Museum for exhibition as an example of contemporary book illustration and printing, and deserved that honour. The engraved title-page is printed in two or three colours and gold, with the bright colours in the vignettes touched in by hand; the other illustrations, all by Birket Foster, are printed in black and two or three neutral tints, and there are ornaments and initials printed in gold throughout the book. Two editions appeared in 1851; the third in 1855; the fourth, printed by Edmund Evans, in 1862. Even in the fifth edition, 1869, printed by Vincent Brooks, Day & Son, the title-page vignettes are still hand-coloured; but in the sixth edition, 1872, also printed by Vincent Brooks, they are at last printed in colours.

Henry Vizetelly also printed in 1851 a small gift book *Guess if you can!*, with wood-engraved borders in various colours, and, in 1852, Ida Pfeiffer's *A Woman's Journey Round the World*, a long travel book illustrated with twelve wood-engravings, in black and two tints, which although not signed seem to have been engraved by Edmund Evans, and may be his first colour work. Evans, born in 1826, and Birket Foster's closest friend since they had been apprenticed together at Ebenezer Landells', had set up on his own as an engraver and printer in 1847, and had moved in 1851 to Racquet Court, Fleet Street. Vizetelly may have handed over surplus engraving jobs to Evans. He had already helped to found *The Illustrated London News* in 1842, and had started *The Pictorial Times* in opposition to it in 1843, in conjunction with Andrew Spottiswoode, the Queen's Printer. He now became much more engaged in the editing and publishing of both newspapers and books.

Between 1850 and 1854, Vizetelly says that most of his time was

[1] G. Buday, *The History of The Christmas Card*, London, 1954, p. 63.

given up to the production of illustrated books. One of these was an illustrated edition of Martin Tupper's *Proverbial Philosophy*, 1854, published by Thomas Hatchard of Piccadilly, which is very much a forerunner of the wood-engraved gift books of the 'sixties. It was set in Caslon Old Face and illustrated with wood-engravings after Tenniel, Gilbert, Foster, Horsley, Cope, the Severns, and others, and decorated initials by Noel Humphreys. It ran to three hundred and eighty pages, and was bound in blue cloth, blocked with a pleasant but unsigned design in gold and blind.

Among his publishing ventures, which were of considerable scope, Vizetelly published the first English edition of *Uncle Tom's Cabin*, in 1853; but his later work is of importance in wider fields than the history of book design. His adventures as Paris Correspondent of *The Illustrated London News* are engagingly recounted in his autobiography. At the age of sixty-nine he was fined, ruined, and sent to prison, for publishing the first translations in English of Zola's novels. More happily, he also found time to write a series of books on the wines of France, including *Facts about Champagne and other Sparkling Wines*, 1879, and *A History of Champagne*, 1882.

The status of wood-engravers in the mid-Victorian period was high: their names were often placed on title-pages, and mentioned in advertisements. They held a remarkable position at the heart of the publishing world, where literature met art, and several, like Vizetelly, were men of exceptional intellect and character. Ebenezer Landells, for example, was one of the founders of *Punch*; W. J. Linton was a poet, political reformer, and friend of Mazzini. Less eccentric than these, but in his engraving business the greatest of them all, was Edmund Evans (1826–1905). His short autobiography, so far unpublished,[1] reveals him as a man of great simplicity and kindliness. Although not an intellectual, he had publishing vision and enterprise, and was a true artist.

Evans was apprenticed at the age of fourteen to Ebenezer Landells, where he was joined a year later by Birket Foster: the two became close and lifelong friends. When young, they had many

[1] An edition by the present writer is planned.

sketching expeditions and holidays together: Evans married a niece of Foster's wife, and in later life they lived as neighbours in Surrey.

In his autobiography Evans states that another engraver was also signing his work 'E. Evans' during his apprenticeship, and that he often saw his signature on blocks engraved after drawings by 'Phiz'. This engraver was probably responsible for an engraving signed 'EVANS Sc.' at the end of *Ancient Spanish Ballads*, 1841, and also for a frontispiece engraved in two colours for *Sir Uvedale Price on the Picturesque etc* (Edinburgh, Caldwell, Lloyd & Co.; London, W. S. Orr & Co., 1842). It is unlikely that Edmund would have been entrusted with finished engravings so early in his apprenticeship.

In 1847 he came out of his time and, despite offers from Landells to stay on as his assistant, he set up on his own.

By 1851, Evans had progressed sufficiently to set up his own engraving and printing office at Raquet (or Racquet) Court, off Fleet Street; and there, for nearly fifty years, he stayed, becoming the most successful engraver and printer from wood of his generation. The business was transferred to his sons in May 1898: and children's books were still being printed in colour from his original wood blocks, by the firm of Edmund Evans Ltd, in 1962.

Evans quickly made a reputation for colour work. His first signed colour blocks seem to be those in Mrs Pfeiffer's *A Visit to the Holy Land*, published by Ingram, Cooke & Co. in 1852; they were printed in black, pale yellow and pale blue, and the frontispiece states 'Printed in tints by E. Evans'. The illustrations were drawn by Birket Foster.

Then came *Letters Left at the Pastry Cook's*, 1853, and the beginning of his large trade in yellow-back covers, as described in the previous chapter. Quality in printing was not the foremost requirement, although brightness of the coloured inks was: in that Evans excelled. They provided him with a bread-and-butter line for many years.

Evans's development as an engraver and printer of fine book illustrations in colour during the next few years was almost entirely

in collaboration with Birket Foster (1825–99). Foster had been born in North Shields from a Newcastle-upon-Tyne mother; his grandfather had been a naval officer, a friend of Wordsworth and Southey, and had known Bewick.[1] The Foster family moved to London when Birket was five, but the influence of Bewick, and a love of the country, remained. He was apprenticed to the wood-engraver Landells, but his master, holding the view that while many could engrave, few could draw, kept Foster drawing. For this he had perhaps a fatal facility: he might have become a greater artist than Bewick, if his art had undergone the discipline and concentration of wood-engraving. His wonderful skill in evoking the traditional beauties of the peaceful, southern English countryside – thatched cottages, immemorial elms, church towers, lovers' stiles, sheep, etc. – quickly achieved tremendous popularity, and he found himself meeting a continuous demand to go on repeating it: a demand perhaps already nostalgic and partly caused by the spread of the railways which were simultaneously opening up the countryside and destroying it.

Foster's first commissions after he left Landells came from Henry Vizetelly, and included *The Country Year Book*, 1847, and *Christmas with the Poets*, 1851, described above (p. 128). Some further works with tinted engravings included illustrations for Mrs Pfeiffer's travel books, and *Fern Leaves from Fanny's Portfolio*, 1853, engraved by Edmund Evans. Then in 1856 came *Sabbath Bells Chimed by the Poets*, an extremely pretty and successful anthology devised by Joseph Cundall, with text designed and printed by Charles Whittingham at the Chiswick Press, and Birket Foster's illustrations presumably overprinted, on the Chiswick Press sheets, by Edmund Evans, in four or five colours – his first full-colour reproductive engraving. The Chiswick Press initials used throughout the book were coloured by hand. Later editions of *Sabbath Bells*, in 1861, 1862, and after, were reset and entirely printed by Edmund Evans.

Evans's next important colour book was *The Poems of Oliver Goldsmith*, published by Routledge in 1859 (pl. 44). The illus-

[1] Marcus Huish, *Birket Foster*, London, 1890.

trations, again by Birket Foster, are more colourful than those in *Sabbath Bells*, since nine or ten printings were used; they achieve a delicacy that makes this book perhaps both the printer's and artist's masterpiece: certainly nothing they produced afterwards surpassed it. In addition to Foster's colourful illustrations, set amongst the poems, there are ornamental titles and decorations designed by Noel Humphreys, printed in black and pale grey. It is probable that the book was planned by Joseph Cundall, as his son states, although his name nowhere appears in it. A second edition appeared in 1860, with some additional engravings, including one of Goldsmith's grave, at the end of the Introduction; further editions, all printed by Edmund Evans, appeared in 1877 and later.

In 1859 there also appeared *Odes and Sonnets*, with illustrations in colour by Birket Foster, and ornamental designs in colour by John Sliegh. The title-page and credit page (pl. 45) are gallant and not unsuccessful attempts to use wood-engraving to give an effect of illumination: nothing else quite like them occurs in the whole century. The engraving and colour printing were done by the Brothers Dalziel, Edmund Evans's principal rivals, who had set up their Camden Press in 1857. In colour printing, however, the Dalziels never seriously rivalled Evans either in volume or quality. Among their most successful colour work were children's books for Routledge, including Speckter's *Picture Fables*, 1858, Hans Andersen's *Out of the Heart*, and *The Children's Poetry Book*. Colour printing is hardly mentioned in their autobiographical volume *The Brothers Dalziel*.

In 1860, two splendid examples of Edmund Evans's colour engraving and printing were published. The first, *A Book of Favourite Modern Ballads*, is bibliographically confusing. One edition, which may have been the first, was published by W. Kent & Co. (late D. Bogue), dated 1860, in which the illustrations are printed in black with one or two neutral tints, and the decorations, by Albert Warren, in gold: it carries a Preface by Joseph Cundall, who had devised the book, and may have been its true publisher. It makes an extremely handsome volume. Another edition, undated, was published by Ward, Lock & Tyler, and is identical except that

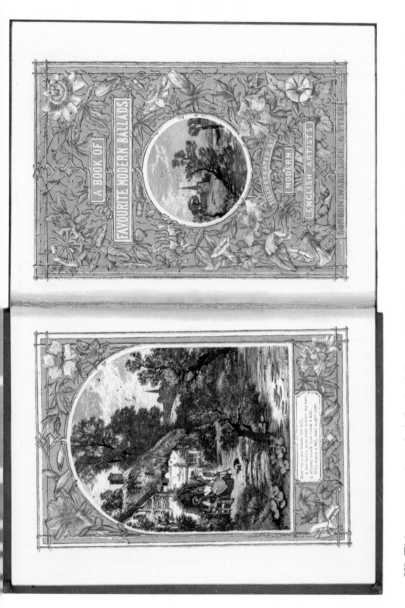

VI Title-page opening of *A Book of Favourite Modern Ballads* (c. 1860), edited by Joseph Cundall. These pages, designed by Albert Warren, with illustrations by Birket Foster, were printed from wood by Edmund Evans. 8⅜ in. x 6¼ in.

the illustrations are all printed in six or eight colours, and the decorations and type in a neutral colour. Albert Warren's double title-pages, surrounding two pictures by Birket Foster (pl. VI), make one of the most charming openings in mid-Victorian book production. Beside Birket Foster, the illustrators include J. C. Horsley, Harrison Weir, Abraham Solomon and Samuel Palmer. The colour-printed version was also issued in two halves, entitled *Choice Pictures and Choice Poems*, and *The Illustrated Poetical Gift Book*, both undated. The coloured illustrations are much larger, and less delicate, than those in the *Poems of Oliver Goldsmith*, but it is, in all its forms, a fine book.

Common Wayside Flowers, by Thomas Miller (Routledge, 1860), is the only other important collaboration between Birket Foster and Edmund Evans in colour, and is a pretty book (pl. 40). The coloured engravings of flowers are large in scale, free in outline and varied in shape and size, with the type set to fit: the typography is of the plainest and, apart from some very short thin rules, there are no decorations or initials: the book does not need them. The binding design of the cloth edition, signed by Albert Warren, is one of the richest of the period: an overall design blocked in gold contains four pasted-down sections of colour printing on paper (of flower designs not inside the book), and this is repeated on the back; the spine is blocked in gold and white. *Common Wayside Flowers* was several times reprinted.

In 1858, Birket Foster decided to give up book illustration for water-colour painting, and by 1860 had completed all the contracts to which he was committed. Wood-engravings by him in books published after that date are usually reprinted from earlier works. The only important exception was *Pictures of English Landscape* (see p. 97), which he undertook for the Dalziels, and which was published in 1862. It contained no colour.

The withdrawal of such a prolific artist was no doubt a blow to the engravers, but Evans had plenty more irons in the fire. One series, unpretentious to look at but steady sellers, had begun in 1857 when Routledge asked him to engrave twelve coloured illustrations, by W. S. Coleman, for the Rev. J. G. Wood's *Common*

Objects of the Sea Shore. It was quickly followed by *Common Objects of the Country, Common Objects of the Microscope*, Coleman's *Woodlands, Heaths, and Hedges*, and similar pocket volumes on wild flowers, ferns, butterflies, birds' eggs and aquariums. They sold at 2s. 6d., and although Evans printed only the plates, they must have represented a steady flow of work, since for several of the titles the first edition alone is said to have been 100,000 copies.[1] Many of these small books, partly because they are so unpretentious, are extremely attractive and delicate (pl. 43B).

Uniform in size with these popular small books, but more serious in purpose, was a new translation of Chevreul's *The Law of Contrast of Colour*, published by Routledge in 1860. Chevreul, an organic chemist, and Director of the Gobelins Dye works, whose book had been first published in France in 1838, had for long been lecturing to manufacturers and workmen in France on the important industrial applications of this subject. It is curious that no one in England, for example Owen Jones, ever tackled the theory of colour as a subject for chromolithography. Chevreul's book was illustrated with seventeen plates, engraved on wood and printed in colours by Edmund Evans, which are brilliant in colouring and exciting as compositions.

In the more showy gift book field, Evans's next important colour book was *The Art Album*, published by W. Kent in 1861. It is a pleasant quarto with sixteen large colour plates after water-colour drawings by thirteen artists, padded out with poems; but the engravings are not so fine as Evans's earlier work in smaller size. The case of the cloth edition is an exceptionally fine example of Victorian publishers' binding design. It is blocked in gold and blind on purple cloth, with, in the centre, a pasted-down colour panel printed on paper with the book's title lettered across bunches of Traveller's Joy. Unfortunately, it is not signed. The same illustrations, indifferently reprinted, and in a different order, with different text, were served up a few years later by Ward, Lock & Tyler under the title of *Beauties of Poetry and Art*. A modification of the earlier binding design was used, blocked in gold, red and blind on purple cloth – still very rich.

[1] F. A. Mumby, *The House of Routledge*, 1834–1934. London, 1934.

The Psalms of David, illustrated by John Franklin, which Sampson Low published in 1862, was entirely printed by Evans; on every page the wood-engraved initial letters are printed in red and blue. It is one of the prettiest books of the 'sixties, although ignored by Gleeson White and Forrest Reid, and if Evans was responsible for its design, it shows his superiority in book-making over the Dalziels.

Evans's colour printing at its very best is seen again in *A Chronicle of England*, written and illustrated by James Doyle, elder brother of Richard, and published by Longman in 1864. It is a quarto of four hundred and seventy pages, entirely printed by Evans: the numerous small illustrations are set in the text and printed in up to ten colours, as bright as if they had just been painted. As well as being a most gifted draughtsman, Doyle was a heraldic expert (his *Official Baronage of England* is still a standard work) and made full use of his knowledge. And no one throughout the nineteenth century could mix such bright and clear inks as Evans. These small illustrations rival anything that even Baxter ever did.

Another outstanding example of Evans's colour printing is *In Fairyland*, 1870, a folio which is also Richard Doyle's masterpiece: it contains some of the most entrancing children's book illustrations ever made.

It seems to have been in 1865 that Routledge and Warne began to publish 'Toy Books', from which date the enormous output of colour-printed books for children really begins. Routledge's 'Toy Books', first announced late in 1865,[1] measured $10\frac{1}{2} \times 9$ in. and consisted of six pages of text and six pages of coloured illustrations, printed on one side only, bound in coloured paper covers, which often, surprisingly, were not illustrated but were titled in rich and colourful 'fairground' lettering, with equally rich borders. The illustrators for the earliest titles were announced as H. S. Marks, J. D. Watson, Harrison Weir, and F. Keyl but individual artist's names were rarely given on the books themselves. They were sold at 1s., or mounted on cloth at 2s. The first titles were printed by Edmund Evans, but soon the quantity was so great that Kronheim, Leighton, Vincent Brooks, and the Dalziels were also called in.

[1] e.g. in *The Bookseller*, December 12, 1865.

Warne's first Toy Books were published under the aegis of 'Aunt Louisa', who was Laura Valentine, Warne's general editor, and the earliest titles may have been gathered together as *Aunt Louisa's Sunday Picture Book,* first published 1865–6. These too were printed by Evans, somewhat crudely; a later edition, redesigned and redrawn, was printed by Kronheim and is one of the best in the series.

The 'Aunt Louisa' Toy Books were usually collected and bound in cloth volumes, each containing four titles. In nearly all, the artists are anonymous: occasionally, a clue is given by style or subject (nearly all the animal pictures are by Harrison Weir, who is sometimes named) or by initials. The quality of the pictures and the printing varies, but they deserve a higher place in the history of book illustration than they have ever been given. Most of them are simple, vigorous, and honestly drawn; their colouring is both rich and subtle, hardly ever crude or garish; they are fine examples of popular art and of hand-engraving and printing processes[1] now superseded, in the interests of cost, with a large sacrifice of quality; and many of them provide fascinating glimpses of Victorian life. Slightly smaller toy books were soon being published by Routledge and Warne at sixpence (1s. on cloth); and similar series were published by several publishers, including The Religious Tract Society; Nelson; Read, Brooks & Co. (publishers of the 'Grandma Goodsoul' series); Gall & Inglis of Edinburgh; and Maclure & Macdonald of Glasgow.

The first artist to have his own name on the Toy Books he designed was Walter Crane (1845–1915). Crane had been apprenticed to the wood-engraver W. J. Linton, where he learned how to draw on wood rather than how to engrave; the first book in which he is named as illustrator is J. R. Wise's *The New Forest*, published by Smith, Elder in 1863, and the sixty-three illustrations, engraved on wood by Linton, show little of his talents. Crane was in fact a true illustrator, not a painter condescending to allow his drawings to

[1] The Toy Books printed by Evans and the Dalziels were printed letterpress, from wood. Kronheim and Leighton mostly printed letterpress from wood or metal, sometimes combined with lithography. Toy Books printed by chromo-lithography are unusual.

be reproduced on book pages: he was also a very conscious designer, and was interested in the design of textiles, clothes, furniture and other artifacts: when they appear in his drawings, they are carefully considered.

His designs for the covers of his own *Walter Crane's Toy Books* are a significant contrast to the other Toy Books: they are less vigorous and colourful, but they were, in their day, new and original, and to us they foreshadow the art of the 'nineties. His illustrations inside are also original and unlike the work of any of his contemporaries – although there are, in places, echoes of the drawing of Burne-Jones and Rossetti (cf. *Beauty and the Beast*). His best and most elaborate drawings are highly sophisticated, but very rich, and beautifully printed by Evans, who printed all Crane's books.

The first of Crane's Toy Books seems to have been the *Railroad Alphabet* and the *Farmyard Alphabet*, which according to Edmund Evans's autobiography were published by Routledge in 1865. In all, he designed about fifty Toy Books between 1865 and 1886.[1]

Evans, with Routledge and Warne, had created a market for illustrated children's books which had not existed before. A successor to Walter Crane had to be found, and Evans chose Randolph Caldecott (1846–86).[2] Caldecott's first book illustrations had been for *Old Christmas*, 1875, and *Bracebridge Hall*, 1876, commissioned by the wood-engraver J. D. Cooper: he followed these with illustrations for Mrs Ewing's stories for children. In 1878 Evans commissioned Caldecott to provide two Christmas Toy Books, *John Gilpin* and *The House that Jack Built*. From then until his early death, Caldecott produced two such books every year, sixteen in all, of which many more than a million copies have now been printed, and which are still being printed from the original wood blocks. As a humorous illustrator, without bite, but with a touch of poetry, Caldecott is immortal.

Evans's other famous protegé was Kate Greenaway (1846–1901). She was the daughter of a wood-engraver, and her first commission

[1] Forty-six are listed in G. C. E. Massé's *A Bibliography of First Editions of Books illustrated by Walter Crane*, London, 1923.
[2] See Henry Blackburn, *Randolph Caldecott*, London, 1886.

appears to have been for an 'Aunt Louisa' Toy Book from Kronheim & Co. The illustrations, for *Diamonds and Toads*, appeared in *Aunt Louisa's Nursery Favourite*, 1870, and are in startling contrast to her later work, which is the essence of insipidity. In 1877, Kate Greenaway took a book of her own verses and drawings to Edmund Evans, who immediately accepted them and obtained Routledge's agreement to publish it as a 6*s*. book, called *Under the Window*. Without consulting Routledge, and to that enterprising publisher's horror, Evans printed twenty thousand copies; but they sold out immediately, and Evans found great difficulty in keeping up with the sales. *Under the Window* is – in January 1963 – still in print, and still being printed from the original wood blocks.

Edmund Evans records in his autobiography that he photographed these drawings on to wood: the day of the photo-engraved line block was drawing closer.

Illustration by John Gilbert to 'You spotted snakes', engraved on wood by Edmund Evans, in *Shakespeare's Songs and Sonnets*, London, 1862.

16

Colour printing from wood: G. C. Leighton, Kronheim, Dickes and Fawcett

COLOUR PRINTING from wood was rare during the 'forties but became an industry during the 'fifties. In 1856, *The Illustrated London News* became the first journal in the world to include regular colour plates which were printed from wood. (It had already included four colour plates in a supplement to its Christmas issue on December 22, 1855.)

These colour plates, and those which appeared in The *Illustrated London Almanac* from 1858, were printed by George Cargill Leighton (1826–95), who in 1858 became the printer and publisher of *The Illustrated London News*.

George Leighton had been apprenticed for seven years to George Baxter, and when out of his time, in 1843, he had joined several other pupils of Baxter's, to form a business called Gregory, Collins & Reynolds, as related in Chapter 5, p. 33. In 1849, Reynolds had joined Minton's pottery works, Gregory went to Kronheim & Co., and Leighton took over the business, calling it 'Leighton Brothers'. In the same year Baxter's Patent expired, and Baxter filed a petition for its renewal; Leighton, aged only twenty-three, opposed the application. The case was heard before the Judicial Committee of the Privy Council, Lord Brougham being in the Chair, and was decided in favour of Baxter. Leighton's case, that if the Patent were continued, he would not be able to earn his living as a colour printer, was demolished by the evidence of two other of Baxter's ex-apprentices, Crewe and Gregory, called by Leighton himself, who admitted that they were earning good wages. Baxter's

Patent was extended for a period of five years, because the Court agreed that it was of benefit to the public, and that Baxter had not yet succeeded in making a profit from it. He was advised by Lord Brougham to sell licences in his process, which he proceeded to do.

Insofar as Baxter could claim a patent in his process, it lay in the use of a metal intaglio plate for printing a base, on to which the colours were added from wood blocks. This, therefore, was the one thing Leighton could not do without infringement; and the fact that he had to do without it probably helped to ensure his commercial success.

In 1851 Leighton printed six colour plates for Volume III of the *Art Journal*: the first is a 'facsimile' of 'The Hawking Party' by Landseer, done (according to the accompanying text) in sixteen printings, and approaching the richness of Baxter's own prints; the other five are of Minton's tiles, in up to six printings, impressive in a volume otherwise entirely illustrated in black and white. In 1851, Leighton also provided two colour plates for *Peter Parley's Annual*. One of his next works was *The Village Queen*, by Thomas Miller, illustrated with four colour prints previously exhibited on Cundall & Addey's Stand at the Great Exhibition.

Then came *The Poultry Book*, 1853, a serious work on the breeding and management of poultry, published by W. S. Orr, with twenty-three splendid colour plates by Leighton after paintings by Harrison Weir. This book is, possibly, the first manual published in Britain on a purely practical, non-artistic subject, containing plates printed in full colour. There are vivid portraits of a turkey, a peacock, geese and ducks, as well as domestic poultry. Harrison Weir had himself been a pupil of Baxter's, and according to the title-page the colour plates were printed under his superintendence. Probably about ten printings were used. The colouring is often quite impressionist and has a pleasant softness and subtlety. The drawings are much larger in scale than Birket Foster's (the plate area is generally about $7\frac{3}{4} \times 5\frac{3}{4}$ in.) and the artist was obviously working for the process: certainly he and the engraver collaborated with most happy results.

The Poultry Book may have been issued in parts: the bound volume contains at the back an announcement of its successor, *The Theory and Practice of Landscape Painting in Water Colours*, by George Barnard, concluding with the words: 'To those who so liberally patronized the "POULTRY BOOK" rather as a Work of Art than as a Treatise upon an important branch of Domestic Economy, the Publishers venture to recommend its successor and companion volume as not unworthy of its reputation, and uniform with it as regards typography and size and method of illustration.

'The First Part will appear on the 1st of January, 1854, and the Work will be completed in Six Monthly Parts, Price Half-a-Crown each.'

George Barnard was the art master at Rugby. Of whatever use his *Landscape Painting* was to artists, it is certainly, with its twenty-six colour plates, a most interesting manual of what could be achieved at that time by colour printing. On only one plate, no. 4, with twenty-five panels showing harmonious arrangements of colour, does there appear to be any hand-colouring. Plates 22 and 23 might be sketches, or notes, by a French Impressionist, and are, in their way, among the most improbable examples of colour printing of the whole century. The second edition of *Landscape Painting* was dedicated to Michael Faraday (whose niece Leighton married), and published in 1858: and there were later editions. Barnard published *Drawings from Nature* in 1865, in similar format, but it contains only four Leighton colour plates: the other plates are mostly two-colour lithographs.

Leighton also made four very attractive colour plates for an illustrated edition of Harriet Martineau's popular *The English Lakes*,[1] published in 1858 at Windermere: an odd book containing six steel engravings, numerous small illustrations drawn and beautifully engraved on wood by W. J. Linton, printed separately and pasted down on the pages, and a hand-coloured folding geological map.

[1] The British Museum and other copies I have seen contain only two plates, of 'Wray Castle' and 'Dungeon Ghyll', but a folder containing four 'chromatic Pictures of the Lakes', including 'Keswick from Castlerigg' and 'Rydall Water', is in the Constance Meade Collection.

From 1858, Leighton must have been heavily occupied with managerial and technical problems at *The Illustrated London News*, where he remained until 1884. *The Illustrated London News* colour plates are remarkable productions and deserve study: it is a pity that, probably owing to their large size, they were never collected and published in book form. The covers for the Almanacks, many designed by Thomas Macquoid, are among the best things of that kind of their period. Macquoid (1820–1912) was an ornamental designer like Noel Humphreys, but a greatly inferior artist. The cover for 1866, unsigned, was in the style of Henry Shaw; later covers were designed by W. G. Smith. The inside colour plates, mostly of flowers, birds, and domestic animals, were at first of high quality, but deteriorated, in drawing and design, during the 'sixties. Twenty-four of them appeared again in *Pictorial Beauties of Nature*, published by Ward, Lock in 1873.

Other books with important and interesting Leighton colour plates are : *Schnick Schnack*, with thirty-four coloured plates for young children after Oscar Pletsch, 1867; *The Story without an End*, a children's book with haunting illustrations by E. V. Boyle, 1868; W. B. Tegetmeier's *Pigeons*, 1868, with sixteen illustrations by Harrison Weir, in which metal relief plates appear to have been used as well as, or instead of, wood; and *Gems of English Art*, 1869, in which Leighton reproduces twenty-four paintings, but not as well as Baxter or even his own earlier work; the book's most successful feature is its polychromatic binding, unsigned (see Chapter 17, p. 156).

In 1885, ten years before he died, Leighton sold his business to Vincent Brooks, Day & Son.

After Evans and Leighton, the three most notable and prolific producers of letterpress colour printing in books were the firms of Kronheim, Dickes, and Fawcett. The first two were Baxter licensees, using their licences to produce Baxter-type prints from about 1850 onwards. Both became large suppliers of colour plates to book publishers, competing on price rather than on quality: the Baxter process was not adhered to, processes were mixed (both Kronheim and Dickes were lithographers as well as engravers) and it is often

impossible to say exactly how a given colour print was produced. Most Kronheim and Dickes plates are printed letterpress from wood or metal blocks, or both.

J. M. Kronheim (1810–96)[1] was born in Magdeburg, and worked as a printer and lithographer in Paris and Edinburgh before coming to London about 1846. The earliest book illustrations signed by him may be in children's books published by the Religious Tract Society in the early 1850s, for example *A Book about Birds* and *A Book about Animals*. These each contain six plates printed by normal chromolithography. Another, *The Children of the Bible*, contains six plates by the Baxter process, of which Kronheim was a licensee, i.e. by letterpress blocks printed on top of an intaglio base plate. All these attractive small books appeared in embossed coloured paper boards lithographed in gold and blue.

According to Courtney Lewis[2], Kronheim sold out his interest in his firm to one of his partners, a Mr Frauenknecht, in 1855, tried other things in Germany and America for some years, and then returned to his old firm, where he remained till he retired in 1887. Frauenknecht died in 1883.

Kronheim colour plates after the mid 1850s fall generally into one of two categories, which can easily be distinguished from each other: they are either Kronheim's variation of the Baxter process, or they are straightforward letterpress from wood or metal blocks.

According to Burch (*Colour Printing*, 2nd edition, 1910, pp. 134ff.) for his 'Baxter' process Kronheim used from eight to sixteen colours, printed from zinc or copper plates on top of the steel key plate impression. The drawing must have been done by a team of artists, who were nearly always anonymous: Kronheim's plates, frequently not signed at all, rarely had anyone else's names on them if not his.[3] Some of the drawings are vigorous, some are insipid, but all are careful and detailed. Some of his topographical and flower

[1] There is no biography or bibliography of Kronheim and he is not in D.N.B. Sources of information are R. M. Burch, *Colour Printing*; C. Courtney Lewis, *The Story of Picture Printing*; some sources they mention; and his work.

[2] *The Story of Picture Printing*, p. 174 et seq.

[3] Two plates in *Aunt Louisa's Sunday Picture Book*, n.d., printed by Kronheim, are signed 'G. Jungmann del.sc.' ('The Story of King David', nos. 3 & 4); and there are a few other examples in the 'Aunt Louisa' series.

plates for the small Religious Tract Society books like *The Christian Wreath* [1853], *The Coronal*, 1858, and *The Christian Chaplet* [1859] are exquisite. His factory also produced sets of colour plates for at least four Bibles, two editions of *Pilgrim's Progress*, two *Gulliver's Travels*, and a *Don Quixote*. The biggest Kronheim colour plates which I have seen are a set of Bible illustrations for the Religious Tract Society in which the colour area is $12\frac{7}{8} \times 9\frac{5}{16}$ in.

The other category of Kronheim's colour printing, sometimes described on title-pages as 'Kronheim's oil-colour process', was used mostly for cheaper children's books. Frederick Warne and George Routledge (who had been in partnership from 1851 till Warne set up on his own in 1865) were his chief customers for this kind of work. Frederick Warne's 'Aunt Louisa' books were mostly printed by Kronheim (although some were by Edmund Evans and Dalziel) and achieve a vigour, almost a coarseness, that is refreshing when compared with the over-refined Kronheim Bible plates.

William Dickes (1815–92)[1] was, according to Docker, apprenticed to the wood-engraver Robert Branston, and in 1835 became a student at the Royal Academy Schools. In 1846 he opened an office in Salisbury Square, off Fleet Street, as an artist and engraver on wood and copper; in 1849 he removed to 4 Crescent Place, Bridge Street (between Fleet Street and the river) and added lithography and colour printing to his qualifications. About 1851 he moved again to $5\frac{1}{2}$ Old Fish Street, Doctors' Common; and in about 1864 built large premises for his colour printing at 109 Farringdon Road, a little north of Fleet Street.

He exhibited colour prints at the Great Exhibition of 1851, and at various later International Exhibitions; and, presumably about 1850, became a licensee of Baxter's process.

One of his earliest and best clients was the Society for the Promotion of Christian Knowledge: they used his talents to provide coloured illustrations for the works of Anne Pratt (1806–93), the most prolific and popular writer on home botany of the mid-

[1] See *The Colour Prints of William Dickes*, by Alfred Docker, London (350 copies), 1924; and sources mentioned for Kronheim.

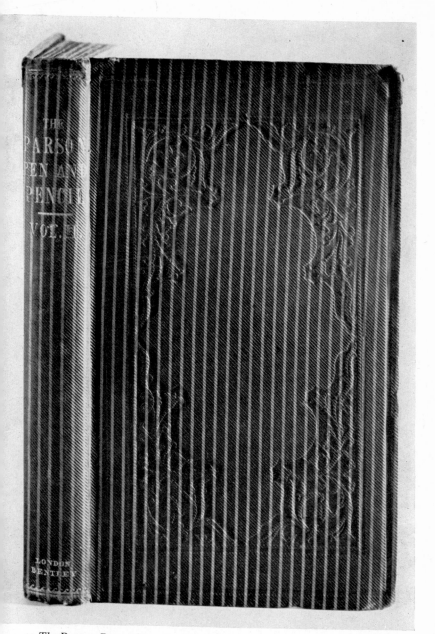

49 *The Parson, Pen and Pencil*, 1848. Blocked in gold and blind on maroon
striped diagonal-ribbed cloth. $8\frac{1}{8} \times 5$ in. *Constance Meade Collection,
Oxford.*

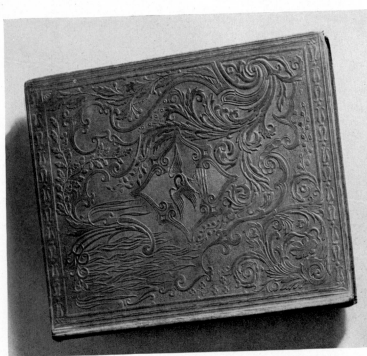

50B Fisher's *Drawing Room Scrap Book*, 1851. Gold blocking on magenta cloth. 11 $\frac{5}{16}$ × 9 in.

50A Fisher's *Drawing Room Scrap Book*, 1839. Blind embossing on fine green cloth. 11 $\frac{5}{16}$ × 9 in.

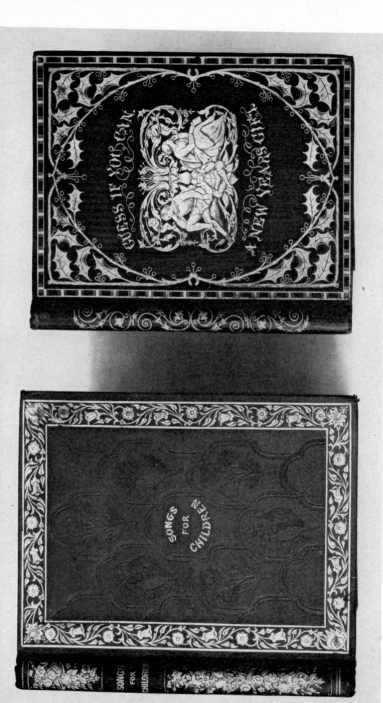

51B *Guess If You Can*, 1851. Blocked in gold on green cloth with fine ripple grain. 7 × 5¼ in.

51A *Songs for Children*, 1850 (see pl 16). Blocked in gold and blind on dark green ribbed cloth. 7⅞ × 5½ in.

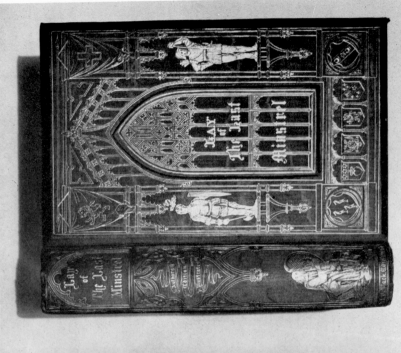

52B *The Lay of the Last Minstrel*, 1854. Blocked in gold

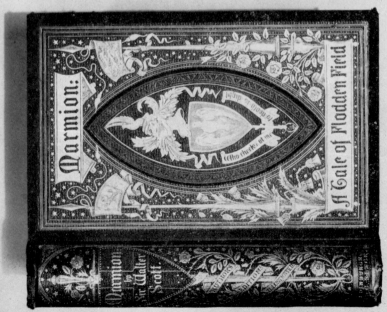

52A *Marmion*, 1855. Blocked in gold and blind on

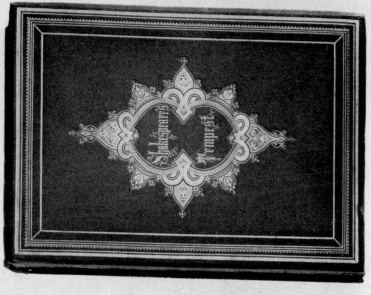

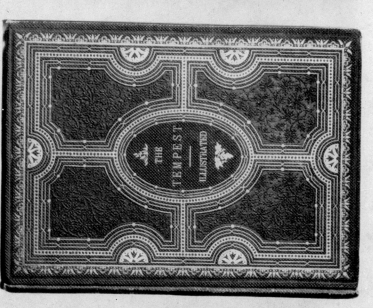

53 *The Tempest*, Bell & Daldy (1860). Two copies of the same book: left, blocked in gold and blind on purple bead grained cloth; right, blocked in gold on blue sand-grained cloth, showing a later, deteriorating style. 10 × 7¼ in.

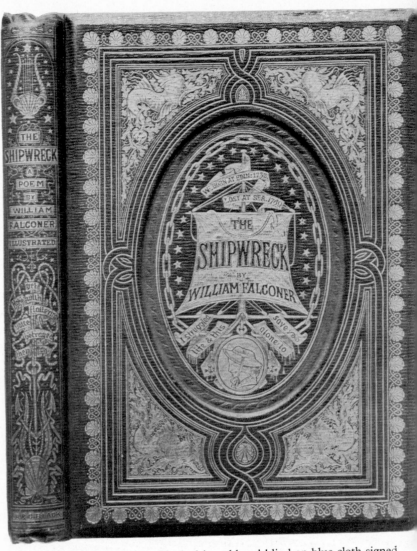

54 *The Shipwreck*, 1858. Blocked in gold and blind on blue cloth signed JL (John Leighton). $8\frac{1}{2} \times 6$ in.

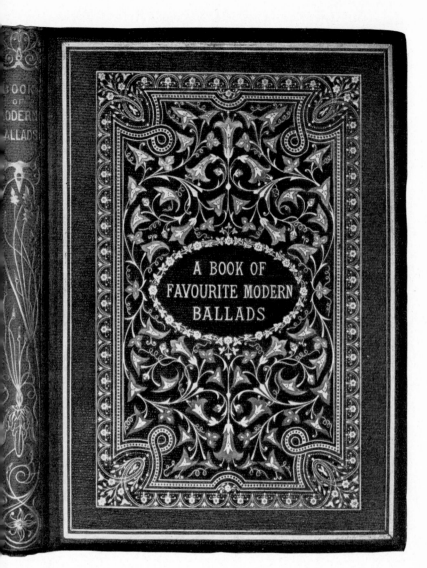

55 *A Book of Favourite Modern Ballads* (*c.* 1860). Blocked in gold on purple grained cloth. $9\frac{5}{8} \times 7$ in.

56A *The Promises of Jesus Christ* (1866). Blocked in 56B *Light for the Path of Life* (1858). Blocked in gold

57A *The New Forest*, 1863. Blocked in gold and blind on red grained cloth. Signed J L (John Leighton). $9\frac{3}{4} \times 6\frac{7}{8}$ in.

57B *A Round of Days*, 1866. Blocked in gold on green sand grain cloth and red and blue paper inlays. Signed J L (John Leighton). $10\frac{3}{8} \times 8$ in.

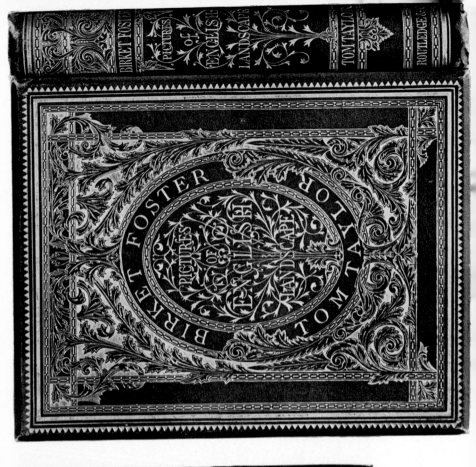

58A *The Task*, 1855 (see pl. 35). Blocked in gold on emerald green cloth. Signed J L (John Leighton). $8\frac{3}{8} \times 6\frac{7}{8}$ in.

58B *Pictures of English Landscape* (1862). Binding design by Owen Jones, blocked in gold on blue cloth. $10\frac{3}{8} \times 6\frac{7}{8}$ in.

59 *Enoch Arden*, 1866 (see pl. 41B). Blocked in gold on blue pebble grain cloth. 8⅞ × 6¾ in.

60A *Ruined Castles and Abbeys*, 1862. Blocked in gold and blind, with inset photograph, on purple morocco

60B *The Church's Floral Kalendar*, (c. 1862). Blocked

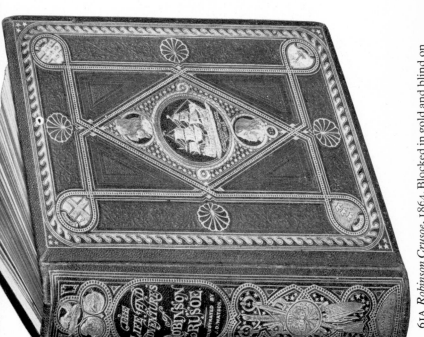

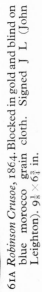

61B *Robinson Crusoe* (c. 1876). Blocked in gold and black on brown cloth. Signed M. $10\frac{3}{4} \times 7\frac{1}{2}$ in.

61A *Robinson Crusoe*, 1864. Blocked in gold and blind on blue morocco grain cloth. Signed J L (John Leighton). $9\frac{1}{8} \times 6\frac{3}{4}$ in.

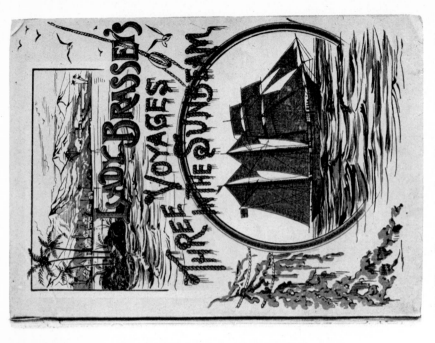

62B *Three Voyages in the Sunbeam*, 1889. Blocked in green, blue grey and black on salmon pink cloth.

62A *Rhymes and Roundelayes*, 1875. Blocked in gold and black on green cloth and orange paper inlays.

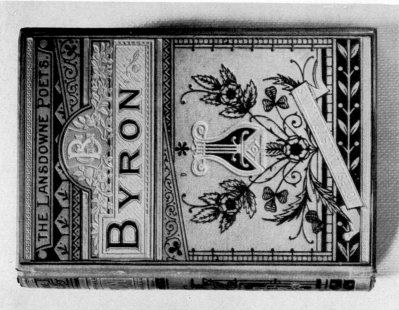

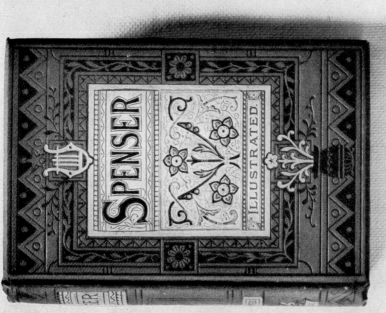

63A *Spenser, c.* 1880. Blocked in red, gold and black on blue-green cloth. $7\frac{1}{2} \times 4\frac{7}{8}$ in.

63B *Byron, c.* 1880. Blocked in gold and black on blue cloth. $7\frac{1}{4} \times 4\frac{3}{4}$ in.

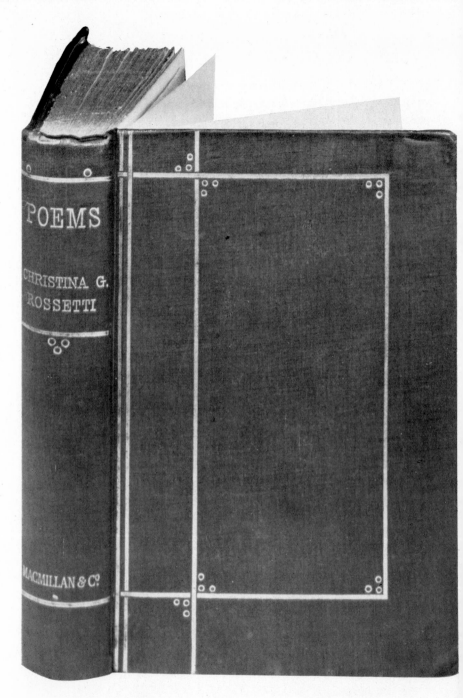

64 C. Rossetti's *Poems*, 1891. Blocked in gold on dark blue cloth. This design, by Dante Gabriel Rossetti, first appeared on *Goblin Market*, 1861. $7\frac{1}{8} \times 4\frac{3}{4}$ in.

century. Sowerby's *English Botany*, which when completed in 1814 contained illustrations of nearly three thousand native plants and was the most comprehensive illustrated national flora that had ever appeared in any country, was illustrated with hand-coloured copper plates. The seventh volume of a third edition of Sowerby, with over a thousand of the same plates, still hand-coloured, appeared as late as 1854. Anne Pratt's *The Flowering Plants of Great Britain*, in three volumes, 1855, contained two hundred and thirty-eight exquisite[1] colour plates drawn and engraved by Dickes and printed by Baxter's process; the same author's *Wild Flowers* was published in 1852 in a small ($5\frac{1}{4} \times 4$ in.) volume, followed by a second volume in 1853, each containing ninety-six charming illustrations in colour printed from wood blocks. The same work also appeared in folio sheets, each with descriptions and illustrations of two wild flowers on one side of the page. Colour printing was coming into its own as a useful servant of the community.

Dickes also produced the coloured plates for Anne Pratt's other works, e.g. *Our Native Songsters*, 1853, *Ferns*, 1855, *Poisonous Plants*, 1857, and *Grasses*, 1859; and for numerous other publications of the S.P.C.K.

Among Dickes's finest colour plates are the twelve which first appeared in the fourth edition of Charles Kingsley's *Glaucus*, 1859, and eleven in P. H. Gosse's *A History of the British Sea-Anemones and Corals*, 1860: the softness, subtlety and richness of the colouring far exceeds in quality the best achieved by the four-colour processes of today.

Gosse's earlier *Popular British Ornithology*, 1849, was illustrated with beautifully hand-coloured lithographs, and his *The Aquarium*, 1854, with fine chromolithography printed by Hanhart. The extraordinary household in which these books were written is unforgettably described in Edmund Gosse's *Father and Son*.

Another publisher for whom Dickes worked was S. O. Beeton, the husband of the author of *Household Management*. For him Dickes printed eight colour plates, drawn by H. Anelay, for *Robinson Crusoe*, dated 1862, which was one of the first *Robinson Crusoes*

[1] But not, according to modern botanists, of great botanical value.

to appear in England with illustrations printed in colour.[1] They were reprinted many times during the next thirty years and are among the best colour plates ever made for that much illustrated work.

Dickes's colour plates were usually signed, and when the signature, outside the colour area, is on an etched plate, it is an indication that the Baxter process was being used. For the colour plates in ordinary children's books where the fidelity required in botanical or scientific illustration was not necessary, he used a series of wood or metal relief blocks, and the signature is printed letterpress.

Dickes was a modest and conscientious craftsman, pioneering in colour printing for the growing middle- and lower-middle class reading public, and all his work was clearly of the highest quality that he could make it for the price: often, perhaps, higher.

The third notable letterpress colour printer, after Kronheim and Dickes, was Benjamin Fawcett (1808–93)[2] of Driffield in Yorkshire.

Unlike all the other colour printers so far mentioned, Fawcett never worked in London, and most of his output was for books.

For over thirty years he produced both hand-coloured and colour-printed plates; his colour printing (often touched up, even in large editions, by hand) was, in his chosen fields, unsurpassed by anyone, including Baxter: he set himself, and all his workpeople, the very highest standards that were possible. It is only a pity that he was not a typographer and had no great designer-printer like Whittingham with whom to collaborate: whereas his plates are superb, the rest of the make-up of the books which he printed, or to which he contributed, are, at their best, ordinary.

Fawcett had set up on his own as a bookseller, stationer and printer at Driffield, in about 1831; and being energetic, ingenious, artistic and ambitious, he had published various works himself, with illustrations designed and engraved on wood by himself and

[1] The earliest editions of *Robinson Crusoe* with printed colour plates which I have seen are (*a*) chromolithographed colour plates by Wehnert; Bell & Daldy, London, 1861; (*b*) colour plates by Kronheim; Knight & Son, London, 1861; (*c*) colour plates by A. F. Lydon, printed by Fawcett; Groombridge, London, 1862.

[2] See Rev. M. C. F. Morris, *Benjamin Fawcett, Colour Printer and Engraver*, London, 1925.

others. In 1844, the Reverend Francis Orpen Morris was appointed vicar of the neighbouring village of Nafferton, about two miles from Driffield; and from this chance sprang a fruitful collaboration in publishing. Both Morris and Fawcett were devoted naturalists. One of their first joint works was a *Bible Natural History*, which was originally published in twenty monthly parts, price 6*d*. each, each part containing eight hand-coloured wood-engravings: the engraving and printing was done by Fawcett.

About 1849, Fawcett and Morris began collaboration on *A History of British Birds*, a work whose success made the names of both men widely known. *British Birds* was published by Groombridge & Sons of London, who had been pioneers of popular natural history books, and was first issued in shilling monthly parts, with four hand-coloured plates and twenty-four pages of text. Every one of the three hundred and sixty odd plates was (according to Morris's son) engraved on wood by Fawcett himself and the specimen plate for the colourers painted by Fawcett's wife. In 1852 the Queen accepted the dedication of the work, so that, from Part 32 (which appeared in July 1852) onwards, the green covers of the parts were headed with the Royal Arms. The publication took seven and a half years and was completed in the Summer of 1857: it was several times re-issued, both in parts and in six bound volumes.

British Birds was promptly followed by *Nests and Eggs of British Birds* and *A History of British Butterflies*, both by the Rev. F. O. Morris, with illustrations partly printed and partly hand-coloured by Fawcett; then came books by other authors on *British Game Birds*, a *Natural History of Ferns*, etc. etc.

In 1856 Groombridge published *Rustic Adornments for Homes of Taste and Recreations for Town Folk in the Study and Imitation of Nature*, by the prolific horticultural journalist Shirley Hibberd (1825–90), a charming octavo volume with plates that are among Fawcett's earliest fully-printed colour plates, in about eight colours, and still with some colours added by hand. In an optimistic preface, the author throws some light on the sort of market this and other similar pretty Victorian books were aimed at: 'The last twenty years have been marked by such a progress in domestic aesthetics as to be

worthy of designation as a new era in social life . . . An eminent author has called this the Age of Veneer, and another dignifies it with the title of the Age of Fustian. I shall . . . call it the Age of Toys. We have nearly exhausted the means of morbid excitement, and are growing simpler, because purer in our tastes . . . The mark of our progress is seen in our love for toys, plant-cases, bird and bee-hives, fish-tanks, and garden ornaments – they are the beads in our Rosary of homage to the Spirit of Beauty.'

Another small book from Groombridge is the Hon. Mrs Ward's *Telescope Teachings*, 1859: the plates of eclipses, of night skies, comets, close-ups of moon craters, etc., are exquisite examples of the range of what could now be achieved by the skill of wood-engraver and colour printer. But the highlight of Fawcett's early colour printing, and one of the finest examples of colour printing of the century, is E. J. Lowe's *Beautiful Leaved Plants*, first published in twenty monthly parts at a shilling, with three coloured plates, and then in book form by Groombridge in 1861. Here again hand-colouring is discernible on some plates. They are straightfoward representations of, in many cases, exotically coloured leaves, an ambitious task and a triumph of wood-engraving and colour printing. A further volume, called *New and Rare Beautiful Leaved Plants*, by Shirley Hibberd, was published by Bell & Daldy in 1870, with equally beautiful colour plates by Fawcett.

It is not possible here to list all the books containing Fawcett's colour plates, but among the best of the smaller ones are the Rev. W. Houghton's *Country* and *Seaside Walks of a Naturalist*, 1870, in which the plates are quite as fine as Baxter's. *The Smaller British Birds*, 1874, *English Lake Scenery*, 1880, and *Scottish Loch Scenery*, 1882, are examples of quarto volumes where the increased size of illustration has not diminished their delicacy. The drawings for these and many other of Fawcett's books were made by A. F. Lydon (1836–1917), who was the mainstay of Fawcett's art department for about thirty years, until he left for London about 1883. The biggest books printed by Fawcett with colour plates were *British Freshwater Fishes*, 2 volumes, 1879, and *The Ruined Abbeys of Great Britain*, 2 volumes (1882), in which the plates are certainly

magnificent; but Fawcett's greatest undertaking, entirely illustrated by Lydon, was *A Series of Picturesque Views of Seats of the Noblemen and Gentlemen of Great Britain,* by the Rev. F. O. Morris, begun in the 1860s and eventually completed in 6 volumes in 1880. It contained a total of two hundred and forty coloured plates, of mansions, each printed in an average of eight colours; the plates vary in quality of drawing, as do, for example, the aquatints in Daniell's *Voyage round Great Britain,* but the best are of great charm and beauty; and the colour printing is, as usual, superb. The author's son states, in his book on Fawcett, that over ten thousand copies of this work were sold.

Tailpiece engraved on wood from *Seaside Walks of a Naturalist* by Rev. W. Houghton, with colour plates by A. F. Lydon, London, 1870.

17
Styles in Victorian publishers' bindings

AS DESCRIBED in Chapter 2, the important innovation of using cloth to bind editions of books was introduced perhaps as early as 1822, certainly by 1825. It is extremely difficult to establish the exact year of any binding style: bindings are often much later than the date on a book's title-page, since publishers normally bind only a part of an edition initially; sheets of a book may be bound years later than the date of first publication, and are often sold as 'remainders' to another publisher.

In the year 1847, Joseph Cundall read (to a meeting of the Society of Arts), and subsequently published, a paper 'On Ornamental Art applied to Ancient and Modern Bookbinding'. In it he said: 'In the year 1825 a great Revolution in Bookbinding . . . by the introduction of cloth covers in the place of the drab coloured paper . . . the late Mr Archibald Leighton was the inventor of this great improvement; and Mr Pickering, to whom I beg to tender my acknowledgements for his kind assistance in the compilation of this paper, was the first publisher who adopted it.' It is the sort of date which one would expect a man like Pickering not to get wrong, even after more than twenty years.

In the same year, Cundall mentions and illustrates some contemporary examples of ornamental bindings, and criticizes them from the same point of view that we might take today. For example, he notices that the Grolier pattern on the *Poets' Pleasaunce*, 1847, taken from Shaw's *Encyclopaedia of Ornament*, does not harmonize with Noel Humphreys' floral designs inside; he also says: 'To Mr Owen Jones we are indebted for several ornamental designs in embossed leather; but, from the peculiar treatment which that

gentleman has given them, some few are more beautiful than appropriate. For instance Gray's Elegy, one of the finest and most *English* of English poems, appeared, dressed internally and externally in an old-fashioned monkish garb . . . ' *Gray's Elegy*, 1846, was in fact the first of a series of bindings, probably designed by Jones, in deeply embossed leather, often with gold lining or tooling along the edges and inside on the squares. For some of these, parts of the design must have been built up under the leather as well as punched by a steel or brass die. The firm of Remnant & Edmonds specialized in making these and other embossed bindings and was awarded a Prize Medal for them at the Great Exhibition. One of the last books bound in this style was Owen Jones's *Victoria Psalter* of 1861.

Remnant & Edmonds also invented a method for imitating carved wood, by 'burning in the pattern' (according to the *Reports of the Juries*, 1852) on to actual wooden boards. This method was used for some copies of Owen Jones's *The Preacher*, 1849 (pl. 24) and for a few smaller books, but mercifully does not seem to have been much favoured by book buyers.

Then there were the black papier maché bindings (see p. 72), supreme examples of Victorian Gothic and perhaps the biggest triumph among all the ingenuities of Victorian commercial bookbinding. Cundall called it 'the monastic style' and said 'such covers can only be executed when great numbers are required, as they are cast in moulds, the first cost of which is very great'. The minimum, and probably the normal, quantity order of these bindings was one thousand. About eight different titles seem to have been bound in this style, of which three appeared in later editions:

Parables of Our Lord, 1847; *The Good Shunamite*, 1847; *Miracles of Our Lord*, 1848; *A Record of the Black Prince*, 1849; *Sentiments and Similes of Shakespeare*, 1851 (2nd edition, 1857); *The Origin and Progress of the Art of Writing*, 1853 (2nd edition, 1855); *The Coinage of the British Empire*, 1855 (3rd edition, 1863); and *Quarle's Emblems*, 1861 (illustrated by Charles Bennett and W. Harry Rogers).

They were manufactured by a patent process invented by Messrs Jackson & Sons of 49 & 50 Rathbone Place,[1] consisting of a mixture

[1] See the Great Exhibition *Catalogue*, 1851.

of papier maché and plaster composition, usually on a metal frame-work. The process was also used for architectural plaques, etc. The composition sides were usually hinged on leather spines. The *Sentiments and Similes of Shakespeare* has small 'terracotta' ovals inserted on the front and back, which Messrs Longman's surviving ledgers show as having been supplied by Jackson at threepence a pair.

One of these bindings is shown on the table in Holman Hunt's painting *The Awakening Conscience*, exhibited at the Royal Academy in 1854, and was scathingly referred to by Ruskin in his analysis of the picture as 'those embossed books, vain and useless – they also new – marked with no happy wearing of beloved leaves'.[1] The book, however, by its size and the date, must have been Noel Hum-phreys' *The Origin and Progress of the Art of Writing*.

Gift books were also, during the 'forties and 'fifties, published with sides of vellum, velvet, silk, porcelain, tortoiseshell, enamelled and gilt papier maché, varnished tartan paper on wood, and other fancies. Paul Jerrard, for example, at 111 Fleet Street, published at least thirteen 'elegant Drawing-Room Books' in fancy bindings, at between 21*s*. 6*d*. and 31*s*. 6*d*., advertising them as 'Paul Jerrard's Cream and Gold Special Presents': the insides, usually consisting of lavishly hand-coloured lithographs, with texts printed in gold, were in imitation of Owen Jones's *Flowers and their Kindred Thoughts* series.

But such exotic and peculiar binding materials, like books illus-trated with genuine butterflies' wings, were, on the whole, freaks. The main output of publishers' editions were covered in either paper or cloth.

Paper was less durable, but was the easiest to print, and was fully exploited throughout the period. Many of Joseph Cundall's children's books, including the Home Treasury, were issued in paper boards printed with most attractive designs, from 1843 onwards, using both wood block and lithographic processes for colour printing.

[1] Quoted in R. Ironside & J. Gere, *Pre-Raphaelite Painters*, Phaidon Press, London, 1948.

As described in Chapter 12, paper boards were also used during the 'forties for nearly all the numerous series of cheap novels and non-fiction. Many of the standard cover designs were printed in several colours and were of an extremely high standard of design (pl. 13). Pickering also issued books in paper boards, using typographical borders in a single colour on plain glazed paper, in his usual impeccably classical taste. Colour-printed illustrations on covers, which had been used for children's books since the early 'forties, did not become common until the 'yellow-backs' were introduced in 1853; from then on, pictorial paper boards were the most normal covering for both cheap fiction and for illustrated children's books.

Some fancy papers were used, chiefly for children's books, for example the pink papers, embossed to imitate cloth, used for *A Book about Birds*, and other titles published by the Religious Tract Society in the 'fifties; and paper was the basis of various highly extravagant designs for gift books, such as Noel Humphreys' *The Coins of England*, 1846 (see Chapter 10, p. 71).

More dignified books were sometimes issued with a cloth spine and paper sides, e.g. Henry Shaw's *A Booke of Sundry Draughtes*, Pickering, 1848, with a design from one of the plates reproduced on the sides; but this method was not used as often as it might have been. Several of Shaw's works, and others published by Pickering, were issued with leather spines and sides covered in a plain plum-coloured paper.

Cloth, however, was the chief book covering for editions, although those who maintained libraries would buy their books in sheets for binding in leather.

The varieties of cloth itself were considerable. They have been described and illustrated in Sadleir's *The Evolution of Publishers' Binding Styles* (London, 1930); and *XIX Century Fiction* (London, 1951); the illustrations of cloth grains were repeated in *The Book Collector*, Spring 1953, and only a brief summary need be given here. Machines for graining cloth were on the market from early in the eighteen-thirties and many of the grains were exceedingly attractive. As well as the 'ribbon-embosser's' grain illustrated by

Sadleir in *Binding Styles*, there were leaf, seaweed and geometrical designs; a few cloths were also striped, some were spotted, and others were marbled. The colour range of standard cloths was restricted, but included a rich blue, an orange and some bright greens which seem to be no longer available.

The principal way of decorating book cloths was blocking in gold and blind from hand-cut brass blocks. But elaborate designs were also *printed* (with ink) on to cloth; for example, Noel Humphreys' *Insect Changes*, 1847 (see Chapter 10, p. 73), was printed, in a design after Holbein, in three colours, and the *History of . . . Bayard*, Longman, 1848, had an overall printing of black diagonals enclosing gold fleur-de-lys, on red cloth.

Whether these and similar designs were blocked from brass or printed from wood is difficult to determine. Gold leaf must be blocked with heat, and requires brass, but other colours could be printed from wood, the danger being that it would split if pressure became excessive. Some books (e.g. *The Nursery Rhymes of England*, London, J. R. Smith, 4th edition, 1846) have cloth covers blocked in blue and gold inks and signed 'Gregory, Collins & Reynolds', who were wood block printers. The higher cost of brass and the greater difficulty of cutting it would make wood preferable whenever possible. Pictorial designs printed on cloth or paper in inks (as opposed to gold leaf) were probably printed from wood all through the nineteenth century; lithography does not seem to have been used for printing on book-cloth until the 1930s.

Blocking in gold from hand-cut brass blocks (the method still commonly used today) began in 1832 (see Chapter 2). The blocking was done, as it still is, after the cloth had been pasted on the boards but before the boards, or case, had been fixed to the book. The earliest pictorial design blocked in gold, as recorded by Sadleir, is the rope and anchor round the title on the spine of *Tom Cringle's Log*, 1833; and examples can be found for every year thereafter.

An early example of a design blocked in gold over the whole front side of a book (as opposed to a small central decoration) is on *Lockhart's Spanish Ballads*, Murray, 1841, which was probably designed by Owen Jones. The spine is actually blocked with the

VIIA *The Poetical Works
of Edgar Allan Poe*, n.d.
(Ward, Lock & Tyler,
c. 1865 ?). Bound by
Leighton Son & Hodge.
Unsigned design.
9⅛ in. x 6⅝ in.

VIIB Unsigned
binding, book dated
1863 (see pl.IVB).
7½ in. x 5½ in.

date 1841, and the date 1842 is blocked on the spine of Thomson's *Seasons*, published in that year by Longman; but the practice of including dates in the brasses was soon discontinued, except for some annuals.

Gold blocking was often done in conjunction with blind blocking, but blind blocking (i.e. the production of a raised or sunk design without any use of gold or coloured ink) was rarely used by itself. The cover designed by Ruskin for his *The Seven Lamps of Architecture*, 1849, entirely blind and covering front, back and spine, was therefore all the more unusual.

Designs for covers soon became highly elaborate, and many were of great beauty; although almost any intricate design will look well when shining in gold leaf on a brightly coloured cloth.

The first source for the decoration of cloth bindings was obviously the designs on leather bindings, and there are many which follow one or other of the well-known traditional styles. Then there are designs which appear to have been built up from printers' flowers; and others based on the baroque designs in old pattern-books, or other engraved originals.

As the annual quantity of books being produced grew, so did the problem of providing cover designs: every designer with a talent for decoration must have at one time or another found himself drawing for the brass-cutter.

Some artists specialized in this work, and eventually began to sign their designs; and most of those who did so have been identified.[1] The most prolific designer of bindings was John Leighton ('Luke Limner'), 1822–1912, nephew of the bookbinder Archibald Leighton, and cousin of George Cargill Leighton, the colour printer. The earliest design with his initials known to Miss Pantazzi is on Eugène Sue's *Paula Monti*, Chapman & Hall, 1845; and from then on he must have designed many bindings a year for nearly every leading London publisher, both for cutting on brass, to be

[1] Miss Sybille Pantazzi of Toronto Art Gallery has done pioneer work in this field. See her article 'Four Designers of English Publishers' Bindings, 1850–80, and their Signatures' in the *Papers of the Bibliographical Society of America*, vol. 55, 2nd Quarter, 1961; and her article on John Leighton in *The Connoisseur*, vol. CLII, 1963.

blocked on cloth, and for cutting on wood, to be printed on paper.

John Leighton was a mediocre designer, but significant because he was popular and active in so many fields. He was one of the earliest purely commercial artists produced by the Industrial Revolution: besides his work for book and magazine publishers (which included decorations and illustrations) he designed Christmas cards,[1] bank notes, seals and medallions, playing cards and other graphic items, as well as doing some work in photography. Leighton was a good craftsman, who fully understood the limitations and possibilities of the media he employed; humour creeps pleasantly into some of his designs, but his lack of originality would make it difficult to identify most of them if they were not signed.

Other designers of brasses who signed their work include W. Harry Rogers, Albert H. Warren, Robert Dudley, and John Sliegh (or Sleigh) (the subjects of Miss Pantazzi's monograph mentioned above), T. Sulman, and Matthew Digby Wyatt. In addition, bindings exist signed by 'J. M.', 'C. B.' (?Charles Bennett), and combinations of C. & T., J. & M., C. & H., and R, T and M, which are as yet unidentified.

Many fine binding designs are unsigned, which is curious; it was so easy for the designer to inset his initials unobtrusively in a complicated brass, and even the smallest wood-engravings of the Victorian period often carry the initials of both designer and engraver. Notable unsigned bindings which spring to mind are those on *The Art Album*, W. Kent, 1861, and *Gems of English Art*, Routledge, 1869. The former owes much of its success to a cut-out colour-printed illustration on paper which is inset in a countersunk panel on the front and back covers, a device frequently used but not often with such taste. Photographs, most often circular, were also used in this way. The cutting out and sticking down of a simple shape can have presented few difficulties, but complicated cut-outs were also used: for example, the cover of the Religious Tract Society's *The Town and Country Toy Book* (n.d., before 1860) has a cut-out of a crested jay on a branch, in colour, stuck down and

[1] G. Buday, *The Christmas Card*, 1954, credits Leighton with drawing the first robin on a Christmas card in 1862.

VIIIA Bound by
Westleys, book dated
1853 (see pl.IVA).
Signed JL (John
Leighton).
10¼ in. x 7¼ in.

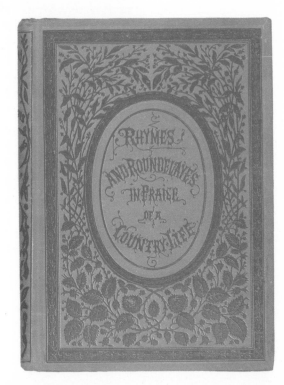

VIIIB Bound by
Leighton Son & Hodge,
book dated 1857.
Unsigned. 9⅛ in. x 6½ in.
Collection F. Jardine.

strikingly contrasted with a beefeater, blocked in gold on red cloth, with additional blocking in black.

Gems of English Art appears to be blocked in gold, red, blue, brown and green on purple cloth, but on minute examination the front of the book is seen to consist of a pasted-down sheet of paper, printed with a geometrical and floral design in colours and blocked in gold. At this time, colour on cloth bindings was nearly always obtained by inlays of coloured paper (e.g. *A Round of Days*, 1866, pl. 57B); but blocking in other colours besides gold and black was of course practicable, and can be seen on the cover of *Beauties of Poetry and Art*, Ward, Lock, & Tyler (n.d. *c.* 1865) (see above, p. 134). The inlaying of coloured paper labels on cloth and over-blocking them in gold was still traditionally used in hand binding, but it must have taxed the bindery finishers considerably when editions in this style were called for: it would add an unthinkable amount to production costs today, even if men with the requisite skill could be found.

For a period around 1860 there was a fashion for placing a panel of paper centrally on the front of cloth covers; the panel might be oblong, circular, oval, almond-shaped or 'mandorla', or in more complex shapes, was white or coloured, and was blocked in gold. The surrounding cloth was heavily blocked in blind and gold. Examples include *Light for the Path of Life*, Griffith & Farran, n.d. (1858) (pl. 56B); Wordsworth's *The White Doe of Rylstone*, Longman, 1859; Longfellow's *The Song of Hiawatha*, W. Kent, 1860; Harrison Weir's *The Poetry of Nature*, Sampson Low, 1861; *The Pilgrim's Progress*, Routledge, 1861; Mrs Gatty's *Parables from Nature*, Bell & Daldy, 1861; *English Sacred Poetry*, Routledge, 1861; and *Favourite English Poems*, Sampson Low, 1862. Only four of these designs, *Hiawatha*, *Pilgrim's Progress*, *English Sacred Poetry* and *Favourite English Poems*, are signed, all with the initials of Robert Dudley.

This style was, perhaps, the most attractive of all the decorative gift-book binding styles of the Victorian period; and it was most successful when the central panel was white.

Some interesting bindings were designed at this time by Dante

Gabriel Rossetti, in complete contrast to the general style of the period. The first was on the first edition of his sister's *Goblin Market*, published by Macmillan in 1862, a severe design of straight lines with tiny circles blocked in gold on blue cloth, which has no particular harmony with the rest of the book. It is disconcerting to find this date on a design which might have been made in the 1890s or the 1900s (pl. 64).

Rossetti also designed cases for his brother's translation of Dante's *Divine Comedy*, Macmillan, 1865; Swinburne's *Atalanta in Calydon*, Moxon, 1865, consisting of four simple gold roundels on white buckram; Christina Rossetti's *The Prince's Progress*, Macmillan, 1866; his own *Poems*, F. S. Ellis, 1870; and Maria F. Rossetti's *A Shadow of Dante*, Rivington, 1871. All are highly idiosyncratic and effective.

William Morris also designed a few cases for his own books which are strongly in contrast with the average of the times, e.g. for *Love is Enough*, Ellis & White, 1873; *The Story of the Volsungs & Niblungs*, F. S. Ellis, 1870; and *The Earthly Paradise*, Reeves & Turner, 1890.

During the 'sixties, the usual designed bindings for gift and poetry books remained conventionally decorative, and owed more to the skill of their execution, and the infallible quality of gold on coloured cloth, than to the originality of the designs themselves.

As the century progressed, the dignity and taste of designs deteriorated, as recollections of Georgian restraint grew fainter.

In the 'seventies, abstract decoration, influenced by 'artistic printing', became more and more meaningless (pl. 63A, B). The symbolic illustration or cartouche, which John Leighton had done so well, was expanded into overall illustration (pl. 62A).

Some excellent illustrative designs, blocked only in gold on dark cloth, were used by Macmillan for their series of illustrated classics (see p. 163); and covers designed by Caldecott (e.g. *What the Blackbird Said*, Routledge, 1881, in gold, red and black on grey cloth) and Walter Crane were distinguished; but the depressing average is illustrated by Spenser and Byron on pl. 63: overloaded, heavy and pretentious, very like the grey terraces of little bow-windowed

houses with stained-glass above the front door of the same period. At the least, illustrative covers like *Voyage of the Sunbeam*, 1889 (pl. 62B) and numerous children's annuals of the same period, blocked in colours, had lost the meaningless ornamentation of the last ten years and had regained some vigour. Mention should be made here of the magnificent ornamental bindings for the works of Jules Verne, published by Hetzel in Paris from the 'seventies onwards. Some made bold use of gold and black blocking, others consisted of illustrative designs blocked in gold and several colours: all were of superb craftsmanship and perhaps surpassed everything of the kind that was being produced in Britain during the last twenty years of the century.

The revival of interest in book design which took place in Britain in the 'nineties did not neglect bindings. The designs of Charles Ricketts (e.g. *Poems Dramatic and Lyrical* by Lord de Tabley, 1893) and Laurence Housman (e.g. *Goblin Market*, 1893, *The End of Elfintown*, 1894, and *Green Arras*, 1896) brought in a new era altogether.

An illustration by John Pettie, engraved on wood by Dalziel, in *Wordsworth's Poems for the Young*, London, 1866.

18
The end of an epoch

R. C. K. ENSOR, in his *England 1870–1914*, observes that 'round about 1870 occurs a watershed in English life. The race of giants, who had rendered the first half of Queen Victoria's reign so memorable, had passed or was passing.' So it was also in the world of book design: but a new generation of giants was coming up. In 1870, William Morris was thirty-six, and Emery Walker nineteen; in America Daniel Berkeley Updike was ten, Will Bradley two, and Bruce Rogers was just born.

William Morris issued the first book from the Kelmscott Press in 1891. This event was a convenient point from which to start my earlier account of modern book design, and is an equally convenient terminal for the Victorian period. The Kelmscott Press was in fact both an end and a beginning. It was entirely inspired by the past; yet it inspired the future. Such was its effect, that young men in many parts of the world gazed at Kelmscott pages as if at a revelation. Some went off and did likewise. Others, including Updike, Bruce Rogers, Carl Poeschel, S. H. De Roos and Oliver Simon, went off and did something quite different. The stir of Kelmscott was the beginning of a movement of revival in book printing which was felt round the world.

Having said this, and it is true, it must also be said that, if the Kelmscott Press had never existed, it would not have been necessary to invent it. The reformation of printing design would have happened anyway. It had, in fact, already started, both in Britain and America, before Morris printed a single Kelmscott edition.

For over four hundred years, methods of printing books had not changed much. But from 1870 onwards the speed of change greatly accelerated. The two changes which really mark the watershed between the old and the new are the inventions of photographic

block-making and mechanical composition. Both were pioneered (as so much else at this time) in America. *Harper's* in New York was using half-tone blocks in 1884; the *Strand Magazine* of London contained line blocks, half-tone blocks and wood-engravings in its first number in January 1891.

Various machines for composing type had been in use for years but the book trade was not affected until the Linotype and Mono-type machines were perfected between 1890 and 1900. (Books were still being commonly set by hand even after 1918.)

The introduction of blocks, made photographically from draw-ings, very quickly destroyed the wood-engraving industry. Artists could draw in different ways, including in washes, and the look of book pages was completely altered. Mechanical composition did not in itself make book pages look different, but the mechanical methods of making type punches and matrices, which the compo-sing machines entailed, resulted in the introduction of vast numbers of new type faces, and thus greatly added to the problems and possibilities of book designing.

The numbers of papers used for books also began to increase. Cheap wood-pulp papers began to be used during the 'seventies; coated 'art' paper, for half-tone blocks, came in during the 'nineties. Special papers were required for other new processes: photography had been used in lithography since the 'sixties, photolithography by the three-colour process was being developed in the 'eighties, and offset-lithography after 1900. Photogravure, conceived by Fox Talbot, was a working process from the 'eighties. Another important development was the standardized point system (still today not standardized internationally) which was adopted in England in 1898.

The story of book design during these years of technical turmoil contains few important highlights until the 'nineties.

Charles Whittingham died in 1876, having outlived Pickering by twenty-two years. The Chiswick Press was acquired by George Bell, the publisher, who had already combined bell and Aldine anchor for his title-page device. In 1878, Charles Jacobi, who had been an apprentice in the press, became assistant manager, and in

1885 manager, of the Chiswick Press: in 1901 he became its Managing Partner. Under his reign, many good things were produced. Jacobi was no originator, but he had a strong sense of style in printing and knew how to use the material he had inherited. His sound abilities as a typographer can be seen in the various books he wrote and especially in his ten variants of a title-page, devised for teaching, which are shown in his *Notes on Books*, 1892, and in T. L. De Vinne's *Title-pages as seen by a Printer*, New York, 1901.

Andrew Tuer (1838–1900) was another printer who, like Jacobi, was more conscious of the past than of the future. He began publishing, as 'Field & Tuer', in 1877, and founded his Leadenhall Press imprint in 1890. Tuer tended to affect 'Ye Olde' styles, often in deliberate fun, but he had a real feeling for type. He began *The Printers' International Specimen Exchange* in 1880, which collected, bound up, and distributed actual offprints contributed by compositors and printers both at home and abroad. Its influence was more in the field of jobbing than of book printing, but its pages are a good place in which to study the extraordinary things printers had quite suddenly become capable of designing.[1] The Leadenhall Press style is shown at its best in the various entertaining books illustrated by Joseph Crawhall which Tuer produced, and in John Ashton's *A History of English Lotteries*, 1893. We must here also mention Charles Hindley's *The History of the Catnach Press*, 1887, published by Hindley and printed by E. A. Beckett: it was produced in the same light-hearted antiquarian spirit, and its pages were made especially pleasing by a lavish use of both printed and hand-painted colour.

Ordinary commercial book printing deteriorated during the 'seventies and 'eighties, because of new possibilities in cheapness of methods and materials. The first edition of *Kidnapped*, 1886, printed and published by Cassell, may be taken as an unlucky but not unfair example of the average of its period: even on the title-page there are several battered letters, and the Modern type in which the book is set is very worn throughout. The actual typography's worst fault is that it conspicuously lacks any style at all.

[1] See V. Ridler, 'Artistic Printing', in *Alphabet & Image*, London, 1948.

This is the general complaint against nearly all books of the period.

A certain style, and excellence of machining, was however maintained in Edinburgh by R. & R. Clark and T. & A. Constable. Robert Clark has already been mentioned: Walter Biggar Blaikie (1847–1928) was the chairman of Constable's, and a remarkable character. A cousin of Robert Louis Stevenson, he had trained as a railway engineer, and worked in India as Engineer to the Rajah of Kathiawar. He joined Constable more or less accidentally and became a notable scholar-printer, finding in himself a flair for the niceties of book design. W. E. Henley dedicated a book to him as 'Artist-Printer'; William Morris is reported as having said that Blaikie's types were the ugliest he had ever seen, and Blaikie answered that Morris's books were just old bric-a-brac.[1] Blaikie was also a distinguished amateur astronomer and something of an authority on the Jacobite period.

Of the English printers, Richard Clay of London and Bungay was capable of good work, when allowed to do it by the publishers.

In America, the Riverside Press, of Cambridge, Mass., were also doing good work. They were design-conscious, since in 1895 they hired the young Bruce Rogers; but even before his arrival, a real style can be seen in such books as O. W. Holmes's *The One Hoss Shay*, n.d. (*c.* 1891) (p. 165) illustrated with line blocks from drawings by Howard Pyle, and T. B. Aldrich's *The Story of a Bad Boy*, 1894, illustrated (from tooled half-tones and line blocks) by A. B. Frost. Both have title-pages in red and black and are attractive books in every way, including original ideas in binding design.

Among commercial gift books, the best of the whole period are perhaps to be found among the series published by Macmillan, which began with Caldecott's *Old Christmas*, 1875, and *Bracebridge Hall*, 1876. Their characteristic dark green or black cloth, blocked in gold with pictorial designs, is still conspicuously attractive. The changes of style and technique in illustration, from Caldecott to Hugh Thomson, can be studied in their pages. In *Rip Van Winkle*, 1893, for example, the wood-engravings after George Boughton show a complete change from the 'sixties and 'seventies: mechanical

[1] John Connell, *W. E. Henley*, 1949.

methods are creeping in, the engraver is copying wash tones in the same style he has learned to use for photographs. There are similar changes in colour printing. The firm of Edmund Evans may be carrying on as before, but the lithographic colour printing of Raphael Tuck and Marcus Ward gives many children's books of the 'eighties and 'nineties an utterly new look. Some very fine effects can be achieved by the new techniques, for instance in Lucius Rossi's colourful illustrations to *The School of Scandal*, n.d. (1891). The advances of photolithography in the reproduction of works of art can be studied in the plates (printed by Lemercier and Firmin-Didot in Paris) of Audsley's books on Japanese art (see p. 98), and in the work of the London printer William Griggs (1832–1911). Griggs had become an expert in the reproduction of works of art and a pioneer of photolithography, which he combined with collotype; in 1919 the firm he had founded was amalgamated with the Chiswick Press, which then changed its name to Charles Whittingham & Griggs. His finest colour printing can be studied in *Portfolios of Industrial Art* which he edited from 1881 to 1898, the *Journal of Indian Art and Industry*, 1884–1916, and Warner's *Illuminated Manuscripts in the British Museum*, 1902–3.

The outstanding letterpress printer in America at this time was Theodore Lowe De Vinne (1828–1914). In 1850, De Vinne had joined, as a journeyman compositor, the printing house of Francis Hart in New York. In 1858 he became a junior partner, and in 1877, when Hart died, he became head of the firm; by 1883 he owned the business, which had changed its name to his. De Vinne was a good printer, and also an author: his *Plain Printing Types*, 1900, was the first handbook on the subject, preceding Updike's much greater work by twenty-five years. But De Vinne, like Jacobi, lacked true originality: as C. P. Rollins remarks: 'Conventional types, conventionally arranged, and printed with precision: this is the worst and the best that may be said of De Vinne's printing.'[1]

It was from amateurs, not professionals, that new ideas entered the design of books. One of the first was the Rev. C. H. O. Daniel, who had begun printing as a boy, and continued his private press as

[1] *Signature* 10 (New Series), London, 1950.

The One Hoss Shay

With its Companion Poems
How the Old Horse Won the Bet
&
The Broomstick Train
By Oliver Wendell Holmes
With Illustrations by
Howard Pyle

LONDON
GAY AND BIRD
KING WILLIAM ST., WEST STRAND

An American title-page of *c.* 1891, designed by the Riverside Press before
Bruce Rogers went there. Original in red and black (*reduced*).

Provost of Worcester College, Oxford. He revived the Fell types, then lying forgotten in the University Press, and used them for a charming series of small limited editions between 1877 and 1919: his use of them led to a recognition of their qualities in the Press itself, and they have remained a valued asset ever since. Robert Bridges, the poet, designed two of his own books, in 1883 and 1884, for printing by Daniel, and insisted that they should be plain and without ornament: the revolt against decoration was already in the air. The painter Whistler also had ideas on book design, which can be seen as early as 1878, but especially in his *Gentle Art of Making Enemies*, 1890. This book was part of a whole new movement in book design, which owed nothing to the Kelmscott Press, but a great deal to Oscar Wilde, to ideas on art then effervescing in Paris and in Holland, and to the brains of several young men such as John Lane, Algernon Methuen, William Heinemann, Joseph Dent, Elkin Mathews, and Grant Richards, all of whom had set up publishing businesses in London between 1888 and 1897.

Yet the greatest, and certainly the most influential, of all the amateurs was William Morris. He was not interested in the printing industry; he knew very little about it, or any of its processes, although he had had several contacts with it. In 1856, at the age of twenty-two, he had founded *The Oxford and Cambridge Magazine*, and probably met Whittingham, when he got the Chiswick Press to print it. His two earliest books of poems, the *Defence of Guinevere*, 1858, and *The Life and Death of Jason*, 1869, were both printed at his own expense by Chiswick, and to our eyes look admirably designed. In 1866, and again in 1871, Morris planned a fine edition of one of his own works; blocks were engraved, and specimen pages set up by the Chiswick Press, but were abandoned.

Eventually, fired again with enthusiasm for printing as an art by his friendship with Emery Walker, whom he met in 1884, he returned to the attack. The Kelmscott Press was founded, and when it was wound up, after Morris's death in 1896, it had produced fifty-three titles. It had also been a commercial success, which helped to convince many who would otherwise have scoffed.

The Kelmscott books, all uniform in general style, did not show

how books should be designed in 1890 (although some people thought they did). They were in fact quite unsuitable for reading: it would be interesting to know how many Kelmscott owners have ever read more than a single page in any Kelmscott book. If they did not show how books should be designed, what did they show?

They showed that books could be magnificent. There is no doubt that Kelmscott editions are rich and satisfying objects, to look at, to handle, and to remember. They have an insistent integrity that means much today, and must have meant more in the 1890s.

The second thing they showed, as no lesser books could have shown, was the basic ingredients which go to making fine books. Morris accepted no single item as he found it, except the hand-press, and he probably tinkered with that. He had paper specially made for him by Joseph Batchelor in Kent: customers and printers alike needed reminding that modern paper could actually be a satisfying thing in itself. He rejected every type currently available and designed three of his own: they were magnificently black, and reminded people that a page of type could be as rich and decorative as a page of medieval manuscript. He had ink specially ground, to remind people that black ink could be really black, and red ink could be red. He took infinite pains; and through it all, his own terrific vitality, and the fact that he himself was a writer as well as a designer, saved the venture from preciousness or sterility.

In 1901, De Vinne, in his work on title-pages, wrote of the Kelmscott Press as follows:

'The best features of the Kelmscott books are not at once noticed; the oddities are first seen, and are copied and exaggerated. It is a great misfortune that the Morris style has been so often imitated, for it was devised by Morris for medieval books or subjects, and should be used for them exclusively. The imitation of Morris typography in any book on a modern subject is practically an anachronism . . . The great merit of the Kelmscott book is in its superb presswork. Its types are always sharp, clear and clean; impression is uniformly even; the black ink is a full black, the red ink is always bright but not shiny, and the two colours are in accurate register. No printer of the fifteenth century did better; few did as well.'

De Vinne's remarks are as much a tribute to his own perception, as to Morris's skill. Yet in the same work, *Title-pages as seen by a Printer*, he ignores, because he clearly disapproves, the one group in England who were really doing something new. Some poor examples of 'nineties work are held up to scorn: but among all the title-pages he illustrates, he shows nothing by Shannon, Ricketts, Pissarro, Horne or Laurence Housman, men who had for some ten years been producing a new sort of poetry in book design: men who, like Morris, had the priceless gift of originality, but who, unlike Morris, were prepared to work within the printing industry as it actually existed.

The Index